D0771271

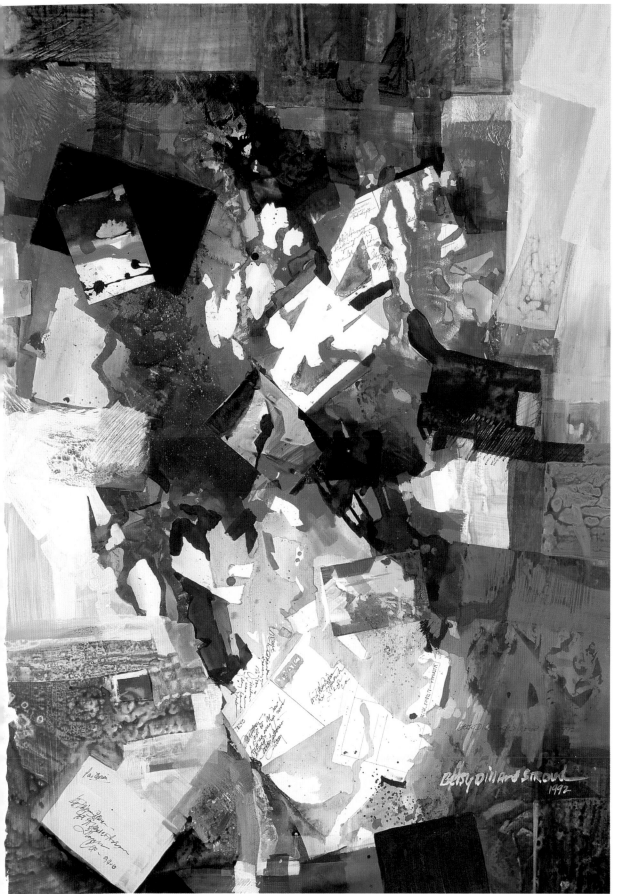

painting from the **inside out**

POSTCARDS FROM THE EDGE, #4
Betsy Dillard Stroud ✛ 40" × 30" (102cm × 76cm) ✛ Watercolor, acrylic, ink, collage on cold-pressed watercolor board ✛ Collection of the artist

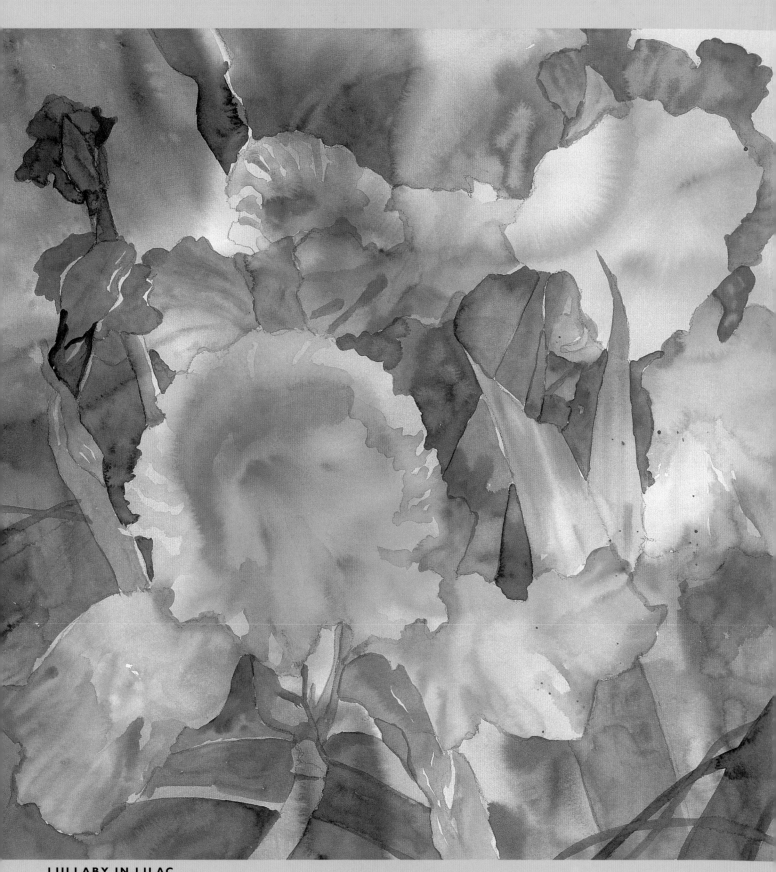

LULLABY IN LILAC
Betsy Dillard Stroud ✤ 22" × 30" (56cm × 76cm) ✤ Watercolor on 140-lb. (300gsm) cold-pressed paper ✤ Collection of the artist

painting from the
inside
out

19 projects and exercises to
free your creative spirit

"As a painter, color is my language,
my brush is my voice, and my finished
painting is my testimony."

—Betsy Dillard Stroud

betsy dillard stroud

NORTH LIGHT BOOKS
CINCINNATI, OHIO
www.artistsnetwork.com

about the author

A born Virginian, Betsy Dillard Stroud now resides in Scottsdale, Arizona with her very bad dogs, Scalawag and Edgar. The influences of her eastern upbringing and the spirit of the West and Southwest infuse her work.

Stroud was educated at Stuart Hall Episcopal Girls School in Staunton, Virginia, and received her B.A. from Radford College, and her M.A. in art history from the University of Virginia, where she was the first woman in the graduate arts program. Stroud had just completed the course work for her doctorate and her orals in art history, when she wrote her first book, *Coming Hither—Going Hence.*

She is a signature member of the American Watercolor Society, the National Watercolor Society and the Rocky Mountain National Watermedia Society. She is a former president of the Southwestern Watercolor Society based in Dallas, and is a Life Member and Royal Scorpion of the Arizona Watercolor Association. She is also a member of "The 22" × 30"" Watercolor Critique Group in Scottsdale.

A winner of twenty-two awards, one of which is a High Winds Medal from the American Watercolor Society, Stroud has had twenty-two one-woman exhibitions of her work. She has exhibited in over 140 invitational, joint and competitive national and regional shows.

A highly respected workshop teacher and juror since 1987, she teaches painting workshops nationally and locally at the Scottsdale Artists' School and the Shemer Art Center in Phoenix. Also a professional writer, Stroud served as Associate Editor of North America for *International Artist Magazine* (1998-2001) and is a frequent contributor to many art magazines. Stroud received her CTM certificate and is a member of Park Central Toastmasters in Phoenix, Arizona.

Painting From the Inside Out. Copyright © 2002 by Betsy Dillard Stroud. Manufactured in China. All rights reserved. No part of this book may be reproduced in any form or by any electronic or mechanical means including information storage and retrieval systems without permission in writing from the publisher, except by a reviewer, who may quote brief passages in a review. Published by North Light Books, an imprint of F&W Publications, Inc., 4700 East Galbraith Road, Cincinnati, Ohio 45236. (800) 289-0963. First edition.

Other fine North Light Books are available from your local bookstore, art supply store or direct from the publisher.

06 05 04 03 02 5 4 3 2 1

Library of Congress Cataloging-in-Publication Data

Stroud, Betsy Dillard
 Painting from the inside out : 19 projects and exercises to free your creative spirit / Betsy Dillard Stroud.
 p. cm.
 Includes bibliographical references and index.
 ISBN 1-58180-122-X (alk. paper)
 1. Painting—Technique. 2. Creative ability—Study and teaching. I. Title.

ND1473 .S77 2002
751.4—dc21 2001054622

The permissions on page 141 constitute an extension of this copyright page.

Edited by Jennifer Lepore Kardux
Designed by Wendy Dunning
Interior production by Kathy Bergstrom
Production coordinated by John Peavler

metric conversion chart

to convert	to	multiply by
Inches	Centimeters	2.54
Centimeters	Inches	0.4
Feet	Centimeters	30.5
Centimeters	Feet	0.03
Yards	Meters	0.9
Meters	Yards	1.1
Sq. Inches	Sq. Centimeters	6.45
Sq. Centimeters	Sq. Inches	0.16
Sq. Feet	Sq. Meters	0.09
Sq. Meters	Sq. Feet	10.8
Sq. Yards	Sq. Meters	0.8
Sq. Meters	Sq. Yards	1.2
Pounds	Kilograms	0.45
Kilograms	Pounds	2.2
Ounces	Grams	28.3
Grams	Ounces	0.035

dedication

Shakespeare wrote: "A teacher influences eternity." It is with the knowledge of this truth that I dedicate this book to four of my greatest teachers.

To artist/teacher NAOMI BROTHERTON, who has given so much to so many, and especially to me.

And in memory of:
My mother, LIZE, who taught me about beauty and survival.
My uncle/stepfather, HERBERT NASH DILLARD, JR., who taught me about art, music and literature.
THE REVEREND ALBERT ACHILLES TALIAFERRO, whose incandescent light inspires me still.

acknowledgments

Without the love, support and physical assistance of my friends, I would not have been able to write this book. I am profoundly grateful to: Norbert Baird, who assisted me in most of the photography, who kept me calm and who gave me immeasurable help in so many ways; to Gail Wilkinson, who also helped me photograph and always had a cheerful word and glowing smile; and to Diane Maxey for her generous photographic help with my initial proposal.

For other incredible gifts of the spirit during the past few years, I wish to thank the following friends: Lynn and Anne McLain; Maureen Bloomfield; Mary and Bill Arendt; Joanne West; Jason Williamson; Paul Jackson; Dan and Ann Burt; Jeff Heath; Anna Howell; Miri Weible; Dick Phillips; Cynthia Woody; Terry and Wyatt Earp; Richard and Iole Miller; and the infamous members of my critique group "The 22" × 30"."

Many, many thanks to my editor Jennifer Lepore Kardux, who has the patience of Job and an incredible tolerance for the eccen-tricities of southerners. Moreover, a big thank-you to Rachel Rubin Wolf, who got me started on this project.

Thanks to photographer Mike Thompson, for taking great transparencies and to all of my contributors, both students and friends, for sharing their wonderful artwork. I would also like to thank the Scottsdale Artists' School, where I developed some of the techniques mentioned in this book.

Finally, I want to thank Scalawag and Edgar for keeping their tails wagging fast and for loving me no matter what.

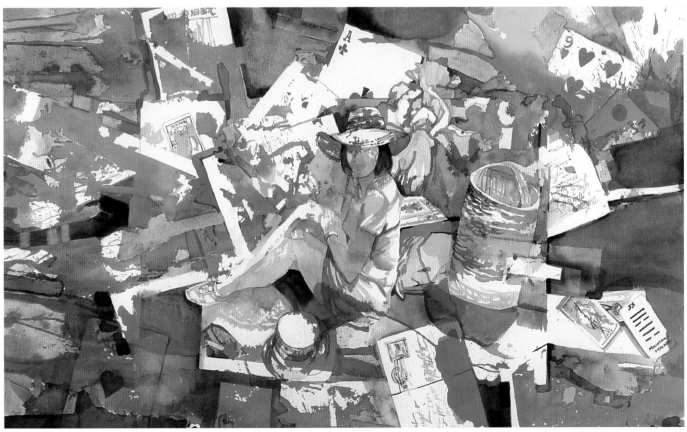

SELF-PORTRAIT
Betsy Dillard Stroud ✧ 26" × 40" (66cm × 102cm) ✧ Watercolor on 200-lb. (425gsm) cold-pressed paper ✧ Collection of the artist

table of contents

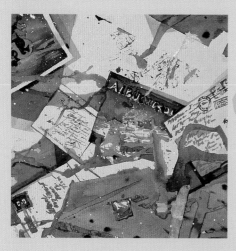

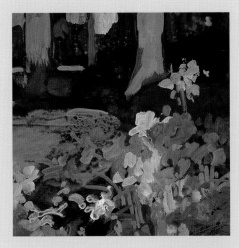

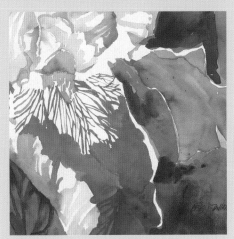

introduction

For as long as I can remember, I have been fascinated with art. As a child, I stood on tiptoes in my grandmother's parlor to look at the giant art book on her huge round, marble table. It was too heavy to lift, so I would try to move it forward with my tiny hands, until finally someone would get it down for me. When I was eight, I copied Botticelli's *Birth of Venus* from that book, trying desperately (with my ten-cent store paints and brush) to reproduce the beautiful colors and the extraordinary shapes I saw before me.

In the small town of Rocky Mount, Virginia, where I grew up, there were no art stores, so the ten-cent store had to do. Then, shortly before my ninth birthday, my uncle Herbert (he later adopted me after my father died) gave me my first set of oil paints, and my parents found a tole painter who taught me the rudiments of painting. From that moment on, I aspired to become a painter. At times, it seemed a circuitous route. Yet upon reflection, every step was essential and every step contributed to my artistic development.

> "Every painting should be a surprise journey with an unexpected ending."
>
> —Robert E. Wood as taken from the author's class notes (1926-2000)

You, too, have a lifetime of experiences, thoughts, feelings and ideas—priceless source material and inspiration for your art. For, as artists, if we express in our work what we know in our hearts, we cannot help but be successful.

In the first grade, I looked with envy at the neat coloring books of my friends. My coloring books were messy globs, slashed with thick staccato strokes and heavy crayon marks, displaying a complete disregard for the boundaries of the page. To save my soul, I could not stay between the lines! Now, I realize that at six I was "Painting From the Inside Out," although I did not know it. I had abandoned myself to the creative process instinctively as most children do. Throughout the years, I have struggled to stay in that hallowed place. As you read this book and try the projects in it, it is my sincere wish that you, too, will surrender yourself to creative abandon and "Paint From the Inside Out." Explore ceaselessly, and with the exception of the exercise in chapter two, I promise I won't make you stay within the lines.

Coming from a family of lawyers and judges with a decided intellectual bent, I chose an academic route at first, and was the first woman in the Graduate Fine Arts Department at the University of Virginia. It was during these exciting years of studying art history that I learned discernment and how to look. I got my master's degree and entered the doctoral program. I did all my course work for the doctorate and even passed my orals. But an essential ingredient was missing, and although I didn't know it on a conscious level, I was not totally committed to art history. I had become a closet artist.

In the meantime, my wonderful uncle Herbert died, and I felt compelled to write a book about him. Writing that book, entitled *Coming Hither—Going Hence*, changed my life. I met and married a Texan, moved to Dallas, and became a full-time painter. That was twenty-two years ago. Though my marriage did not survive, my indomitable desire to become a painter did! Other life changes brought me to Arizona, where I have now lived for the past five years. Change is a natural stimulus, and if welcomed, serves as an important ancillary to the creative process.

This book will push you past boundaries to encourage you to explore new ideas and to trust and develop your own aesthetic abilities. As you start these creative projects, expect the changes that will undoubtedly come. They will be reflected in your artwork and in you, yourself. Let them happen. Making art is about self-discovery and expression as much as it can be about beauty, social statement, life and death, love, rage, psychoses, rumination and experimentation. True art encompasses all things.

In 1985 in a watercolor workshop in Dallas, Robert E. Wood made a statement that will remain indelibly etched in my memory. He said, "Every painting should be a surprise journey with an unexpected ending." Let me remind you that the painter's journey should not be hurried. It is a journey that will take the rest of your life. It is sometimes a journey of small steps and sometimes giant leaps into unknown territory. It is a journey that will never cease to stimulate you, delight you, confound you and challenge you. That is the fate of an artist.

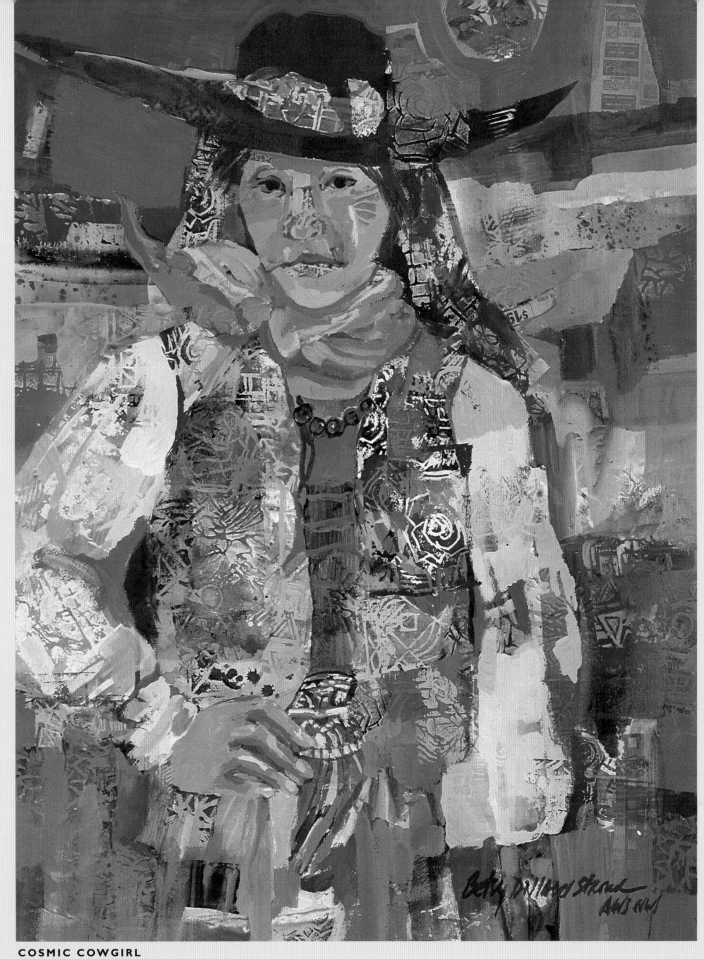

COSMIC COWGIRL
From the series, "Whatever Happened to Randolph Scott?" ✦ Betsy Dillard Stroud ✦ 30" × 22" (76cm × 56cm) ✦
Collage, acrylic, watercolor on 140-lb. (300gsm) cold-pressed paper ✦ Collection of the artist

Materials

When you paint in watercolor, it is very important to buy the very best materials you can afford. Inferior products make inferior paintings. In order to achieve optimal effects, you must have the right tools. You'll see what I mean if you try to do a graded wash on a cheap sheet of paper.

When you paint in acrylic, on the other hand, some less-expensive products do a very good job. While it is necessary to have some good brushes, you can augment your selection with cheap sponge applicators, twigs, chopsticks and other miscellaneous items that in certain instances work just fine.

Paint

Always buy artist's quality paint. The student grade of paint does not have the same staining power, color luminosity and mixing abilities of a good quality paint.

Watercolors

For watercolors I mostly use Maimeri-Blu brand whose watercolors are a perfect mixture of pigment and gum arabic. They blend beautifully, and the available assortment of colors is spectacular. They are exceptionally brilliant and of intense saturation.

I also use specific pigments from other brands, including Daniel Smith (especially their interference and iridescent watercolors), Schmincke Horadam, Holbein and Winsor & Newton. Try everything until you come up with the perfect palette for you.

Acrylics

For acrylics I use tube, fluid and jar acrylics according to the type of painting I am doing. For abstract painting I use a combination of tube and fluid acrylics. Fluids are good for pouring and, because they have a medium already in them, they make beautiful glazes. On the other hand, because they have a medium in them, if you use them thickly, paint will start to bead up faster than if you use tube acrylics with water as a medium.

Therefore, when I build up layers I like to use tube acrylics with lots of water. I prefer water as a medium when I work on paper and most of the time when I work on canvas. Tube colors give you more body and lend themselves well to landscape, still life and figure painting, especially when you need opaques.

I like Maimeri-Brera tube acrylics, as they are easy to mix and work beautifully using transparent techniques. At the same time, they also work well used in an opaque way. Their color range and selection is terrific, and the saturation of their pigments is incredible. You can experiment yourself with comparisons.

When I stamp into or on a painting, I prefer using the jar acrylics to the fluid acrylics, as the jar acrylics have more body.

Gouache

I also make use of gouache. Coating your paper with gouache and allowing it to dry before painting over it will create a surface that allows you to lift back to the original white of the paper (see chapter seven).

Media to mix with acrylics and watercolor

You can add gels or other media to your colors to get terrific impasto results and textures.

Volume (a light modeling paste) creates great texture perfect for both watercolor and acrylic.

Medio Brilliantante (a liquid gloss medium) is a paint extender that protects the surface of a finished painting. You can seal layers of paint with a half-and-half mixture of gloss medium and water.

Fluid matte medium can be mixed with acrylic to make the medium more malleable. You can also use it to coat or

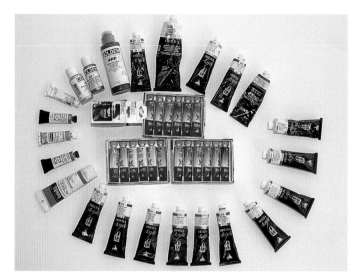

Here's an assortment of some of my favorite watercolors, acrylics and gouache.

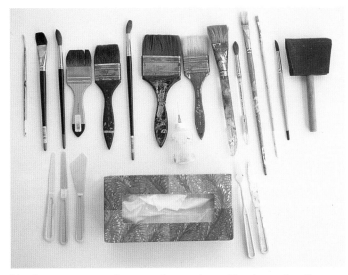

Here's an assortment of my most frequently used brushes and applicators.

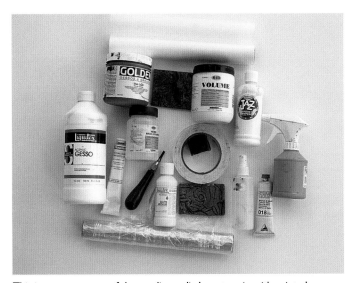

This is an assortment of the acrylic media I use to mix with paint plus other tools of the trade.

seal your paper. Special uses of matte medium are discussed in chapters three and seven.

Pumice gel makes a gravel-like texture. You can mix it straight on the paper (you might have to add some matte medium), or mix it into your paint first. You might want to apply a coat of gesso over it after it's dry to get back a white surface.

Brushes

It is important to have a wide assortment of natural hair and synthetic brushes, and a mixture of both round and flat. Be aware that you should never use your good watercolor brushes with acrylics. Acrylics will ruin natural hair brushes.

Natural sable brushes enable you to model or sculpt with the brush. They carry a lot of paint and work well for wetting your paper.

Synthetic brushes are handy when you need a point that holds its shape. A good synthetic brush works well for layering and glazing acrylics.

Flat brushes are essential for painting skies, running washes, painting wet-into-wet and glazing large areas. Flats are also useful for painting geometric

shapes like rocks, and can be used in non-objective painting as well.

Rounds work well for organic things like flowers, tree foliage, figures and portraits.

Riggers are useful in flower painting, as they make wonderful stalk and twig shapes and very thin lines.

Paper

For most of my more representational work, I prefer Arches 140-lb. (300gsm) cold-pressed paper. It has some tooth, and both glazes and thicker paint work well on it.

Strathmore Aquarius II is a thin, inexpensive paper that doesn't warp. It works well with acrylic stamping and glazing.

Fabriano Uno and Arches 140-lb. (300gsm) hot-pressed paper have wonderful "lifting" ability with watercolor, and work well with all acrylic techniques.

I sometimes use Fabriano Uno soft-pressed paper for watercolor florals. This paper has a unique surface that promotes "floating" in color.

I use Crescent watercolor board (cold- or hot-pressed) when I pour with watercolor. It has a thick surface that lifts

easily and works well with flowing paint.

I use Crescent illustration board (heavy weight), canvas or canvas board for opaque acrylics.

Other supplies

I use Kleenex brand **tissue** to lift paint. It works better than any other brand of tissue because it won't fall apart, dissolve or stick on your painting as easily as other brands.

Liquid tempera works well as a resist (see chapter seven for how to use it).

Black waterproof India ink mixes well with watercolor and is used in chapter seven.

I use **alcohol** only with acrylics. It disperses the paint and can remove acrylic. Cheap Joe's **Oiler Boiler** is a syringelike applicator that comes in a plastic bottle. This is a great tool: You can fill it with alcohol or acrylic paint and draw with it to get texture.

Soft **linoleum blocks** by Daniel Smith, Speedball or Pearl can be carved into beautiful stamps. Make sure the block is soft on both sides so you can manipulate it easier. Carve the blocks with a Linoleum Carver (Speedball). Do not use a knife, unless you want a finger mutilated.

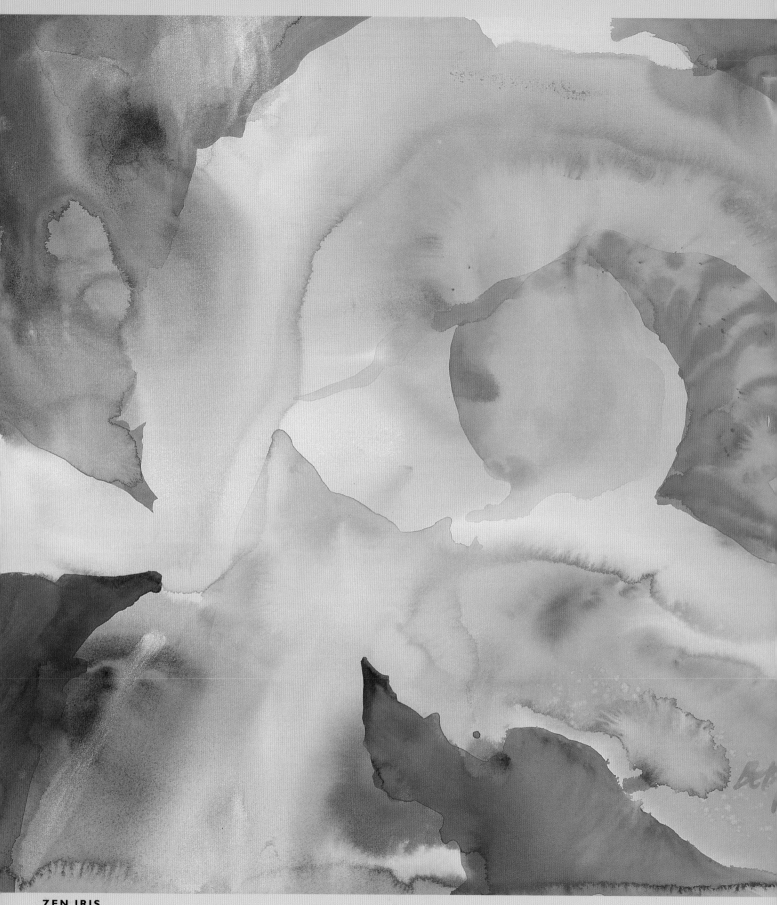

ZEN IRIS

Betsy Dillard Stroud ÷ 22" × 30" (56cm × 76cm) ÷ Watercolor on 140-lb. (300gsm) cold-pressed paper ÷ Collection of the artist

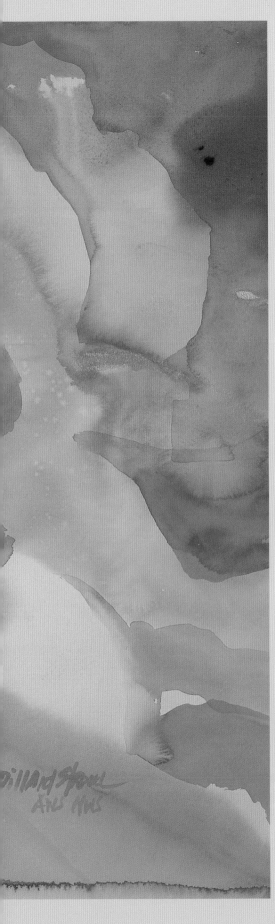

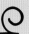

"I shut my eyes in order to see."

—Paul Gauguin (1848-1903)

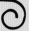

warming up

Think about it. Before a concert, the orchestra sits, tunes, fiddles, blows and bangs the drum. Before a game, athletes bounce balls, practice passing and swing bats into empty space. How many times have you ruined a painting because you had so much creative energy that you continued to paint even though you needed a drying time? Perhaps you couldn't take the time to squirt clean pigment on your palette or to select a harmonious color scheme. The warm-up exercises in this chapter will help you control those urges. They have many aesthetic benefits as well.

Clear your mind of expectations. Start with fresh pigment (and not just a pea-sized dab, either!) and lots of clean water. Grab a big brush—at least two inches (51mm)—and a full sheet of paper. Remember, painting is not a wrist exercise. Get your whole body involved, and unless you are unable, stand up so you can approach your paper with power.

It's very important not to put pressure on yourself to get a finished product. When you release this expectation, wonderful things happen. First, you will probably get a painting that can be developed later on. Second, you will start to see a certain pattern in the way you put paint to paper. Third, you will allow yourself to experience the joy of painting itself. Isn't that one of the reasons why you began painting in the first place?

Zen Painting

I saturated the paper with water and brushed in New Gamboge and Permanent Rose in different values. Before the first wash dried, I painted Indigo and Violet around the sides of the paper, allowing the paint to mingle freely. Lovely diffusions occurred. Once dry, I added a few negative shapes to make a finished painting.

DEMONSTRATION
zen painting

As artists we all have a rhythm indigenous to ourselves—our own personal cadence of expression. It is that natural expression that I call "effortless" or "Zen" painting. In Zen philosophy you become mindful of each moment. This exercise is designed to make you aware or mindful of each brushstroke you apply. You will deliberately put down each brushstroke onto a very wet paper. When you become mindful of your brushstrokes, you get into "flow." (Flow is another word for that state of meditative mind we often find ourselves in when we paint.) When we are in flow we are unaware of the passage of time. That's where we should be most of the time as we paint.

materials list
SURFACE
140-lb. (300gsm) cold-pressed paper

PAINT
Watercolors ◆ Blue Violet ◆ Golden Lake ◆ Green Blue ◆ Dragon's Blood

Iridescents ◆ Silver

BRUSHES
3-inch (76mm), 2-inch (51mm) flat squirrel ◆ no. 14 round sable

1: WORK QUICKLY

Use a 3-inch (76mm) squirrel brush to wet the front of the paper. You can also try wetting your paper at random, or wet it thoroughly with a brush or a sponge both on the back and on the front of the paper.

While the paper is wet, mix up a puddle of Blue Violet and use your 2-inch (51mm) squirrel brush to stroke a swath of color onto the wet paper.

Paint a ribbon of Golden Lake through the purple stroke.

2: INTENSIFY PIGMENT AND ADD CONTRAST

Add a saturated stroke of Dragon's Blood, and add more Blue Violet to intensify the blue-purple area.

Add some contrast and intensity with Green Blue, painting it into the purple/Dragon's Blood areas. Use your round brush to spatter some Green Blue into the mixture as a texture contrast.

3: ENHANCE WITH IRIDESCENTS

Use an iridescent or an interference pigment to enliven your painting, but do it sparingly. You don't want a glitzy painting. Mix up a puddle of pretty intense silver paint, and stroke it into the turquoise areas.

4: ADD MORE TEXTURE

Watercolor is such a transparent medium that we must be wily with ways to add texture. Spattering with paint or water is an effective technique. A little spatter goes a long, long way. Spatter more purple in a place that needs a little oomph.

Now, step back and look at your creation. Crop in or flip the painting to find a pleasing composition. This may be your finished work.

Zen painting with negative shapes

I once had a student who balked when I asked her to use the negative space to define the positive objects she wished to put in her painting. She was exasperated. "Why can't I just paint the cactus?" she asked petulantly.

The treatment of negative space in a painting (all that space that comprises the area around your subject) is as important as the painting of the subject itself. Once you understand this concept, your paintings will improve.

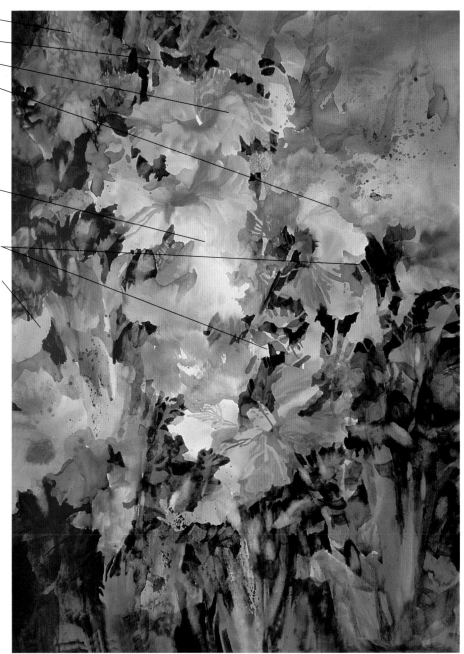

Salt for texture

Negative painting

Original abstract wash

Flower's edge disappears into background, creating ambiguity and a visual segue.

One flower disappears into another "visual passage."

Negative painting

Original abstract wash

Negative Shape Painting
I flooded washes of Winsor Red, New Gamboge and Antwerp Blue onto a wet piece of watercolor board. I spattered that with water, salt and paint while the board was wet, but I had to work fast, as watercolor dries faster on board. When the painting was dry, I used negative painting to carve out the shapes of the flowers and the foliage, using darks created from Phthalo Blue mixed with New Gamboge and a smidgen of Winsor Red and Brown Madder.

Originally, this painting looked like a blob, just like the one in the previous exercise! I challenge you to keep your Zen paintings around for a while, and then play with negative shapes and design to bring them to completion.

BAHAMIAN GARDEN: A CLOSE-UP
Betsy Dillard Stroud ⁜ 40" × 30" (102cm × 76cm) ⁜ Watercolor on watercolor board ⁜ Collection of the artist

Imago Ignota painting

Years ago, I was teaching a workshop in Salt Lake City, Utah. While doing a demonstration, a bottle of fluid black acrylic seemed to lift right out of my hand. Splat! It poured over my whole paper. Instead of panicking, I began smearing the paint around, lifting out and texturing. Out of that seemingly accidental mess, a new way of painting began for me.

Back at home I found expressionistic drawings I had done years before, similar to the Salt Lake City creations. It was then I learned never to underestimate the importance of the subconscious in the creative act.

"Imago Ignota" (*Unknown Image*) is a term developed by Carl Jung that seems to fit the concepts behind these paintings. It refers to all those antecedents that we are born with that can't be articulated verbally. For example, animals are born with instinctive knowledge to help them survive, yet who tells them this? Do cat mothers tell their little kittens about mice?

The Imago Ignota exercises are all about finding your own mark. Do these paintings rapidly and complete them in one or two steps.

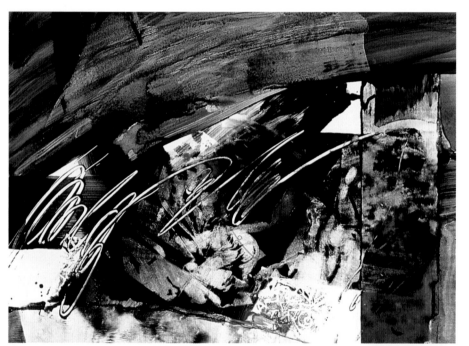

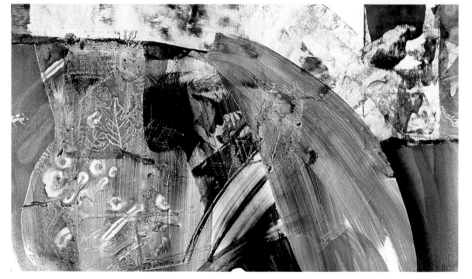

1: MAKE MUD

Pour a big dollop of matte medium onto the surface of the paper. Before it can dry, squirt Carbon Black, Quinacridone Gold and Quinacridone Burnt Orange onto it and quickly smear them around. It looks like mud!

Use a Kleenex tissue on the paint and start lifting. Use chopsticks to draw into the paint. Stamp into the paint with a mixture of Orange Luster and Black. Make a few more brushstrokes and let it dry.

2: GO WITH THE FLOW

Using a big brush will help you stay in rhythm with the painting. Mix up a glaze of Quinacridone Gold, and paint it over sections of the painting, including the original stamping. Add a glaze of Quinacridone Orange over the bottom and you're finished.

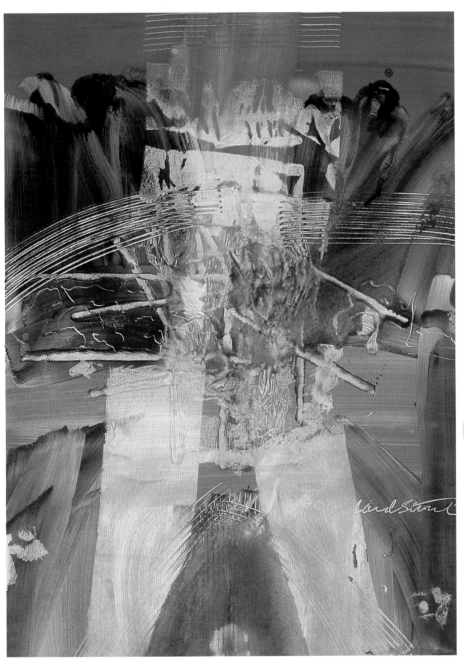

IMAGO IGNOTA, #1
Betsy Dillard Stroud ✧ 30" × 22" (76cm × 56cm) ✧ Acrylic on Strathmore Aquarius II ✧ Collection of the artist

Stay Mindful

I poured Quinacridone Gold and Quinacridone Burnt Orange together into wet matte medium, and smeared it all together, manipulating the paint using a piece of mat board. I added Iridescent Silver and Iridescent Gold into the quinacridone mixture and brushed it onto the surface. Before the paint dried, I drew calligraphic marks with my oiler (filled with alcohol). After this application dried, I mixed up Carbon Black and, with negative painting, carved a pleasing and definite shape.

The shapes that spontaneously evolved from this painting seemed deeply spiritual in nature and reminded me of the ancient altarpieces, funerary steles and religious tableaux I had studied in art history. For me, this type of painting is the consummate expression of "la vie intérieure," my inner life.

Find Your Mark

The Imago warm-up is not to make a completed painting. But guess what? With these paintings, you can almost always get a completed painting as long as you stay mindful or present. After you finish your painting, leave it be for a few days. Then, if you wish, you can play with surface textures, glazing and other methods mentioned in this book.

Painting with one-hundred strokes

The late great painter Irving Shapiro used to present the challenge of completing a painting in a hundred strokes to his workshop classes. You really need a partner with this exercise, because it is almost impossible to count for yourself.

I use this exercise to create mandalas. It is a wonderful way to start a painting session. Traditionally, a mandala is a circular painting (also known as a *tondo* in art history) that was used for meditation or prayer. When you do this exercise, think of something you wish to manifest in your life, and create this mandala as a visual homage to your idea.

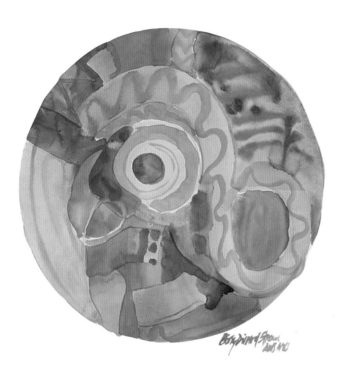

Prosperity Mandala

To make my circle, I took a big plate and drew around its boundaries with a 2B pencil. I used Indian Yellow to start my initial hundred strokes. Before it was dry, I drew into the wet paint with Tiziano Red. I let the yellow swatch dry somewhat before I painted a red ribbonlike band up at the top. Next to that I added yellow and again drew into the wet paint with red. I painted Permanent Green Light in a circle and created neutrals with these initial colors and the addition of Antwerp Blue. Each time you put your brush on the paper it counts as a stroke. If you wish to paint water first to get diffusions, that also counts as a stroke. Try to do a painting with one-hundred strokes. You'll be amazed at how fresh and wonderful it looks.

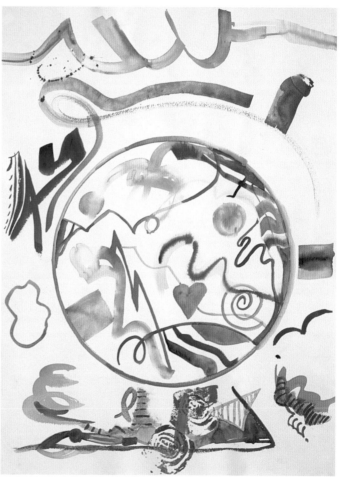

Working With Partners

I have a wonderful master class in watercolor and design whose students are always willing to try everything. It is students like these who make teaching so rewarding. I did the initial mandala with all of them counting my strokes and watching me closely. After I completed the hundred strokes, I allowed the students one brushstroke apiece, and they decorated the area around the mandala.

What do I do now?

This is the question that I hear most, and it's the question that I can't really answer. There is no correct or incorrect way to respond. My friend and fellow artist Dan Burt was also frustrated trying to answer this question. He summed up why: "Students want a concrete answer to an abstract question."

Every stroke you make is a decision, either consciously or subconsciously. Whether you paint abstractly or realistically, the possibilities are endless as to what you do with the next brushstroke. The important thing is to make your own decision and put that brushstroke down somewhere. This type of decision making (personal choice) is what painting is all about.

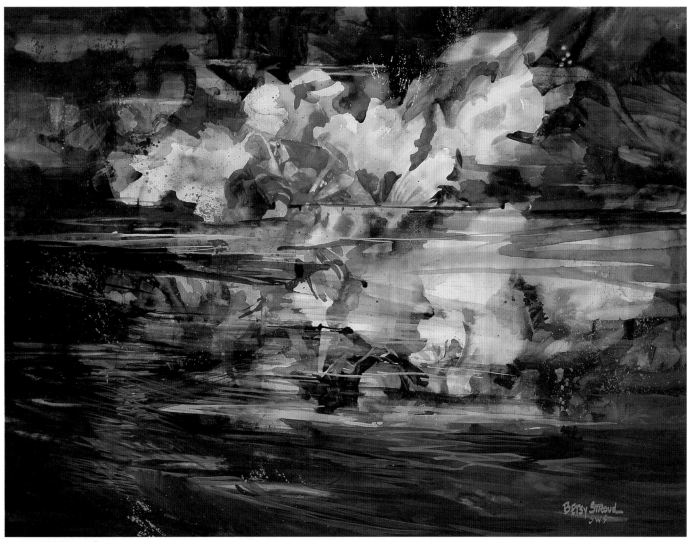

A Painting Emerges

I worked on this painting on and off for three years! First it was a garden, then a landscape. I put it up for a year, and then, preparing for a one-woman show, I brought it out again. I began to add darks to the composition, painting negatively around lighter forms. Soon, suggestions of water and flowers emerged, and *Reflections of an Old Soul* was born.

REFLECTIONS OF AN OLD SOUL
Betsy Dillard Stroud ÷ 30" × 40" (76cm × 102cm) ÷ Watercolor and gouache on 140-lb. (300gsm) cold-pressed watercolor board ÷ Collection of Robert J. Ahola

> "He who does not imagine in stronger and finer lineaments than his mortal and perishing eyes can see, does not imagine at all."
>
> —William Blake (1757–1827)

daring design

Cézanne flattened shapes to the picture plane to tell the viewer that he/she is looking at a painting. He was the first to suggest multiple eye levels. Picasso's *Woman in a Mirror* took this concept further by introducing the idea that one could depict a person from every angle all at the same time. The demonstration in this chapter evolved from my thinking about these two artists and their contributions, and trying to develop a lesson that would include the nuts and bolts of painting. What are the nuts and bolts of paintings? Simply put, they are the elements and principles of design.

The Yellow Line Exercise

Using a yellow-orange line and a no. 12 round synthetic brush, I did a contour drawing of a still life, making certain there were many overlapping shapes. After this initial drawing dried, I painted each shape a different color or value. I glazed the background and some of the objects with Ultramarine Blue to bring the composition together and establish color harmony.

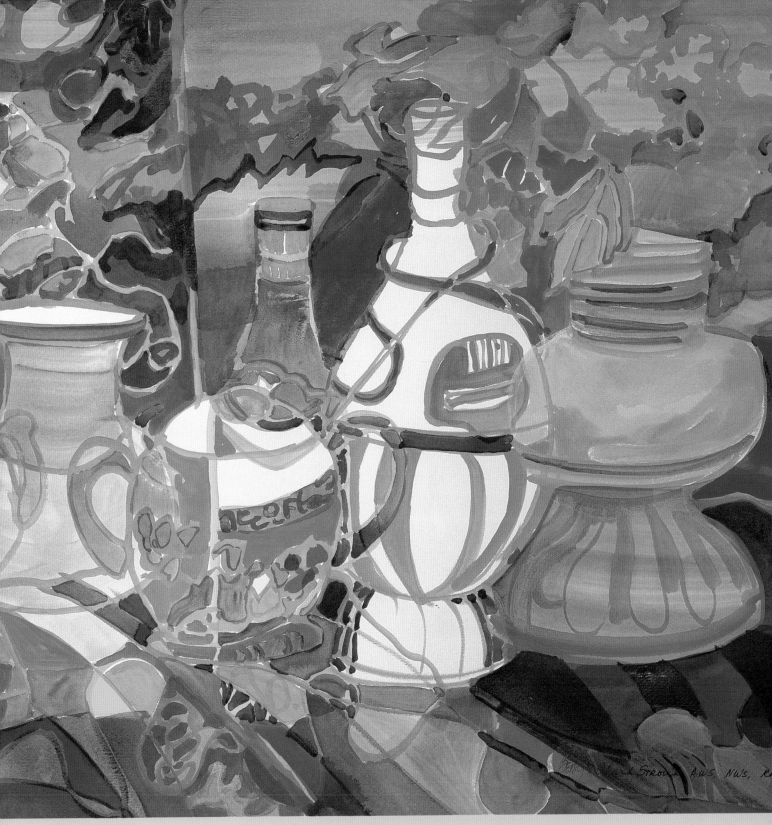

BLUE MOOD
Betsy Dillard Stroud ÷ 22" × 30" (56cm × 76cm) ÷ Acrylic on 140-lb. (300gsm) cold-pressed paper ÷ Collection of the artist

the yellow line "eat your heart out, picasso" exercise

In this painting challenge, there is a special emphasis on color and line. It is so-called because when I first developed this technique I used a yellow line to draw my still life. The Yellow Line Exercise gives you a chance to use your own expressive color sense, your own sense of design and order and your own sense of shape-making to create a beautiful modern painting. In a way it's a creative paint by numbers, except you, yourself, select the color and design the shapes.

materials list

SURFACE
140-lb. (300gsm) cold-pressed paper

PAINT
Tube Acrylic ✦ Cadmium Lemon Yellow ✦ Quinacridone Crimson ✦ Dioxazine Purple ✦ Blue Luster

Fluid Acrylic ✦ Phthalo Turquoise ✦ Phthalo Green ✦ Cerulean Blue ✦ Pyrrole Orange ✦ Pyrrole Red Light ✦ Quinacridone Magenta

BRUSHES
1-inch (25mm) flat ✦ no. 12 round ✦ no. 26 Goliath round

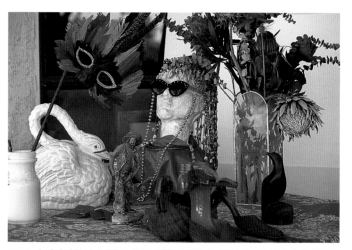

Still Life Setup

When you set up your still life, make it a jumble of objects. Don't be neat. Overlap objects and make it crowded. Pick and choose the objects from this setup and arrange them however you wish. Remember, you can incorporate windows, doors, shades and all sorts of design elements into your original line drawing.

I: DRAW SHAPES

Make a puddle of Cadmium Lemon Yellow on your palette. It's important to have plenty of thin, transparent paint so you won't run out. Use your no. 12 round brush to draw your still life. When drawing your objects, make sure you close off all lines. Overlap the objects and show all the lines of each object through the other objects. Stay focused on creating a good composition with lots and lots of shapes. You can't have too many shapes, but you can have too few.

2: START PAINTING THE CLOTH

Using your 1-inch (25mm) flat brush, start the cloth with watered-down Pyrrole Red Light, and as you paint, drop in some Pyrrole Orange. Keep your paint thin and transparent in case you need to glaze over it at the end. (Do not glaze over a surface until the surface is completely dry.)

When you get to the next shape in the cloth, drop in some Quinacridone Magenta and some Quinacridone Crimson. By painting each section (shape) of the cloth a different value or hue in the same analogous color range, you get exciting kinetic vibrations.

3: MOVE FROM ONE SHAPE TO THE NEXT

Change the color and/or value every time you come to the yellow line. These changes don't have to be dramatic. The late great painter Millard Sheets said, "Always change the color or the value in every inch." Add blues and purples to the background and various reds, yellows and oranges to the vase.

4: PAINT THE STILL LIFE OBJECTS

As you paint, continue changing color and value from one shape to the next. Allow your intuition to make your color choices. The basket is a vibrant weave of complementary colors.

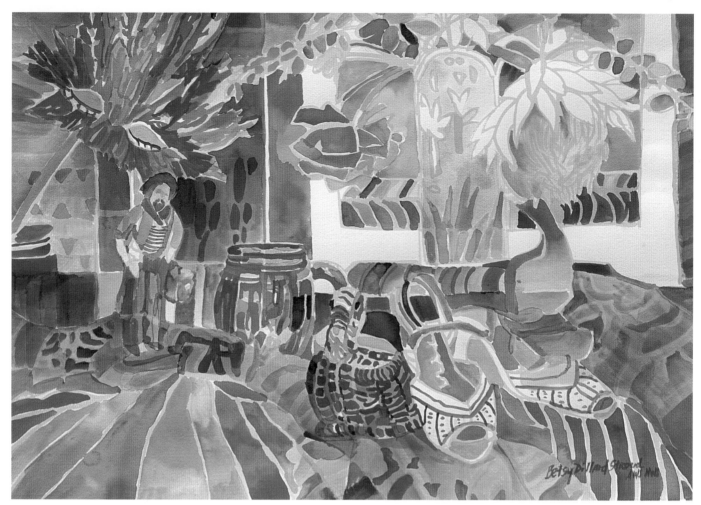

5: ADD FINAL GLAZES

More shapes on the right will add more interesting decoration, so draw them in with yellow paint. After this dries, paint this new area with thin washes of Pyrrole Red Light and Pyrrole Orange, dropping in Quinacridone Magenta. These new shapes integrate this side of the painting with the rest of the composition.

The mask in the upper left quadrant is comprised of many glazes and a multitude of colors. Paint the feathers by alternating Quinacridone Magenta, Pyrrole Red Light and Pyrrole Orange. After this dries, glaze some areas with Phthalo Turquoise and Phthalo Green.

Midway through the painting, the shoes, which had been the focal point, fell into second place. After decorating them using a mix of various pigments with Cerulean Blue and Blue Luster, they became subordinate to the dried flower arrangement which made a more dramatic contrast against the surrounding decoration.

YELLOW ROUND-UP
Betsy Dillard Stroud ❖ 22" × 30" (56cm × 76cm) ❖
Acrylic on 140-lb. (300gsm) cold-pressed paper ❖
Collection of the artist

DOES YOUR YELLOW LINE PAINTING HAVE WHAT IT NEEDS?

+ Do I have an interesting array of shapes of all sizes and colors?

+ What shapes do I have that could be painted very dark or left white? (These shapes are very effective to emphasize a focal point.)

+ Does my composition have enough shapes to make it interesting?

+ What is my focal point?

+ Do I have a specific color scheme in mind?

+ Are my pigments transparent or opaque?

+ Did I let the pigment dry before I glazed over it?

+ Did I follow my hunches about color? Your hunch is that soft voice that whispers in your ear when you paint. It says things like, "Put some purple over there." Listen for it!

+ Did I create some harmonious neutrals with my color choices?

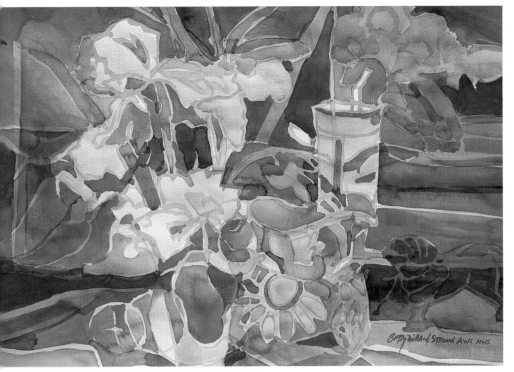

Yellow Line With Watercolor

The effects appear a bit more subtle when you do this exercise with watercolor. When you glaze, for example, some of the previous pigment may come off. Be aware of the character of your pigments. Put the staining transparent pigments down first, and glaze with the more granular ones. In this painting I began with New Gamboge. I decided on a color scheme of triads—orange, red-purple and greens. When I glazed, I painted over some of the original yellow line. This pushes those objects back and is a wonderful way to tie your composition together if it is too busy.

Try to find pigments that make harmonious grays. The grays in this painting are beautifully soft and harmonious. As a result, the painting exudes an ambience of quietude and serenity compared to the acrylic yellow line, which shouts exuberance, joy and energy.

STILL LIFE WITH IRIS
Betsy Dillard Stroud ✢ 22" × 30" (56cm × 76cm) ✢ Watercolor on 140-lb. (300gsm) cold-pressed paper ✢
Collection of the artist

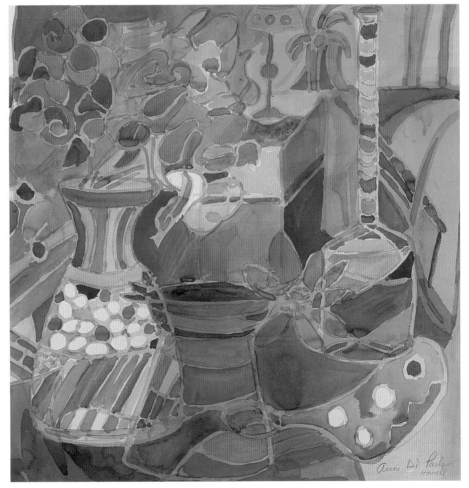

Painting With a Blue Line

Howell used a blue line as the organizing color in her composition. Remember each color imparts its own feeling, so you might try all colors for your line, even black. Howell made sure each layer dried before she added the next. The result is a coloristic delight, with lovely neutrals that balance and make a nice contrast with her other bright colors.

UNTITLED
Anna Di Paola Howell ✢ 24" × 24" (61cm × 61cm) ✢ Acrylic on 140-lb. (300gsm) cold-pressed paper ✢
Collection of the artist

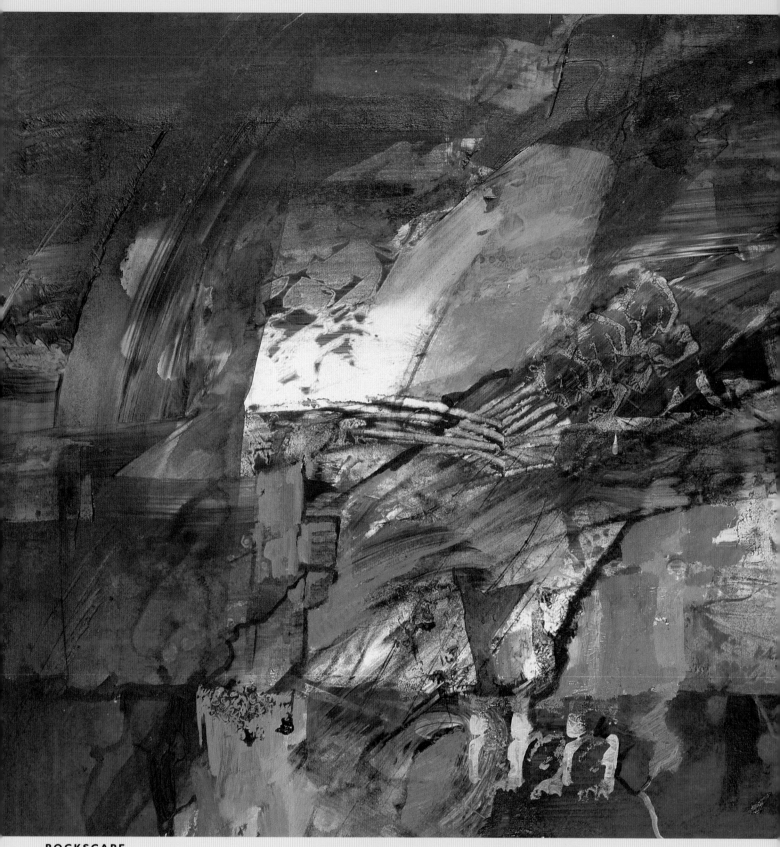

ROCKSCAPE
(Detail) ✢ Betsy Dillard Stroud ✢ 30" × 22" (76cm × 56cm) ✢ Acrylic on Strathmore Aquarius II ✢ Collection of the artist

"Art happens—no hovel is safe from it;
no prince may depend on it; the vastest
intelligence cannot bring it about."

—James Abbott McNeill Whistler
(1834–1903)

texture and painterly surfaces

The development of an artist is like a giant mosaic filled with a multitude of shapes, colors and textures. The mosaic is always in an unfinished state, for there are always new shapes to discover, new colors to juxtapose and new textures to consider.

When you add textural media to acrylic, your possibilities for exploration are endless. You can model it, scrape through it, thicken it, thin it. You can stamp it, spray it and splash it. The ways to change its character are unlimited. With the invention of all the new media on the market, you can do even more unusual things with acrylic, and with watercolor, too.

Capture Feeling Through Texture

In this painting I poured several pigments together, smudged them together and then lifted out. I created layers by painting, drawing in alcohol, stamping with my actual hand and with carved art gum, and then drying each layer before glazing over it if I needed to change the color a bit. This has always been one of my favorite paintings, as I think it was a spontaneous expression that really captured the feeling and texture of the rocky landscape that I live in.

An odyssey of textures

Looking for objects and materials to make textures with is like going on a treasure hunt. Almost anything with a porous surface works, and even the nonporous surfaces can make marvelous effects. Now is the time to clean out your garage and find those incredible surfaces you have in your house!

Stamped and Painted Texture

I began with washes of transparent paint and quickly drew into the wet paint using my oiler filled with alcohol. Then, I began my process of stamping with various stamps, then glazing with color, then drying. I did this repeatedly until I liked the textures and the colors. After stamping the mountains near the top of the composition, I mixed up a sky color of Ultramarine Blue, Phthalo Green and White (a color combination I learned from landscape painter William Hook) and defined the mountain shapes more by negative painting. Finally, I mixed up opaque paint and carved out shapes in the rest of the composition for that wonderful contrast I love to exploit—a transparent next to an opaque.

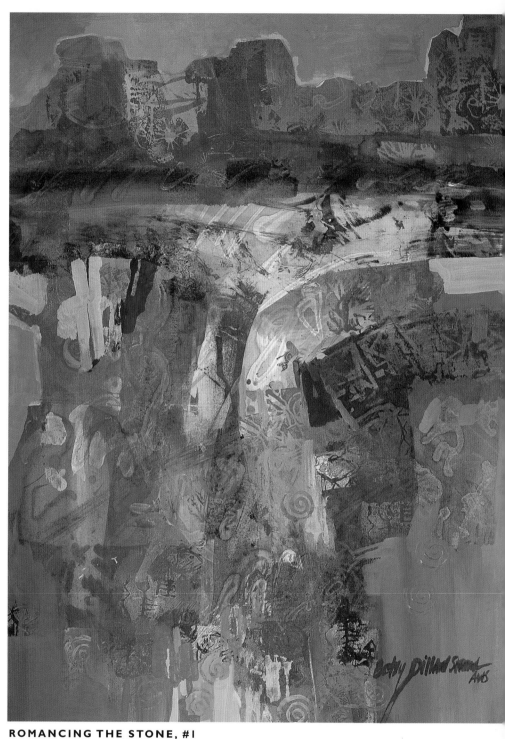

ROMANCING THE STONE, #1
Betsy Dillard Stroud ÷ 30" x 22" (76cm x 56cm) ÷ Acrylic on 140-lb. (300gsm) hot-pressed paper ÷
Collection of the artist

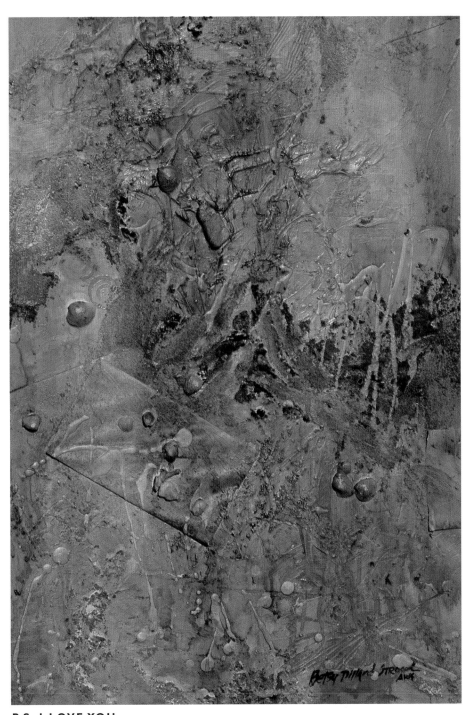

Three-Dimensional Texture

I built up the texture here using moulding paste, gesso, matte medium and collage. Working on heavy-weight illustration board, I applied moulding paste straight from the jar and mixed a small amount of matte medium into it. I also poured a little gesso onto it and started manipulating the mixture with a comb and a palette knife to get interesting textures.

I added some real stones in the composition and an envelope, gluing them onto the surface with matte medium and painting them with gesso.

Twenty-four hours later, after this surface dried, I mixed up some Quinacridone Gold and brushed it over the surface. Before that could dry, I added Cerulean Blue and Quinacridone Orange for subtle color changes.

The shadows cast by the low relief (*basso relievo*) are intriguing. This type of background would work well behind a still life or a figure, and in any abstract work.

P.S. I LOVE YOU
Betsy Dillard Stroud ✦ 30" × 20" (76cm × 51cm) ✦ Moulding paste, acrylic and collage on illustration board ✦ Collection of the artist

Different kinds of textures

Glazing Over Water-Soluble Crayons
Water-soluble crayons comprise the best of both worlds: They dissolve in water to make washes, and you can draw with them. They add texture and color in a distinctive way that differs from any other way of adding texture. Try drawing with a water-soluble crayon into wet washes as well as onto dry paper. Once you've drawn, mix a transparent glaze of Quinacridone Crimson and wash it over the crayon. Use a light touch so you won't disturb the drawing. Look what a beautiful glaze it makes with the texture showing underneath.

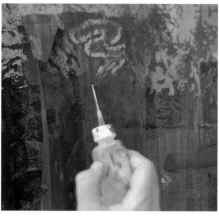

Adding Alcohol Into Wet Paint
Drawing into wet paint with alcohol makes a marvelous texture. You can also spray or drip alcohol from a dropper or a brush, and draw with the plastic end attached to the spray bottle top. Try using an oiler (a plastic bottle that has a syringe attached on the end) for more control. (You can also draw with the oiler using thinned acrylic paint. Just make sure you wash the paint out with alcohol, or it will clog up.) For a subtle line, draw on the dry paper with alcohol. When you cover it with a transparent acrylic wash, it will make a dark line.

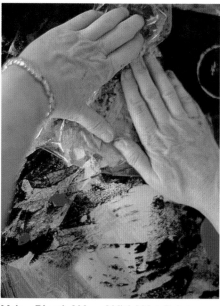

Using Plastic Wrap With Wet Paint
You can use plastic wrap in a variety of ways to make texture. Put down paint and then apply the plastic wrap. For optimal results with this method, let the paint dry before you pull the plastic wrap up. Or, as shown here, paint one side of the plastic wrap, then squoosh it together, pull it apart and immediately apply it to your paper.

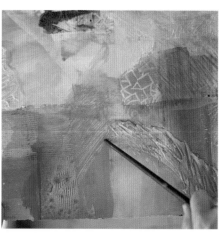

Scraping Through Thick Paint
Making marks with your brush handle is an excellent way to draw into the paint, and to take paint away, pulling it to other parts of the composition.

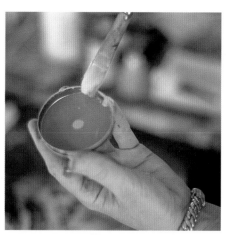

Using Found Objects for Imprinting
I especially like circles, and this lid is the perfect size. There are two ways to imprint a lid. You can paint the rim, stamp it onto your painting and get the outline of a circle. Or, you can paint the top of the lid, stamp it and get a painted circle.

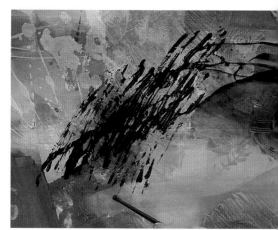

Squirting Your Paint From the Bottle
It's costly, but squirting fluid acrylics right onto your painting produces great calligraphy and texture. You can also draw with the fluid acrylic bottle, although your control won't be as great as with an oiler.

Try squirting on fluid acrylics and dragging your brush handle through the paint to make an uneven texture.

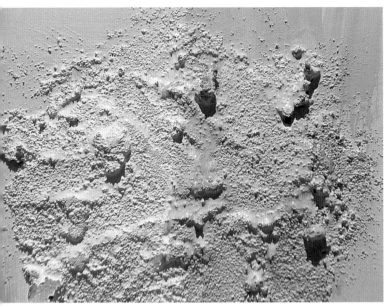

Using Pumice Gel and Gesso

Put down pumice gel and allow it to dry. Paint a veil of gesso over it and allow that to dry, too. Then, add various intensities of color over the texture to make it really stand out.

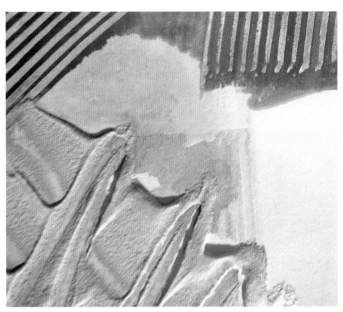

Using Modeling Paste

Put down modeling paste and drag a wide-toothed comb through it. After it dries, cover it with intense color to make the texture stand out.

Masking With Tape

Tear up pieces of drafting or artist's tape and apply it to your paper. Paint over the tape, and when the paint dries pull the tape up. You can tint these shapes, which give the appearance of depth, as they tend to float on the surface, especially if you use color complements.

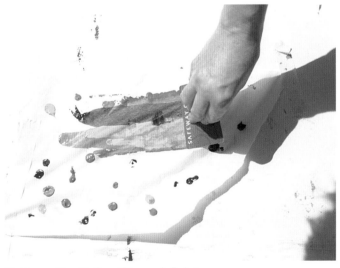

Pulling a Credit Card Through Paint

One of my students, Barbara Lang, showed me this method. Use a thin paper that you find in the doctor's office or in a sandwich wrap. Squirt tube acrylics across the paper, making small dabs of paint. Put different colors beside each other but don't crowd them. Take an old credit card, and pull the paint across the surface. If your credit card becomes smeared with too much paint, wipe it off so that you won't make mud. Keep pulling the credit card across the surface until the paint is very thin. Just look at the beautiful color striations you will get.

Stamping on textures

I started stamping as a result of a dream I had about an icon. The icon appeared to me, dangling in the air with a brush attached to it. The image was so haunting, I drew it when I awoke the next morning. I thought about that image for a year. Then, I was in Corpus Christi teaching a workshop and staying with good friends when I picked up one of their books about Mayan art. As I thumbed through it, I was struck by the resemblance my dream icon had to many of the images in the book. It was uncanny.

The second part of this story involves a trip I made to Washington, DC, where I stopped off at the Women's Museum. Inside there was a provocative exhibition of crayon rubbings done from a gigantic woodcut, which was on display with the rubbings. It was fascinating and rich with texture. The question was this: How could I get that kind of depth into my own work?

Another year passed and I suddenly came up with the idea of using a soft linoleum block to carve my iconic image. Having done my share of etchings, woodcuts and aquatints in college, I knew that I wanted a softer more pliable surface to carve on so I could exert control over the stamping. I carved my remembered icon into that surface, and my next series was born— *Pieces of a Dream*.

Carving your own stamps and adding them to your paintings as layers of texture and pattern help bring interest and personal vision to your work.

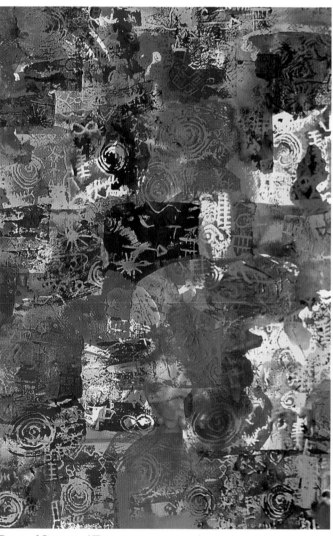

Page of Stamped Textures

Paint the stamp and apply it to the paper.

Put the dry stamp into the wet paint. Lift the stamp up, pulling out some of the paint.

Stamping with a sponge produces exciting texture. Try stamping with bubble wrap, corrugated cardboard, doilies, textured wallpaper and leaves.

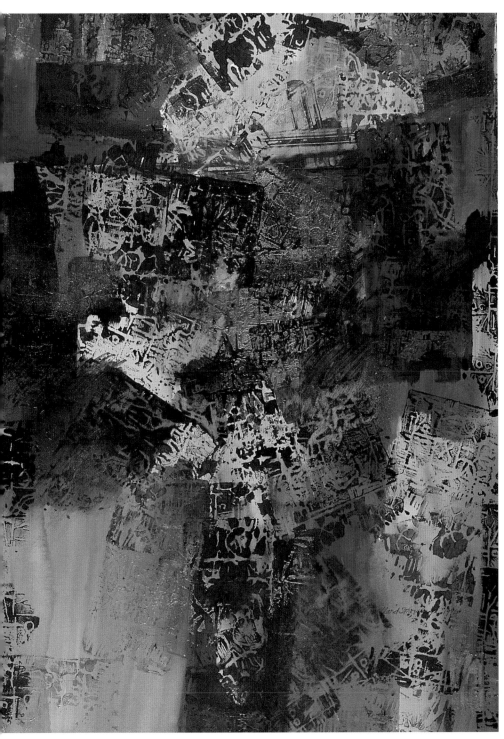

Explore Methods of Stamping

I started this painting with washes of thin, transparent watercolor. I stamped using a carved soft linoleum block coated with Iridescent Bronze paint. With each imprinting I changed the color by including other pigments with the bronze.

When you begin with an abstract underpainting like this, it gives you a lot of leeway to explore stamping. Sometimes you can straddle two or three colors with your stamp, creating integrations between texture and background. When the painting started to take shape, I stopped. It's very easy to become addicted to stamping, and like everything else, exercise moderation, moderation, moderation.

These paintings represent the mystical, interior language of dreams. And, like dreams, the images I conjure up are mysterious and intriguing.

PIECES OF A DREAM, #12
Betsy Dillard Stroud ✦ 30" × 22" (76cm × 56cm) ✦ Acrylic and watercolor on 140-lb. (300gsm) hot-pressed paper ✦ Collection of the artist

creating textures in acrylic

When I moved to Arizona, I was in rock heaven, even though it took time for its unusual color scheme and sensory thrills to evolve in my work. Arizona is a landscape of tertiaries balanced by brilliant, pure colors. The sky can range from a dusty pink with fluffy gold clouds to a Winsor Red with Phthalo Green striations. The desert greens are muted with Cadmium Oranges and Magentas. The mountains are bright violet one day and Caput Mortuum Violet the next. The light here is ethereal.

Although I often paint realistic landscapes, I also am attracted to simplifying and depicting essences. My series of abstract landscape paintings grew out of my attempt to distill and combine two idioms: the spirit (rich Native American symbolism) with the incredible beauty of the Arizona landscape.

materials list

SURFACE
140-lb. (300gsm) hot-pressed paper

PAINT
Tube Acrylic ✦ Ultramarine Blue ✦ Yellow Ochre ✦ Titanium White ✦ Orange Luster ✦ Dioxazine Purple

Fluid Acrylic ✦ Quinacridone Gold ✦ Napthol Red Light ✦ Quinacridone Crimson ✦ Quinacridone Magenta

BRUSH
3-inch (76mm) flat

OTHER
Medio Brillantante ✦ Linoleum block ✦ Kleenex tissue ✦ Alcohol ✦ Oiler ✦ Waxed paper

Rock Photo Reference

I am a rock shop junkie. I grew up in the mountains in Virginia, and that's where I fell in love with rocks. Here in Arizona, there are rocks, like the sky, whose colors almost defy description. They can be turquoise, rose, russet, gold, emerald green to lavender, bright purple, even shocking pink! A small rock is but a microcosm of the bigger cliffs, mountains and boulders. Their character is the same. In my abstract landscape series, I attempted to depict the essence of this beauty and strength using the smaller rocks as my immediate inspiration.

1: SQUIRTING PAINT AND MAKING MUD

Pour a dollop of Medio Brillantante onto the paper, and smear it around with your 3-inch (76mm) brush. Before that dries, squirt on Quinacridone Gold, Quinacridone Crimson and Napthol Red Light and brush them together.

Before the paint dries take a Kleenex tissue and lift out some lights. The combination of thick paint mushed around with the lifting of lights gives the suggestion of rocks.

Use your brush handle and scrape through the thick, viscous paint to produce lines and patterns.

Carve various symbols or designs into soft linoleum blocks, and use a mixture of Orange Luster and Ultramarine Blue to stamp them into the painting. Vary the look of the stampings by altering the pressure you use, and by turning the stamp around as you apply it.

Lift out lights with Kleenex tissue.

Make patterns with brush handle.

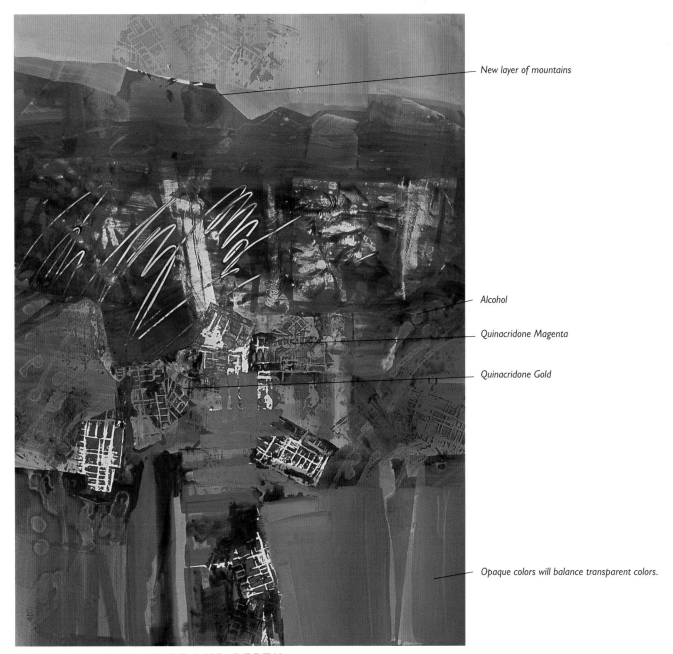

New layer of mountains

Alcohol

Quinacridone Magenta

Quinacridone Gold

Opaque colors will balance transparent colors.

2: ADD MORE TEXTURE AND DEPTH

After the initial textures are completely dry, apply a glaze of Quinacridone Gold and Quinacridone Magenta to go over some of the stamped areas.

Drizzle some alcohol from an oiler into the wet glaze.

Then squirt some Quinacridone Gold, Quinacridone Magenta and Quinacridone Crimson side by side (left bottom). Take a piece of mat board cut into a tiny square and drag this paint downward, creating the semblance of striations of rocks.

Mix the warms (magenta, crimson, gold) and some Ultramarine Blue together with Titanium White for an opaque, somewhat cool steely gray in the lower right to balance the transparent, bright colors. Once you add white to any concoction, you are making that mixture opaque.

If you at look where the sky meets the mountains, you can see a faint image of the previous mountain shape from step 1, created by painting negatively around a previously painted area.

To be successful most paintings rely on some type of contrast: texture, shape, form, color, light, dark, transparent and opaque. So, always leave something of a previous layer. This type of layering gives great depth and beauty to your work. It's what acrylic does best!

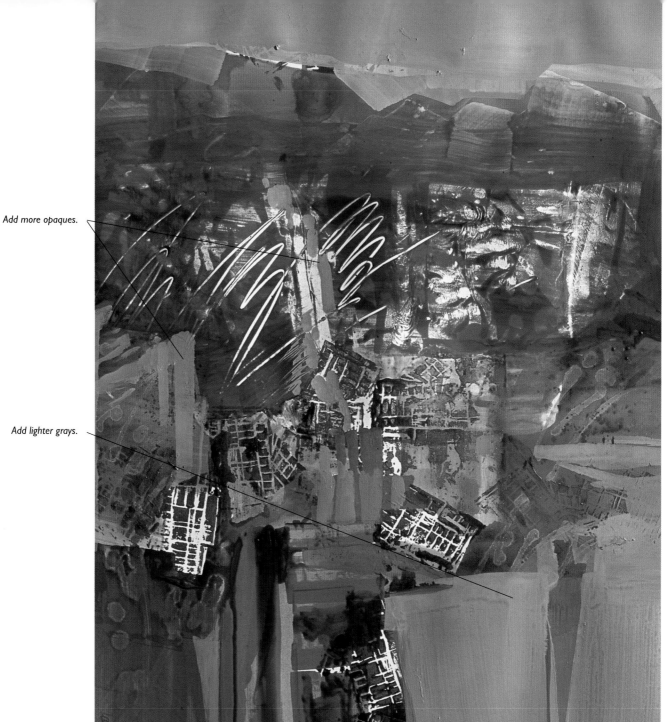

Add more opaques.

Add lighter grays.

3: CARVE OUT SHAPES WITH OPAQUES

Acrylic dries darker, just as watercolor dries lighter. To lighten your grays add more Titanium White to the opaque mixture of blues, reds and gold from step 2. Place a piece of waxed paper in the large gray area on the right, using it as a mask. Paint on both sides of it with a big brush, leaving a striation of darker gray in the middle.

Carve out more interesting shapes with the opaques, painting around the transparent pigments.

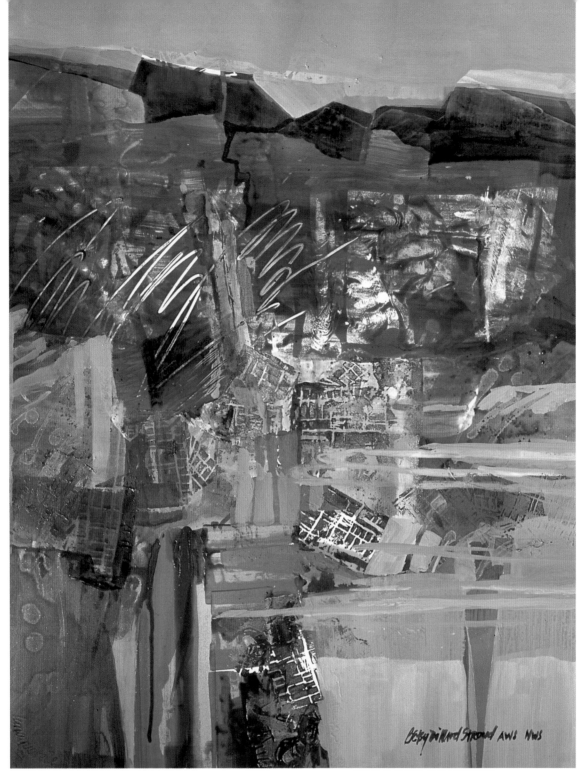

4: ADD FINAL TOUCHES

Lighten the gray areas until they are the value you're looking for. Add more light strokes of paint in the bottom right to suggest water. In Arizona canyons often have water at the bottom of them.

Darken some areas with a glaze of Ultramarine Blue. Tone down some of the whites with transparent washes of gold and Ultramarine Blue in the mountain areas where you've lifted with Kleenex tissue.

Mix up an opaque with Titanium White and Yellow Ochre. Paint it through some of the magenta wash on the right to bring more gold into that spot and neutralize the magenta a bit.

Glaze Ultramarine Blue on the top layer of rocks to push them back and create another mountain range.

RED ROCK COUNTRY: MOUNTAIN, SKY AND WATER
Betsy Dillard Stroud ✣ 30" × 22" (76cm × 56cm) ✣
Acrylic on 140-lb. (300gsm) hot-pressed paper ✣
Collection of the artist

Although watercolor, is transparent, it has much more tooth than acrylic. Surprising effects happen when you combine a mélange of pigments and a highly textured surface. Granular pigments will land in the crags and crannies, and smooth, stained transparent pigments wash right over them. Beautiful diffusions occur.

materials list

SURFACE
140-lb. (300gsm) cold-pressed paper

PAINT
Watercolor ✦ Sap Green ✦ Blue Green ✦ Cadmium Lemon Yellow ✦ New Gamboge ✦ Dragon's Blood ✦ Indigo ✦ Orange Lake ✦ Antwerp Blue ✦ Quinacridone Red ✦ Quinacridone Violet ✦ Neutral Tint

Iridescent ✦ Iridescent Medium

Interference ✦ Interference Red

BRUSHES
2-inch (51mm) square squirrel ✦ 1-inch (25mm) square sable ✦ no. 14 round sable ✦ Bristle brush

OTHER
Gesso ✦ Salt ✦ Palette knife ✦ 2B pencil ✦ Linoleum stamp ✦ Permanent masking fluid ✦ Volume (modeling paste) ✦ Hot pink crayon

1: BUILD UP A TACTILE SURFACE

Use your own linoleum stamps to put petroglyphic symbols or other patterns in the area where the rocks will go. Stamp with Indigo and Neutral Tint.

Apply Volume to the paper with a palette knife on the lower area to suggest rock ledges. Vary the pressure of your hand for contrast, and vary the angle of the knife to create striations.

Scribble a hot pink crayon across the bottom for additional texture.

Mix fluid gesso with a little water, and dribble some of the mixture across the bottom. Use a bristle brush to paint some gesso in other places across the bottom.

Paint cloud formations across the sky with Interference Red. The interference paint will act as a resist and give a somewhat mottled look when you add the final sky color later.

Spatter permanent masking fluid with an old brush across the area next to the Volume for additional texture. Let it dry.

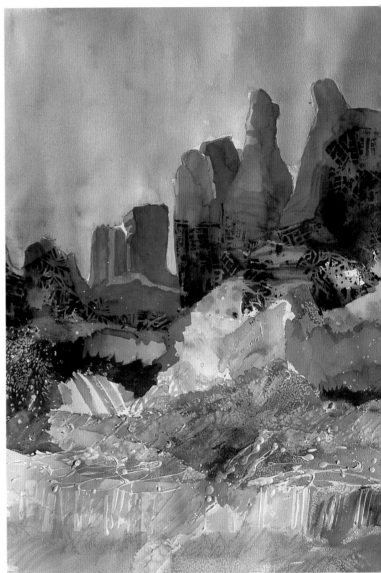

2: PAINT THE SKY AND ITS REFLECTION

Draw a contour of the rocks with a 2B pencil. Mix a puddle of Antwerp Blue for the sky so you can complete it in one step. Then, turn the paper upside down and wash in the sky next to the mountains with a 2-inch (51mm) brush, letting the paint run to the top of the paper. Painting upside down prevents paint from puddling at the mountains. Make sure to overlap all your strokes as you brush the wash over the paper. Turn the paper around and darken the top of the sky by brushing in more Antwerp Blue and letting the darker paint bleed into the wet paper. Sure enough, the interference is giving a nice, subtle texture to the sky.

Add some blue to the bottom of the painting to suggest an area of water reflecting the sky and to create color harmony between the top and bottom of the composition.

3: BRING OUT ROCK AND FOLIAGE TEXTURES WITH GLAZES

Use your 1-inch (25mm) brush to paint the rocks with Dragon's Blood, Orange Lake, Quinacridone Red and Quinacridone Violet, mixing the pigments on the paper. Let the pigments run together and make their own color chords. Putting color in freely lets the paint mush together and naturally go into the nooks, crannies and crevices of the underlying texture.

Add Lemon Yellow for the foliage and drop in Sap Green, Indigo, Antwerp Blue and Blue Green before it dries.

4: ADD MORE TEXTURE

Apply more Volume to the rocks, varying pressure and angle to create interesting and believable rock formations. In retrospect, having color on first and then adding the Volume gives this area greater depth.

Near the bottom where the other texture lies, add less-intense washes of the reds, purples and oranges that you used previously, alternating warm and cool. Across the bottom textured area, paint warms ranging from orange to more intense reds, mimicking colorful rock formations in the earth.

Sprinkle salt liberally into these areas for a more generic texture. Strive for essences rather than specifics.

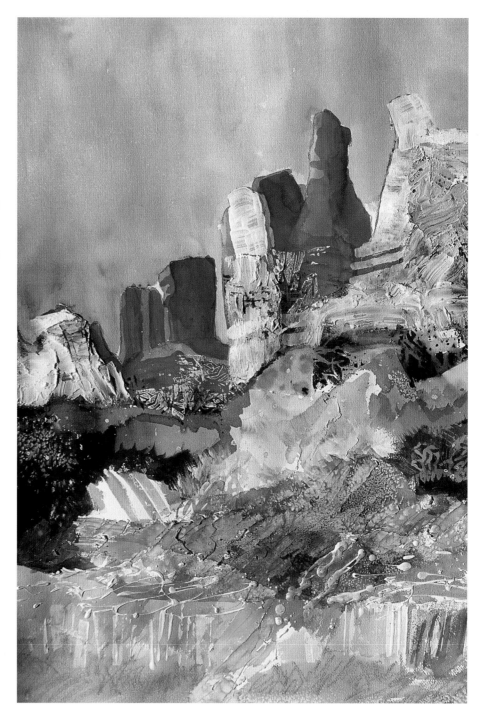

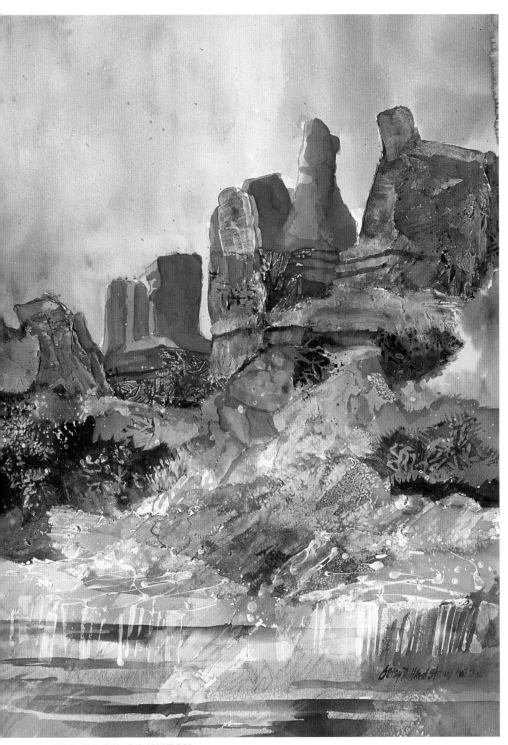

5: ADD MORE GLAZING

When the Volume has dried, glaze more rock color over the rocks, occasionally spattering in some blue and violet with a round brush. Work some yellow into the rocks as well to repeat the foliage color.

Paint Interference Red on your stamp and apply it to the rocks. This will bring some light into the area. Tone down the yellow with glazes of red, blue and violet.

Mix up a little fluid gesso with some bright Cadmium Lemon Yellow. For contrast with the opaque foliage, spatter the mixture into some of the dark foliage areas, lightening and adding texture.

Suggest water and add interest at the bottom by using both horizontal and curving brushstrokes. Drop in violet, yellow and red to represent reflections of rock formations and foliage and to create color harmony in the composition.

RED ROCK COUNTRY
Betsy Dillard Stroud ÷ 30" × 22" (76cm × 56cm) ÷ Watercolor, Volume modeling paste and gesso on 140-lb. (300gsm) cold-pressed paper ÷ Collection of the artist

DEMONSTRATION
seven-layer exercise

If you've ever stood over an acrylic painting that was done in transparent glazes, you've experienced the illusion of unbelievable depth that painting in layers produces. Colors seem to float on other colors, and shapes seem to leap right off the painting. By not describing everything in your painting (ambiguity), you allow the viewer's imagination to participate. Ambiguity holds the viewer's interest. This exercise will show you the myriad advantages of glazing and layering to create ambiguity.

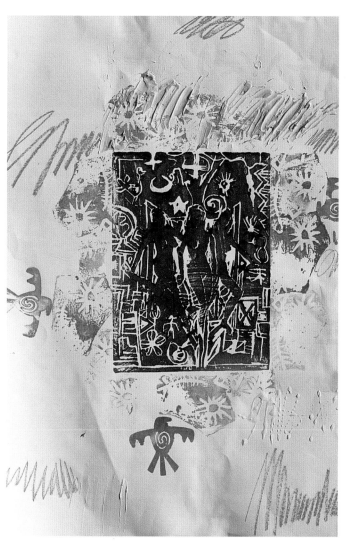

materials list

SURFACE
Strathmore Aquarius II

PAINT

Fluid Acrylic ✦ Quinacridone Crimson ✦ Quinacridone Magenta ✦ Quinacridone Gold ✦ Phthalo Turquoise ✦ Pyrrole Red ✦ Titanium White ✦ Bright Yellow ✦ Quinacridone Orange

Tube Acrylic ✦ Cadmium Lemon Yellow ✦ Blue Luster

Iridescent ✦ Bronze Iridescent

BRUSHES
3-inch (76mm) and 1-inch (25mm) flats ✦ no. 12 round

OTHER
Alcohol ✦ Gel medium ✦ Linoleum stamp ✦ Potpourri ✦ Contact paper ✦ Drafting tape ✦ Comb ✦ Glue ✦ Crayon ✦ Gesso ✦ Spray bottle

1: CREATE A TEXTURED SURFACE LAYER AS THE FIRST LAYER

The object of this layer is to make a strong textural foundation that will pop out with additional layers of paint.

Notice the wrinkles in the paper. How they got there I don't know, but they'll go away once I paint over the whole thing since the paper's so thin.

Make or find a stamp to use as your focal point. I carved one with symbols relating to my life. Paint your stamp with Iridescent Bronze and stamp it onto the center of the page.

Add a couple more stampings for interest, using Blue Luster and Quinacridone Crimson. I used a mold-made stamp for the thunderbird and a self-carved stamp with petroglyphs.

For additional interest and texture and to create a varied surface, you may want to scribble crayon. Sprinkle little objects like potpourri onto the paper, and spray around them with gesso mixed with water. Put down gel medium and drag a comb through it. Draw with alcohol on the dry paper. Drizzle or draw with glue near the middle stamp. Use Titanium White to draw lines at the bottom and the top of the composition. Let this layer dry completely.

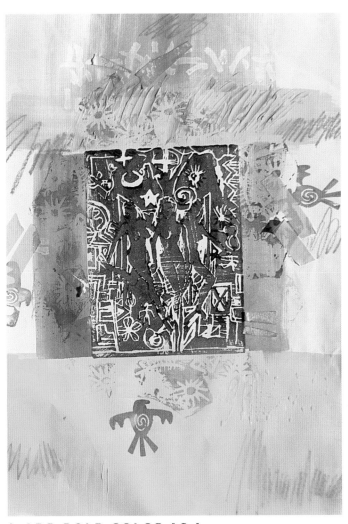

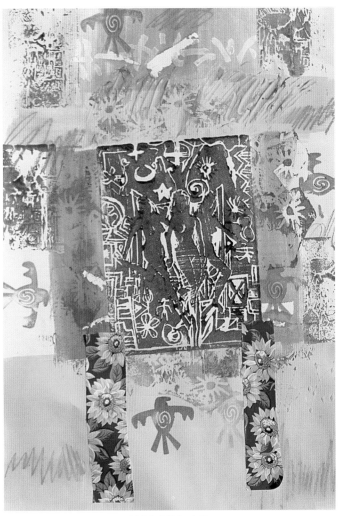

2: ADD BOLD COLOR AS A SECOND LAYER

Use your 3-inch (76mm) flat brush to add a transparent glaze of Bright Yellow and Quinacridone Orange so the texture underneath will come out. Leave parts unpainted to allow another layer to form with the next step.

Put down drafting tape and paint over it with a thin glaze of Quinacridone Orange.

Notice the Titanium White showing through the orange-and-yellow glaze. Deliberately leave parts of this layer unpainted.

3: CREATE NEW SHAPES AS A THIRD LAYER

Accentuate the layered look by using contact paper for masking out areas and to create a new shape. (The patterned contact paper is easier to see.)

Build up more texture by using your round brush to paint a stamp with Quinacridone Gold and Quinacridone Orange, stamping in several places.

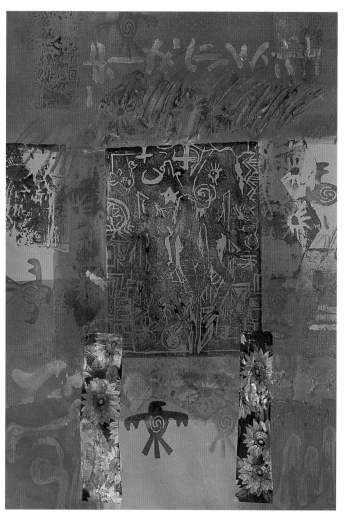

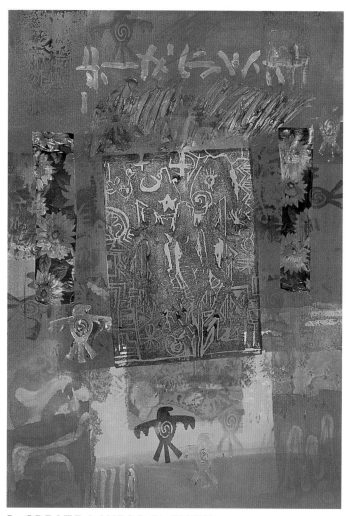

4: UNITE WITH GLAZES

Pull the painting together by glazing a mixture of Quinacridone Magenta and Quinacridone Crimson over a large portion of the composition. Leave some of the white of the paper showing in case we want to use a "color surprise" later. Draw into the wet paint with alcohol for yet another texture.

5: CREATE LAYERS SLOWLY AND TRANSPARENTLY

Remove the contact paper and reapply on the sides to create another shape. By creating layers slowly and letting each layer dry before adding the next, you get a subtlety of color you can't achieve any other way.

The alcohol I drew on dry paper at first didn't show through. The gesso I sprayed over the potpourri is subtle, but there. You never know what will happen when you paint improvisationally, but it sure is fun to take these chances.

Add a Pyrrole Red glaze over some of the composition for more brightness and unity.

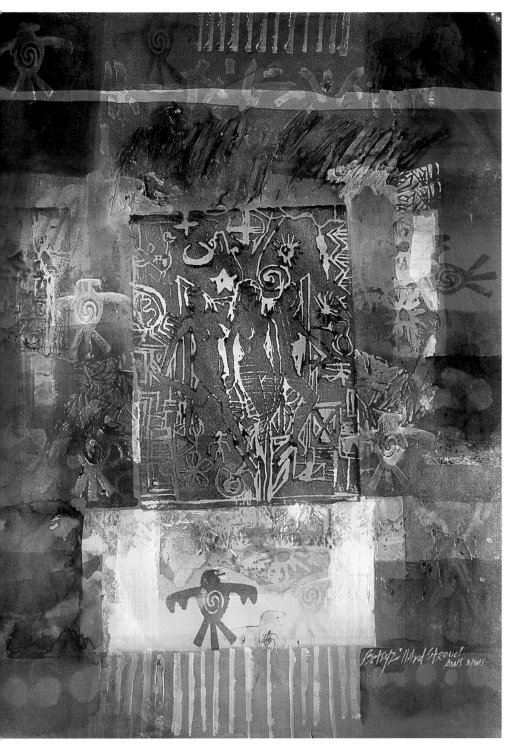

6: ADD FINAL LAYERS SIX AND SEVEN

Mask out a long rectangle in the upper part of the composition to save some warm color. Then, for more drama, glaze Phthalo Turquoise over the top and bottom of the composition.

Add some light in the composition by stamping with gesso mixed with some Blue Luster on the side of the centerpiece.

Be careful to let each and every layer dry completely before moving on to the next one, whether it be a glaze or a texture.

Lighten the corners of the tableau to add more emphasis to the center of interest. Stamp a bit on the right with Cadmium Lemon Yellow and gesso to add more texture and light.

There is a lot going on in this painting, but it is very subtle—the result of time-consuming, yet effective glazing and layering.

STATIONS OF SELF
Betsy Dillard Stroud ✧ 30" × 22" (76cm × 56cm) ✧ Acrylic on Strathmore Aquarius II ✧ Collection of the artist

Using Texture With Stylized Abstraction

This painting started as a demonstration in which I turned an ugly duckling into a swan. "Your paintings are so beautiful and ours are so ugly," my class had been moaning all day. "Poor things," I crooned. "I shall make a very ugly painting, so ugly you all will agree it is hideous." I proceeded to do an abstract underpainting in disharmonious colors. Everyone agreed it was terrible! About that time someone said, "I wish I knew how to do a figure in a painting like this." At that moment, *Wyatt* was born.

I drew the beginnings of a hat onto the paper, but the hideous underpainting was so dark, I could hardly see it. I started stamping with a variety of colors, including gesso. Then, after the paper dried, I glazed most of the composition with a transparent Quinacridone Crimson to pull the whole thing together. I added more details. As I painted, I stayed aware of push and pull, allowing areas to melt into other areas.

When I sold the painting recently, seven guys who own a vacation house together bought it. They wanted all their initials in the painting. I complied by weaving them into the design on the shirt.

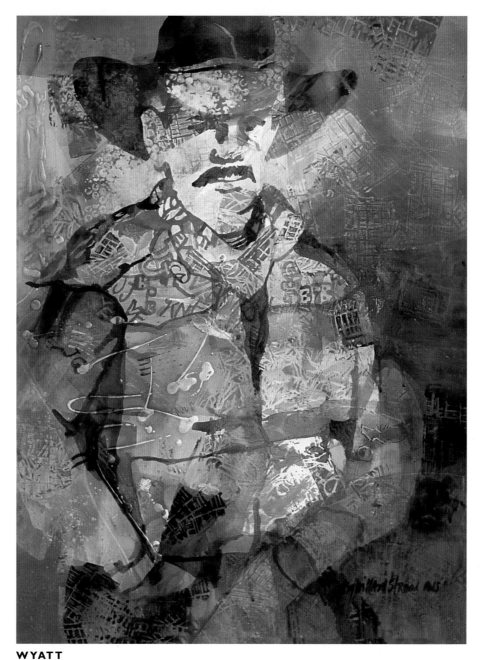

WYATT
Betsy Dillard Stroud ÷ 30" × 22" (76cm × 56cm) ÷ Acrylic on 140-lb. (300gsm) cold-pressed paper ÷
Collection of The New York "7"

46

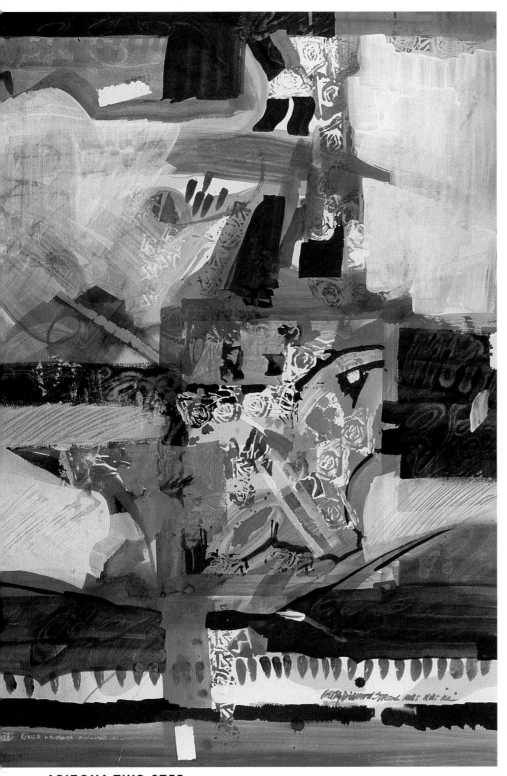

Using Texture With Total Abstraction

In contrast to *Wyatt* (opposite), *Arizona Two-Step* is totally abstract and relies on the properties of color, texture, movement and composition for its impact. In this painting I carved several pieces of art gum in various designs and stamped them into the composition. I painted various pigments onto the surface, and after they dried, I covered them with gesso, leaving some areas more transparent than others. At the bottom of the painting, the brushstrokes reminded me of piano music, hence the title. For texture, I drew with alcohol into wet paint and scratched through the gesso. The off-center rectangle decorated with stamps and calligraphy provides a great focal point, which is balanced out by darks and the white gessoed areas.

ARIZONA TWO-STEP
Betsy Dillard Stroud ❖ 30" × 22" (76cm × 56cm) ❖ Acrylic on 140-lb. (300gsm) cold-pressed paper ❖ Collection of the artist

47

"There are no mistakes. Where my brush goes, that is where I am today. And, I'm dancing in my own landscape."

(interpreted from the Japanese, as heard by the author in a workshop)
—Fujo Kato, Sumi painter (1940–)

improvisational painting

The experience of pouring is the quintessential roller coaster ride of all the improvisational painting techniques I use. Pigments collide, creating magical diffusions. Movement and rhythm unite with color, expressing emotion and spirit. For a moment, the artist becomes the voyeur, the innocent bystander who witnesses the miracle marriage of paint and water.

Pouring paint releases emotional raw material that is deep within us, freed by the simple inextricable act of flinging pigment. If, by nature, you gravitate toward experimental and improvisational techniques, pouring will challenge you the most, as well as give you the most in return. Out of the exquisite chaos, we must bring all our skills as painters and designers to bear, to complete and refine our spontaneous beginnings.

Pouring Technique

This particular painting tells the story of my move from Dallas, Texas, back home to Lexington, Virginia. Subtle clues are in the postcards themselves and are also written into the composition in such a fashion that they are not readily discernible. In this painting series I strive to present a mystery that the viewer can enjoy. Ambiguity and mystery play an important role in my art. In the act of the pouring technique I use here, I present the visual trappings that serve as a foil for my messages, which come later as I develop the composition. I executed this painting with a limited palette—the Vélasquez palette: Ivory Black, Burnt Sienna, Yellow Ochre. I added other pigments in very tiny details for contrast—Scarlet Lake, Cobalt Blue, Interference Silver and Phthalo Yellow Green.

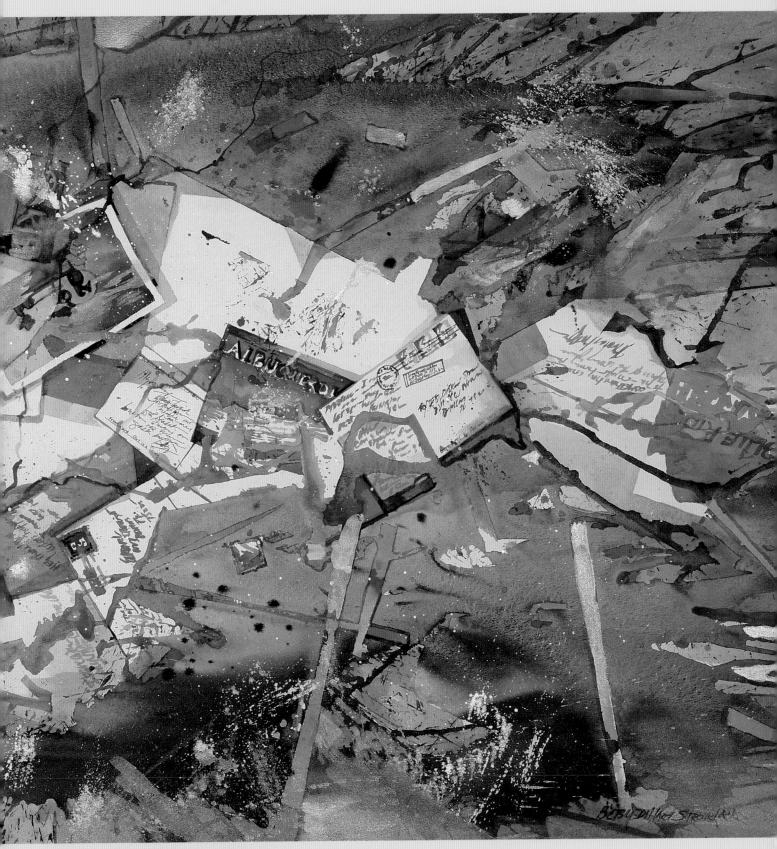

POSTCARDS FROM THE EDGE, #7
Betsy Dillard Stroud ÷ 30" × 40" (76cm × 102cm) ÷ Watercolor on cold-pressed watercolor board ÷ Collection of the artist

DEMONSTRATION
pouring with watercolor

In 1989 I received a painting commission that changed my life. After seeing my one-woman exhibition hanging in a local restaurant in Dallas, Texas, the wife of the World Bridge Champion that year wanted to surprise her husband with a card painting symbolizing his dramatic win. She called me up, and bless her heart, gave me carte blanche to do the painting.

I laughingly tell people that I was born with the ace of diamonds between my gums into a family of card sharks and gamblers. Actually, my father's family was replete with lawyers and judges, but they all loved to play cards.

With this background, I could well imagine how winning such an important competition might feel. With this in mind, I devised a way of painting that could express great emotion and bold drama. I started to pour. These card paintings became my signature work, and with them I earned signature status in the top watermedia societies in the United States. If you paint what you know and paint what you love, the rest will follow.

materials list

SURFACE
Cold-pressed watercolor board

PAINTS
Watercolors • Lavender • Permanent Red Light • Indian Yellow • Verzino Violet • Translucent Orange

BRUSHES
no. 12 or no. 14 round

OTHER
Paper or plastic cups • Baby food jars • Waxed paper • Drafting tape • Permanent masking fluid

The Setup

Pour outside if you can. Place your pigments and other supplies on a big table. Put down plastic if you are worried about your yard, plants or furniture that might be near, and keep your dogs inside!

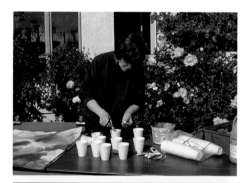

The Consistency of Your Paint

When you begin to pour, you must learn how much water to mix with your paint. If you want highly saturated color, use less water; conversely, if you want pale color, use more water. Mix your pigments separately in plastic cups or baby food jars. Make sure you stir each pigment repeatedly and properly dissolve it before you begin to pour. Take your brush handle or the brush itself, and stir, stir, stir. Mix your pigment with enough water to make it flow.

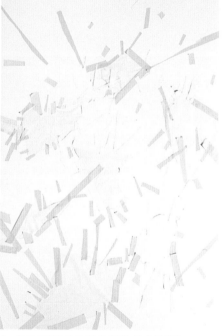

1: PREPARE YOUR PAPER

Use drafting tape, permanent masking fluid, waxed paper or any paper you might want to use for collage to mask out areas that you want to remain white on your watercolor board. Make sure your whites are a good shape. (Ed Whitney defined a good shape as "Something placed obliquely, of different dimensions and different sizes with interlocking edges.")

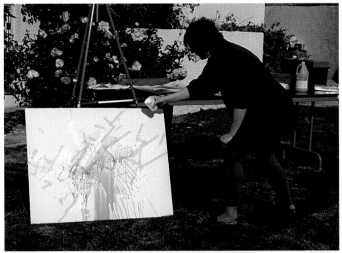

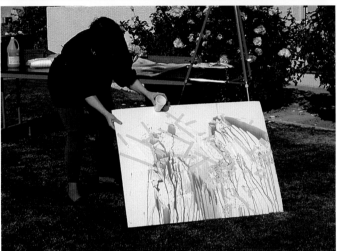

2: FLING YOUR PAINT

Start to pour with your board in an upright position if you want the paint to really move. It's up to you how much or how little you want to tilt your board. You can always start with it flat and tilt it at the very end. Since you are adding pigments at different times, you can get unsightly runs if you wait too long in between "flings." Experiment with various ways of pouring. No one way is best, and each person should discover her own preferred way of sloshing paint.

I like to start with my lightest color sometimes so I can add darker pigments for interesting color fusions. Diffusions differ according to the order in which you add your pigments. I began this painting with Indian Yellow.

3: WATCH FOR THE RED

Dash in a bit of Permanent Red Light and watch it mingle and flow into the yellow first fling. This is the most exciting part for me.

4: ADD LAVENDER FOR CONTRAST

Mix up some Lavender and drop it into the paint. I love the effect Lavender has against the bright reds and oranges: one is transparent, the other opaque; one is brilliant, the other dull. Add the other reds and Verzino Violet.

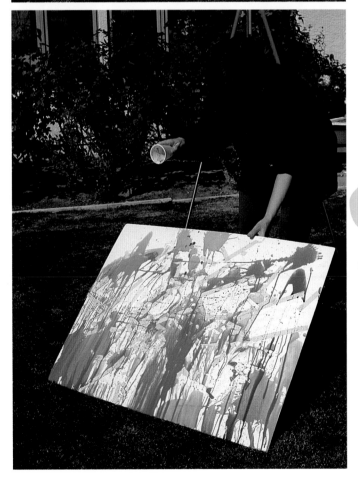

Use Your Own Symbology

Cards are my own personal choice for this exercise because cards have meaning in my life. As a former art historian, I am aware of the importance of using symbols that relate to your own life. I urge you, therefore, to think about your own symbology and use those symbols in your poured paintings. I'll talk more about this in chapter eight.

5: ADD A FEW BRUSHSTROKES

Give the paint a little help by brushing some of the more liquid areas into each other. Brush the paint into the corners which sometimes do not get covered when you pour.

6: UNMASKING YOUR PAINTING

After the paint dries, remove your masking. You can also experiment by removing the tape when the paint is still wet. Now study the shapes, decide where you want the center of interest and start designing the painting. Turn your painting all the way around, looking at it from each side to determine which way works best compositionally. Keep an open mind. As you paint, sometimes the way you see the painting changes substantially and you must follow where it leads you.

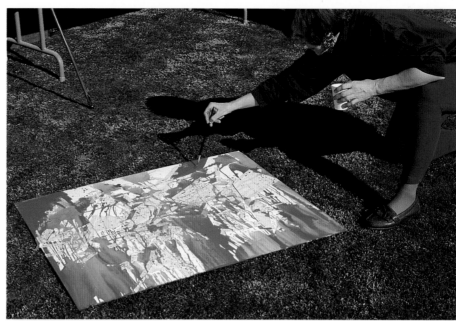

A Venus-Mars Connection

With this technique you are letting watermedia do its thing, which is to flow, mix and mingle beautifully. It is also a technique in which you can successfully combine improvisational methods with more controlled ways of painting.

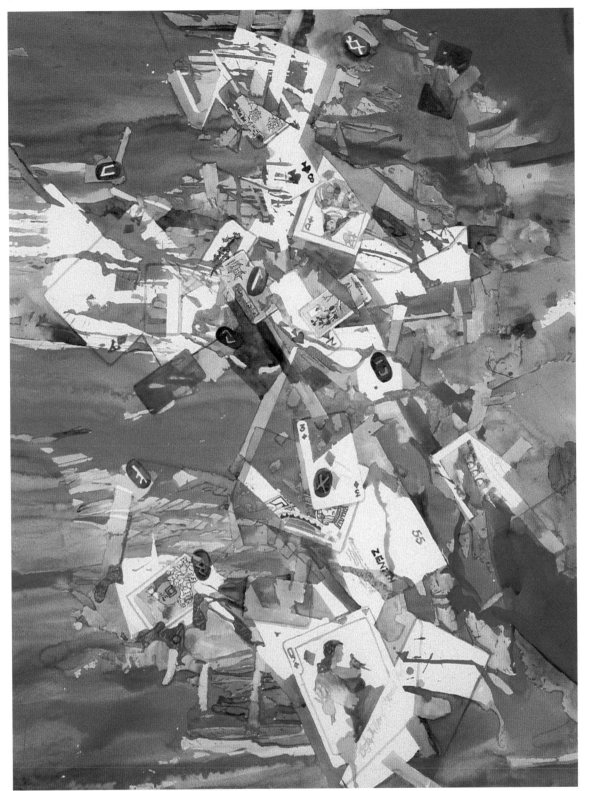

7: FINISH THE DETAILS

I designed this painting with cards that tell a story. I varied the card sizes, colors and shapes, adding color accents in the white shapes which won't become the actual card shapes themselves. I painted some dark rune shapes to give more accent throughout the painting. Every poured painting turns out differently because watercolor has a mind all its own. After all, good art is never about repeating ourselves, is it?

IT'S ALL IN THE GAME

Betsy Dillard Stroud ✧ 40" × 30" (102cm × 76cm)
✧ Watercolor on cold-pressed watercolor board ✧
Collection of the artist

DEMONSTRATION
pouring with acrylic

When you pour with acrylic, don't expect the same experience as when you pour with watercolor. Use fluid acrylic if you want to expedite the pouring. Even though you are using fluids, you'll need to add water to the paint if you want to exploit the paint's transparent properties. Acrylic is not watercolor, and vice versa. Acrylic dries faster, is a bit more intense, and doesn't granulate the way watercolor does.

materials list

SURFACE
140-lb. (300gsm) cold-pressed paper

PAINT
Fluid Acrylic ✦ Quinacridone Magenta ✦ Quinacridone Orange ✦ Hansa Yellow Medium ✦ Phthalo Turquoise ✦ Pyrrole Orange ✦ Napthol Red Light

BRUSHES
2-inch (51mm) flat ✦ no. 12 round

OTHER
Permanent masking fluid ✦ Paper cups ✦ Drafting tape ✦ Waxed paper ✦ 2B pencil

1: SAVE THOSE WHITES

Setup and mix your paints as you did when pouring with watercolor (page 50). To save some whites, mask out a good white shape on the watercolor paper using permanent masking fluid, waxed paper, etc. I knew beforehand that I wanted to incorporate a mask shape with my card designs, so with this in mind, I planned my shapes.

I decided to include some petroglyphic images in this painting. So I painted them on with permanent masking fluid to see what would happen when the paint washed over the images.

2: PURPLE AND YELLOW MAKE MAGIC

I start with my lightest color (yellow), and then quickly pour some magenta in to mix. What color you choose and what order you pour the pigments is totally subjective. Experiment with different choices, by pouring either light or dark pigments at the beginning. Speed is of the essence—you don't have as much time with acrylics as you do with watercolor for the paint to mix and mingle.

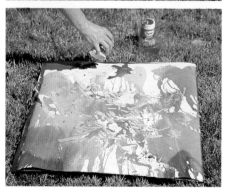

3: MOVE FROM VERTICAL TO HORIZONTAL

Pour on Phthalo Turquoise (strictly an impromptu choice), and lay the board flat on the ground so the paint won't run. That way, you won't get any muddy surprises. Splash on a little more Quinacridone Magenta. It's really bright!

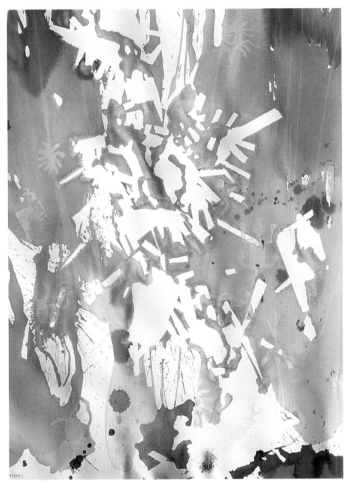

4: CONNECTING YOUR SHAPES

After removing all the mask, you will find a lot of disconnected white shapes. To connect these shapes you must create a good design, by using color, darks and/or gray passages to connect and unify parts of the composition. Herein lies the challenge of this technique. The test is how to create a harmonious surface with a good design and great color from a chaotic beginning.

Masking Fluid (detail)

In this small detail you can see the petroglyphic images I painted on the paper with the masking fluid before I poured. The paint tinted them somewhat, just as I had hoped. Subtle, but nice.

Splashes (detail)

This closeup shows the beautiful passages that can occur in small areas. That brilliant green Zen mark right in the middle of the yellow was an accident—if you believe in accidents! To the right you can see the multicolored striations made around the masked area after I removed the tape and the waxed paper.

5: DRAW FORMS

With a 2B pencil, draw in some major shapes. I drew a mask toward the top, and some cards of various sizes, which I painted in a preliminary way, knowing that I might put in more detail later. I started to develop the feathers of the mask by painting them in variegated color and doing a little linear decoration on them. If you look at the top of the painting, you'll see lots of white shapes that will make interesting feathers once they're painted and drawn on. I added the ace of diamonds and painted it Quinacridone Orange. I added various postcards and an envelope. I painted in two more mask shapes near the middle mask, making them smaller and less important than the middle one. I added touches of turquoise around the composition to give the painting some contrast with cool touches.

Study your painting and look for shapes that suggest certain forms. These forms can become your subject matter.

Paint With Meaning

Did you know that every day in the year is represented by a specific card? For example, my birthday is August 12, and I am the ace of diamonds. The study of cards is a science just like astrology. I often hide things in paintings that are revealed only after looking at the painting for a long time.

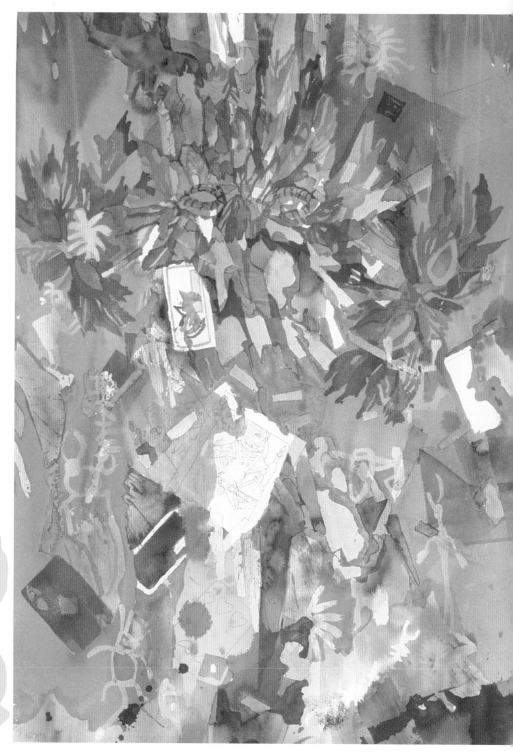

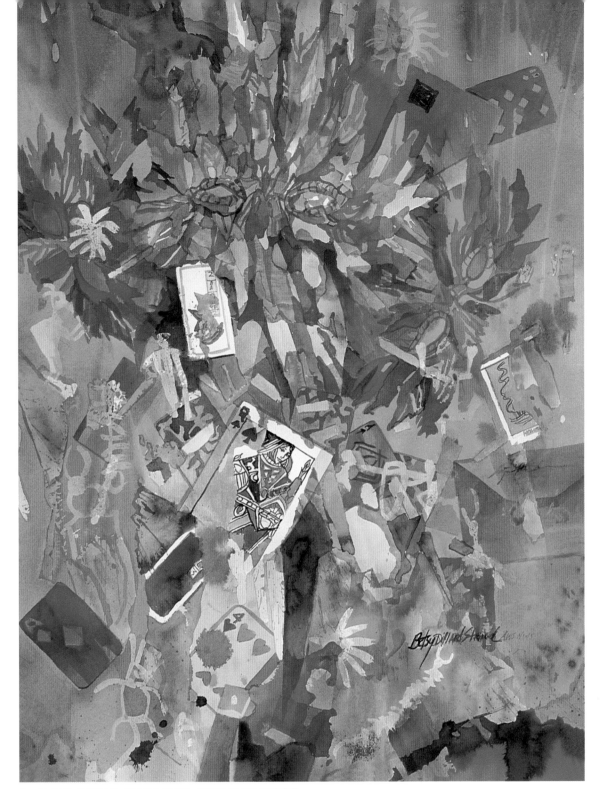

6: GIVE YOUR SUBJECT PROMINENCE

Darken the upper left corner with glazes of Quinacridone Orange and
Pyrrole Orange. I painted around the outer edge of the main mask and
gave it more prominence. I glazed over the ace of diamonds again with
magenta to make it stronger. I painted a neutral on the card on the right
and next to the middle card (the queen of spades). This gave the middle
card more emphasis. On the other hand, I tried to paint the mask as if it
emerged from and yet merged with the background.

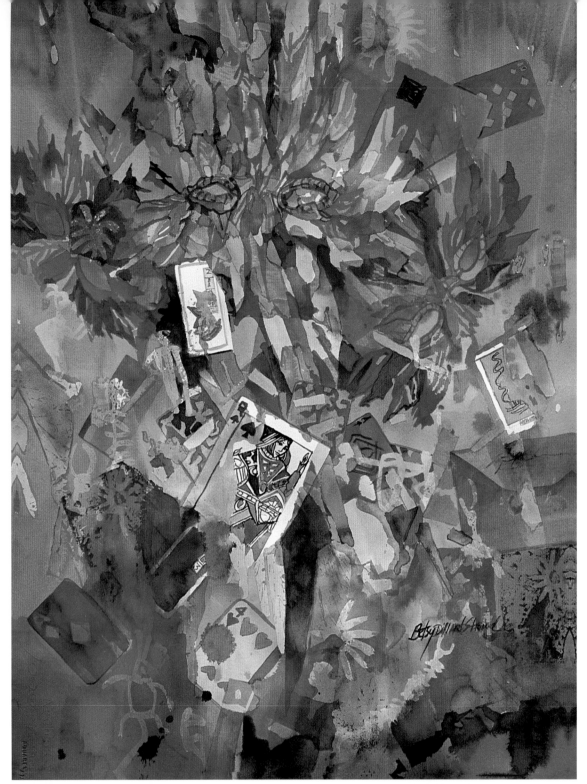

7: ADD FINAL TOUCHES

The two bottom sides of the painting seemed incongruous with the rest. To integrate them I decided to stamp a little on both and glaze down these areas with some Quinacridone Magenta. Now, the painting seemed to hang together better. As a last thought, I toned down the yellow behind the four of hearts and neutralized part of it. It made the shape more pleasing. I also added a dark turquoise near the queen of spades, bringing a little more importance to that area. Then I glazed turquoise over the sun shape on the left mask, which was standing out like a sore thumb.

MASK DANCE, #3
Betsy Dillard Stroud ÷ 30" × 22" (76cm × 56cm) ÷ Acrylic on 140-lb. (300gsm) cold-pressed paper ÷ Collection of the artist

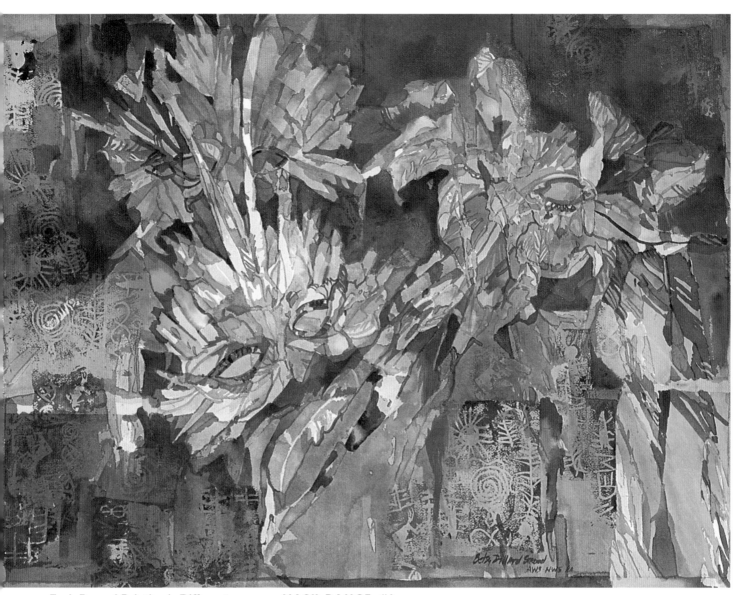

Each Poured Painting is Different

In this painting I poured on many light-value transparent acrylic washes. After the initial washes dried, I added the mask images and related stamped symbols onto the paper using acrylic mixed with iridescent paint.

MASK DANCE, #1
Betsy Dillard Stroud ÷ 22" × 30" (56cm × 76cm) ÷ Acrylic on 140-lb. (300gsm) cold-pressed paper ÷ Collection of the artist

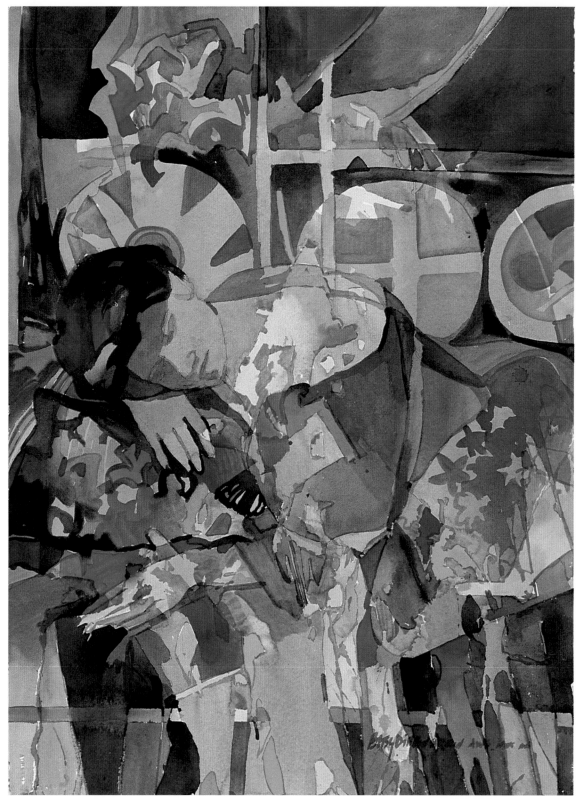

Even Figures Can Emerge From Pouring

I poured high-key pigments onto watercolor paper and let them dry. Next,
I drew the figure of the sleeping girl onto the pour. Most of the figure is
really the abstract underpainting of the pouring, and like the mask in the
demo painting, you really have to look at the painting before the subject
becomes obvious.

BEAUTIFUL DREAMER
Betsy Dillard Stroud ÷ 30" × 22" (76cm × 56cm) ÷
Watercolor on 140-lb. (300gsm) cold-pressed paper
÷ Collection of the artist

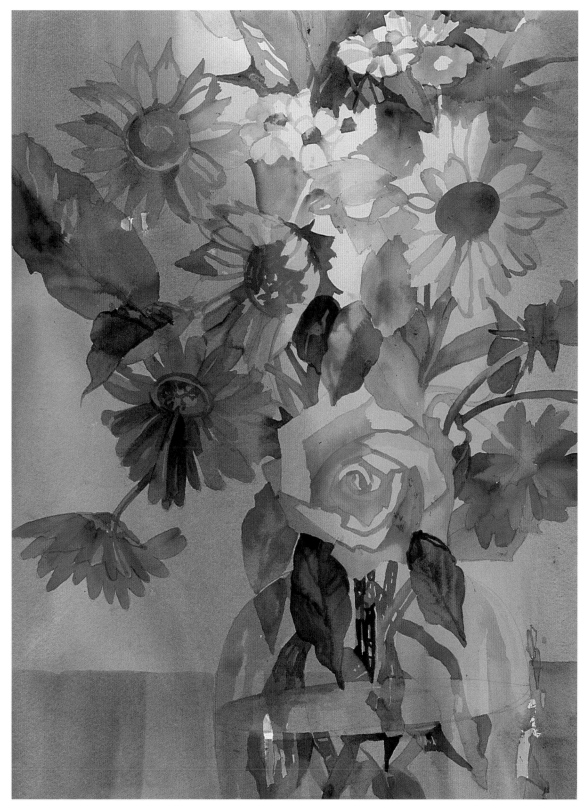

Poured Flowers

I watered down three pigments of acrylic paint and wet the paper. Before the paper could dry, I poured transparent thin washes of the paint and tilted the paper so the colors would run together. After this initial pouring dried, I painted the vase of flowers, leaving lots of the original underpainting showing. With many of the flowers as the painted background, it took just a little calligraphy to say "blossom."

KATHLEEN'S FLOWERS
Betsy Dillard Stroud ✣ 30" × 22" (76 × 56cm) ✣ Acrylic on 140-lb. (300gsm) cold-pressed paper ✣ Collection of Kathleen Burton

AFTERNOON AT THE ARBORETUM
Betsy Dillard Stroud ÷ 20" × 30" (51cm × 76cm) ÷ Acrylic on heavy-weight illustration board ÷ Collection of Mr. and Mrs. David Rausch

"Oh young artist, you search for a subject. Everything is a subject; your subject is yourself, your impressions, your emotions in front of nature."

—Eugene Delacroix (1798–1863)

transparent beginnings, opaque endings

Most successful paintings depend on some aspect of contrast for that special oomph that sets them apart from a more ordinary interpretation. One exciting way to exploit contrast is to use both transparent and opaque paint in the same painting. With glazing, for example, you put a transparent layer over something else—perhaps an opaque. Or, you might start with transparent layers and cover only a part with opaque paint, leaving some of those initial transparent passages. With opaque paint you can use negative painting to define shapes around something transparent. Or, you can do many layers of transparent paint and paint opaques on top, leaving small pieces of the transparent underlayers showing through for sparkle.

In this chapter we'll start three paintings transparently and finish them off with opaque pigments. We'll work on two different surfaces to explore different ways of using acrylics. The main thing is to have fun, spattering and painting freely, and to concentrate on developing a successful painting from a spontaneous beginning.

Technique Helps Convey Mood
A serene mood permeates this scene from the arboretum, caused partially by the ambience created from its black-gessoed beginning.

DEMONSTRATION
acrylic on illustration board

In this exercise you will start with transparent paint in an abstract way and end up using opaque paint to bring in a little realism. It is another exercise in contrast. The dense opaques you will use in the finishing touches enhance the transparency and luminosity of earlier washes. This exercise is also excellent for practicing negative painting.

materials list

SURFACE
Heavy-weight illustration board

PAINT
Acrylic ◆ Pyrrole Orange ◆ Forest Green ◆
Titanium White ◆ Cerulean Blue ◆
Ultramarine Blue ◆ Quinacridone Crimson

BRUSHES
2-inch (51mm) flat ◆ no. 12 round

1: ESTABLISH THE STRUCTURE

Mix up a big puddle of transparent Pyrrole Orange, and paint an almost identical horizontal shape on both the top and bottom of your surface. Leave a small sliver of unpainted board to remember that the sky is the top, the land is in the middle and the water is the bottom. Let this dry.

2: ADD FORM

Add Quinacridone Crimson shapes where the trees will be and at the bottom, as this will be water and will reflect the trees. Keep the paint pretty thin at this point. Remember, it's important to dry your layers after each step.

3: ADD DRAMA

Mix up Forest Green with a touch of Ultramarine Blue, and block in some big shapes over the Quinacridone Crimson using your 2-inch (51mm) flat brush. Add strokes of this dark color into the water area at the bottom. The contrast of the dark green with the red and orange makes for an exciting optical vibration.

4: ADD SKY, LIGHTS AND DEFINITION

Using your round brush, mix a generous amount of Cerulean Blue and Ultramarine Blue with Titanium White to paint in the sky. You will "kill two birds with one stone" here—painting the sky and at the same time defining the tree silhouettes with negative painting. When you paint the foliage, vary the edge by turning your brush on its side and stroking upward. Paint some areas in the bottom half to indicate light and sky reflections in the water. Vary the width, height and dimensions of your shapes to keep your design exciting.

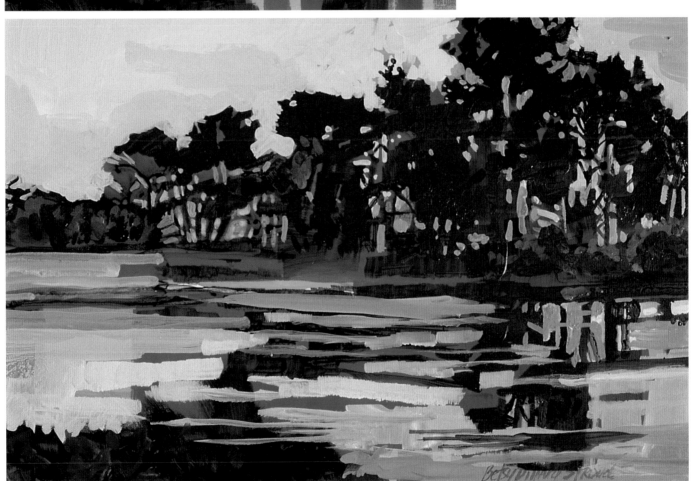

5: ADD FINAL TOUCHES

Sparkles of orange in the sky and specks of red throughout the trees, the riverbank and in areas of the water enhance the dark drama of the trees and add mystique to this subject. The deep transparent green of the trees presents a vibrant contrast to the cool, opaque light blue of the sky and the water.

JUST AFTER SUNSET DOWN THE ROAD FROM PALESTINE, TEXAS

Betsy Dillard Stroud ÷ 12" x 16" (30cm x 41cm) ÷ Acrylic on heavy-weight illustration board ÷ Collection of the artist

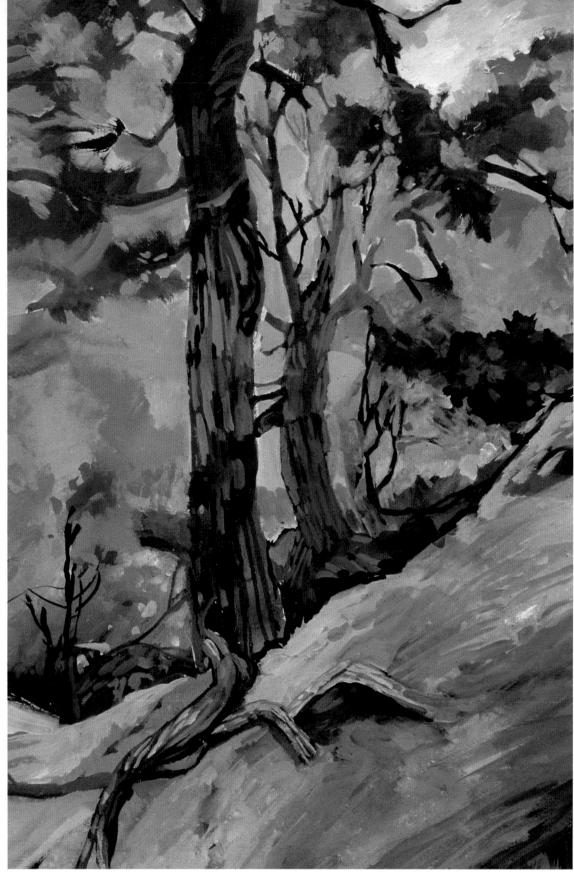

Vibrant Trees

I brushed an abstract arrangement of oranges and pinks onto the board.
After this dried I added tree shapes and built up the painting in layers of
transparent washes. Finally, I added opaques to exemplify the perfect
transparent-and-opaque marriage.

LONESOME PINE

Betsy Dillard Stroud ✛ 30" × 22" (76cm × 56cm) ✛
Acrylic on illustration board ✛ Courtesy of the
Roberts Gallery, Carefree, Arizona

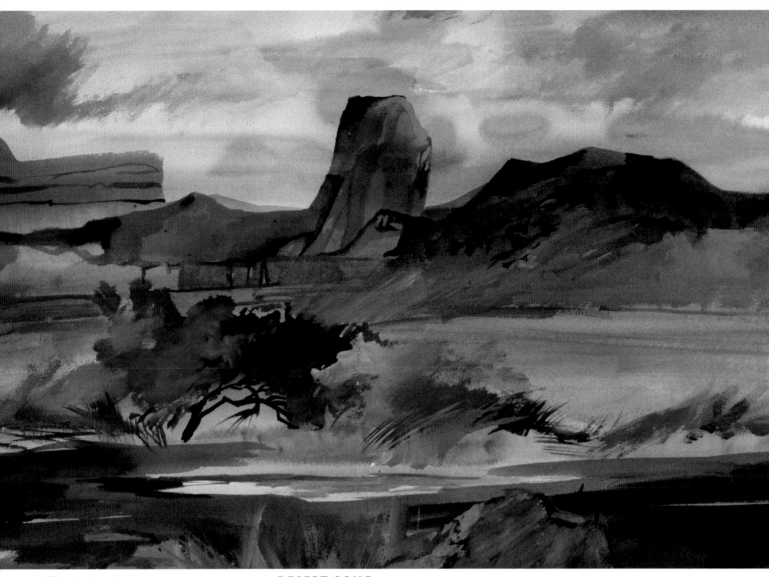

Glowing Landscape

I painted the sky rapidly, wet-into-wet, and dropped the lavender clouds in before the sky dried. I randomly stamped in both opaque and metallic colors to suggest the rugged terrain and also to hint at petroglyphic carvings. Finally, I wove patches of opaque paint in and out of transparent passages to evoke the tactile nature of the landscape.

DESERT SONG
Betsy Dillard Stroud ÷ 22" × 30" (56cm × 76cm) ÷ Watercolor and acrylic on 140-lb. (300gsm) cold-pressed paper ÷ Collection of the artist

acrylic over black gesso

An exciting and dramatic technique to use in landscape painting is to paint on a board, canvas or paper that is coated with black gesso. With this method it is important to build your layers up gradually with transparent color. Do not go into the opaque paints too soon, and you will get rich-looking color filled with drama.

Painting on black gesso automatically imparts mood and mystery to your painting because of the visual effect the black gesso has on successive layers of paint.

materials list

SURFACE
Heavy-weight illustration board

PAINT
Acrylic ✦ Phthalo Blue ✦ Raw Sienna ✦ Ultramarine Blue ✦ Blue Violet ✦ Titanium White ✦ Violet Grey ✦ Dioxazine Purple ✦ Sap Green ✦ Permanent Green Light ✦ Quinacridone Orange ✦ Quinacridone Crimson ✦ Permanent Lilac ✦ Turquoise Green

BRUSHES
no. 10 or no. 8 flats ✦ no. 8 round

OTHER
Black gesso

1: START WITH TRANSPARENT WASHES
After you've coated your board with black gesso, let it dry. Use your no. 8 or no. 10 flat brush to start layering transparent color with Dioxazine Purple for the first set of rocks, Blue Violet for the distant rocks, Quinacridone Orange for the biggest set of rocks (which will be sunlit) and Phthalo Blue for the closest rocks. Even though the color is arbitrary at this point, use a different color for each set of rocks so you can keep them straight. Make sure your washes are transparent. The color will hardly be discernible to the naked eye. Let this layer dry completely.

2: CONTINUE LAYERING
Coat the sky area with Turquoise Green, and give the rocks another coat of the first colors you used in step 1. The painting will start to look rather milky now because of the opacity of Turquoise Green. Let it dry.

3: DEFINE WITH OPAQUES

Mix a little Titanium White into Ultramarine Blue with a touch of Permanent Green Light, and paint a thick layer over the sky. Acrylic dries darker, so don't be surprised if you have to add more and more layers to make this sky bright enough. Brush a little Violet Grey into the foremost rock formation to see if that color harmony works.

Mix a nature's green from Forest Green, Ultramarine Blue, Quinacridone Orange and a little Raw Sienna. Loosely brush in foliage and trunk shapes into the sky area. Add Sap Green in some areas to get a variety of color into these shapes. Concentrate on making good shapes, not in making individual leaf formations. Don't be meticulous. Negative painting in the sky area will give the trees credibility and an interesting silhouette.

Lastly, make some striations of Ultramarine Blue mixed with a little Titanium White for the distant mountain range.

4: ADD FINAL TOUCHES

The painting is too busy, so paint a glaze of Ultramarine Blue on the distant canyons. After this dries, mix Permanent Lilac, a bit of Quinacridone Crimson and Titanium White to make the rosy rock formations that are hit by the light. Paint out the big rock formation in the foreground because it competes with the tree for center stage.

Use a mixture of Blue Violet and Titanium White to add lilac clouds to the sky.

Add a few more lights and darks to the foliage. Note the wide variety of shapes in the tree mass and the simplicity of the rock formations in the distance. The tree shapes are dark and flat to provide a dramatic contrast with the biggest rock formation in the foreground.

The cliff on the left needs more contrast so scumble a lighter value of Violet Grey into the rocks.

CRISP OCTOBER MORNING AT THE GRAND CANYON
Betsy Dillard Stroud ✦ 16" × 20" (41cm × 51cm) ✦ Acrylic on heavy-weight illustration board ✦ Collection of the artist

Moody Landscape

I began this painting with an abstract under-painting of transparent bright orange and red washes. After this layer dried, I came back with dark greens and blues to glaze over the trees. I always leave something of a previous layer showing in my paintings, such as the bright red reflections in the water, which were part of the underpainting. Last, I painted around the trees with opaques and created a moody sky with clouds of gorgeous pinks and oranges.

SOMEWHERE NEAR SEDONA
Betsy Dillard Stroud ÷ 20" × 30" (51cm × 76cm) ÷ Acrylic on heavy-weight illustration board ÷ Collection of the artist

Energized Still Life
I did this painting on canvas board starting out with a red underpainting. I left patches of the original red gesso showing in places to tie the painting together.

SCOTTSDALE STILL LIFE
Betsy Dillard Stroud ❖ 24" × 28" (61cm × 71cm) ❖ Acrylic on canvas board ❖ Collection of the artist

DEMONSTRATION
acrylic on canvas

Paint reacts differently on canvas than on illustration board. Canvas is more porous, so the paint will bleed faster and soak into the cotton or linen easier than it does on paper or board. Most canvas comes coated with gesso or acrylic paint. If you want more tooth, you can add additional layers of gesso to give yourself a more varied texture. If you do gesso your canvas or paper, apply it first in one direction (for example, horizontally), then after that layer dries, apply it the other way (vertically). For a really smooth surface paint on Masonite that has been gessoed and sanded five times.

materials list

SURFACE
Canvas or canvas board

PAINT
Tube Acrylic ✦ Quinacridone Magenta ✦ Napthol Red ✦ Forest Green ✦ Cadmium Red Light ✦ Cadmium Orange ✦ Brilliant Yellow ✦ Titanium White ✦ Permanent Green Light ✦ Ultramarine Blue ✦ Phthalo Green Light ✦ Permanent Lilac

BRUSHES
no. 10, no. 8 flats ✦ no. 8 round ✦ no. 6 rigger

1: GET WILD, WET AND TRANSPARENT

Paint a very thin Ultramarine Blue wash over the sky area down into the land area. While it is still wet, mix some Quinacridone Magenta with the blue and quickly paint in a mountain shape, making sure your mountain tops aren't too round or identical. Use yellow and blue to brush some green into the grass area and the area where the distant trees will be. Use your brush to spatter on reds, magentas, greens, oranges and yellows into the land area. This step needs to be completed all at once before the paint dries.

2: DEFINE SHAPES WITH DARKS

Mix up a dark green from Forest Green, Phthalo Green Light and Ultramarine Blue, and start brushing in foliage shapes. Don't be picky with this step. Keep your washes fluid, and brush in some big, somewhat ambiguous shapes.

3: GET DARKER, BOLDER AND MORE DETAILED

To contrast with the transparent mountain, make the sky opaque using Phthalo Green Light, Ultramarine Blue and Titanium White.

Add more and deeper colors of foliage to the trees, and brush in a horizontal yellow-green strip under the tree shapes to anchor the composition.

Add touches of Cadmium Red Light, yellow and orange to the foreground flowers to start giving body to this area. In the foreground, make an underpainting for the white flowers by using colorful gray mixtures of Titanium White mixed into Ultramarine Blue and Quinacridone Magenta. Draw in some vertical and oblique grass strokes with your rigger using a light green mixture.

4: ADD FINAL TOUCHES

Most paintings require a lot of looking at to make sure everything is harmonious. Add layers of grass in various dimensions growing in different ways, using dark colors and painting over them with lighter strokes. Add bright white ambiguous flower shapes throughout the painting and a darker lavender to the distant flowers on the upper right. Enhance the foliage of the main trees with another layer of Permanent Green Light mixed with a little yellow and white. Dash in a few more light grass strokes with your rigger, and you're through.

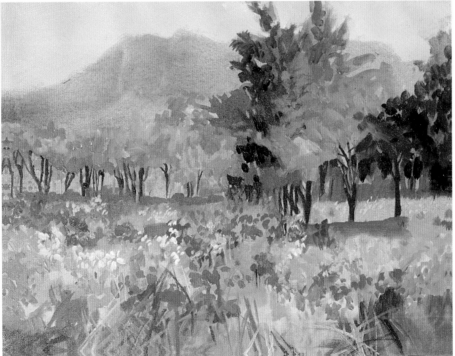

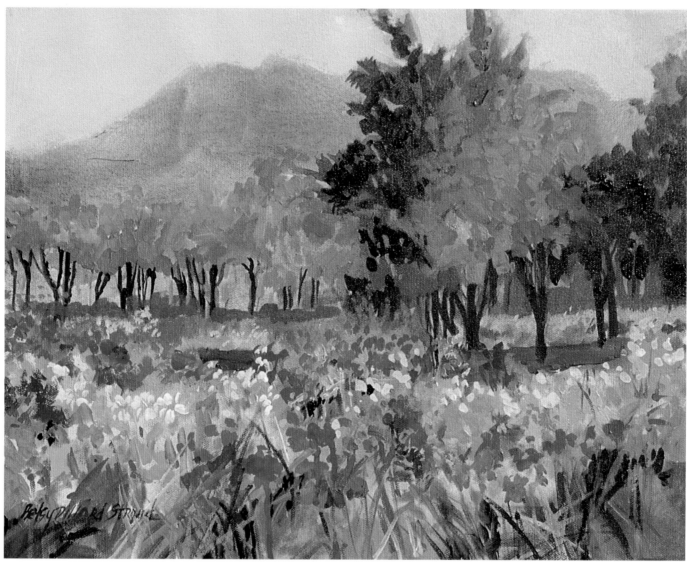

5: MAKE CORRECTIONS

Now is the time to pop out the painting with
some impasto lights in the trees. Mix up Titanium
White, Permanent Green Light and Brilliant
Yellow, and add heavy accents into the foliage.
Add more lights in the flower/grass area with
lighter values of the colors already there. Use
your rigger to brush in lighter calligraphic
strokes, highlights, and the sparkle of sunlight.

SOMEWHERE NEAR TAOS
Betsy Dillard Stroud ÷ 16" × 20" (41cm × 51cm) ÷ Acrylic on canvas ÷ Collection of the artist

Emotional Abstract

I painted this canvas lying flat, first smearing it with fluid matte medium. Before I started painting I made sure my fluid acrylics were ready to use and squirt. I decided to pour out several colors: magenta; violet; crimson; yellow, white and Phthalo Blue. Quickly, while the fluid medium was still wet, I brushed in the color using very little water. Each brushstroke became a Zen stroke and an emotional experience. Once I filled the canvas with transparent paint, I mixed up some Titanium White and brushed it into the mixture to make an opaque contrast. As a last emotional outburst, I squirted thick yellow paint onto the canvas. When I looked at the painting later I realized I had painted an iris amidst all those emotional brushstrokes—a purely subconscious act, and a "Painting From the Inside Out" experience.

CONTEMPLATION: GENESIS
Betsy Dillard Stroud ✛ 40" × 30" (102cm × 76cm)
✛ Acrylic on canvas ✛ Collection of the artist

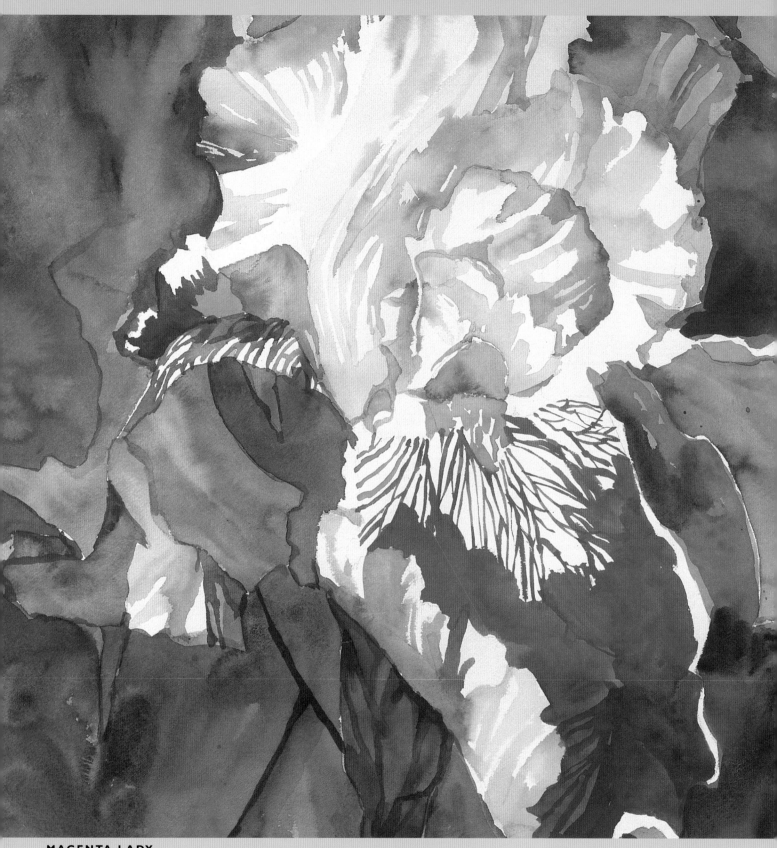

MAGENTA LADY
Betsy Dillard Stroud ✣ 22" × 30" (56cm × 76cm) ✣ Watercolor on 140-lb. (300gsm) cold-pressed paper ✣
Collection of Jefferson Heath

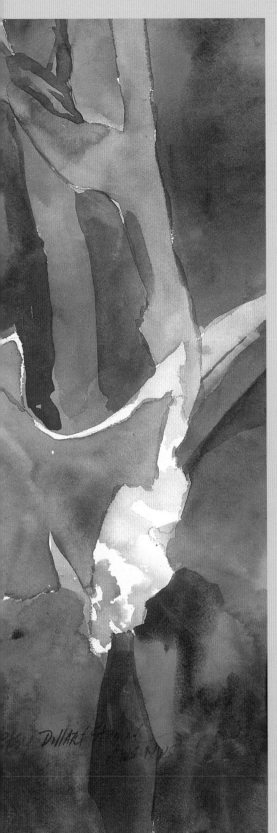

For Lize
Bright purple Iris
A thousand secrets hide beneath your twirling skirt
A hundred cunning colors stain your deep-set heart
Radiant purple Iris
Magenta lady
Dancing in the wind
Against the stormy sky.

—Betsy Dillard Stroud

say it with flowers

Flowers are often considered hackneyed subjects—trite subject matter, not suitable for serious artists. (Tell that to Van Gogh and Georgia O'Keeffe!) For that reason, it is important to inject excitement into your flower paintings, to experiment with innovative concepts and different techniques. Playing with the space on the picture plane and introducing an unusual element into your design can give you dramatic results and a whole new way of interpreting your subject.

I have often thought, "If only I could be an artist the way an iris is an iris!" Flowers and the love of them have always been part of my life. In my heart, each flower painting I do is an homage to my mother, my grandmother and my uncle, whose love of flowers and artful arrangement of their beauty inspired and helped develop the artist within me.

Paint With a Limited Palette

I started *Magenta Lady* with a contour drawing. The challenge was to use a limited palette: Quinacridone Gold, Brilliant Red Purple, Blue Violet, Cobalt Blue and Sap Green. First, I established the shadows and dark pattern weaving through the composition with purples and muted grays. Then, I dropped in the background wet-into-wet with mixtures of gold, violet and green. Last, I established the sunlit flower by using intense saturations of violet and calligraphy on the bottom petal.

DEMONSTRATION
painting a floral vignette

As my former teacher Naomi Brotherton taught me, a vignette is a painting that has four white corners of different size, dimension and shape. In each vignette, there should be a soft piece, or a place on your composition where there are no hard edges. This soft piece serves to unify your design by providing a good contrast with your hard-edged shapes.

This exercise is especially successful for painting flowers. When you paint a vignette, don't draw with a pencil first. The object is to use your brush for everything and to incorporate the white of the paper as a key ingredient in the design of your composition. When you challenge yourself by drawing with a brush, you increase your skills immeasurably, as well as improve your confidence. You will increase your ability to make spontaneous and intuitive artistic judgements.

Don't define the flowers too much. Spontaneous brush painting encourages the natural flow, fusion and mixture of pigment on paper that exploits the magic of watercolor. Let your color express the joy you feel when painting nature's bounty.

materials list

SURFACE
140-lb. (300gsm) cold-pressed paper

PAINT
Watercolor ✦ Naples Yellow Reddish ✦ Cadmium Lemon Yellow ✦ Sap Green ✦ Orange Lake ✦ Shell Pink ✦ Indian Yellow ✦ Indigo ✦ Dragon's Blood ✦ Magenta ✦ Permanent Red Deep ✦ Naples Yellow ✦ Cerulean Blue ✦ Cobalt Blue Deep ✦ Lavender

BRUSHES
no. 14 round sable ✦ no. 6 rigger

OTHER
Linoleum stamp

1: START AT THE TOP
Quickly define a gladiola, on the upper left side of your floral arrangement, by painting the shape of the stalk with Sap Green and a little Indian Yellow. Before it can dry, add the blossom with Cadmium Lemon Yellow and paint a little Cerulean Blue into the Sap Green stalk. Drop in a green on the bottom of the yellow blossom to simulate reflected light and/or shadow.

2: CONTINUE PAINTING ON THE LEFT SIDE
Add an orange blossom to the left side of your floral arrangement using yellow and red, and make a white blossom by painting a very light wash of lavender and dropping in Cobalt Blue Deep. Continue to define the yellow gladiola blossom and paint around a white daisy shape using the violet-blue mixture. Using a pale wash of Naples Yellow Reddish, paint a gerbera daisy shape below the white daisy, and drop a little Magenta and Shell Pink into the center.

3: BUILD A BOUQUET

Move to the top right side of your paper and begin painting in shapes of flowers using the same reds and greens you used on the left. Connect the flowers to the top of the composition. Don't stop short of the edge of the paper as this implies an amateurish timidity. Think of making brushstrokes like playing tennis. Each stroke should have follow-through. Besides, you always want to give your flowers life outside the picture frame. Let them fill the composition and burst outward. Paint some ambiguous light violet-blue shapes to suggest white daisies in the background.

4: DROP IN COLOR

Start to develop the roses by first painting their silhouettes with a light mixture of Magenta and Orange Lake. Do not outline them. Try painting the right shape with your brush. Before it dries, draw in a few definitive shapes with a darker magenta-orange mixture. Continue developing the flowers by painting a yellow daisy and connecting it to the bottom rose with a green leaf shape. Paint a leaf using the green mixture and draw in some leaf striations with Magenta. By moving around the composition and dropping into color, you create color harmony no matter how many pigments you use.

5: CONNECT TO THE OTHER SIDE

Build your composition further by painting a yellow rose with mixtures of Indian Yellow, Cadmium Lemon Yellow and Orange Lake dropped into the center. Draw a stalk with your brush and paint it to the side of the composition to anchor your painting on the right. Continue with the red gladiola shapes and some more leaves. Use Permanent Red Deep and Cadmium Lemon Yellow for the daisy, with Orange Lake dropped in.

PAINT FAST!

It's important to paint nonstop with this method so you won't get hard edges connecting the flowers. Don't be afraid—just keep the paint flowing. Lost edges between flowers provide a visual segue that leads us through the composition.

6: ESTABLISH THE TOP OF THE VASE

Paint in some more ambiguous floral shapes with yellow and splashes of orange in the top left and right. Suggest a light gerbera daisy shape between the two bottom roses with Naples Yellow Reddish. Add some light value leaves on the lower right with a violet-blue mixture. Let this all dry, then paint in darks to suggest the top of the vase using Indigo and Dragon's Blood. Make sure your stroke is horizontal like the vase top.

7: SUGGEST GLASS

Mix up a very light wash of Cobalt Blue Deep and brush it down from the dark shape at the top of the vase. Drop in some greens and a little red, and let them mingle. Paint some stalk shapes and stop. Let it dry, and then suggest a water line and a lip for the vase by painting a little darker value blue. You are trying to capture essences in this type of painting, so do not labor over the vase or any of the flowers.

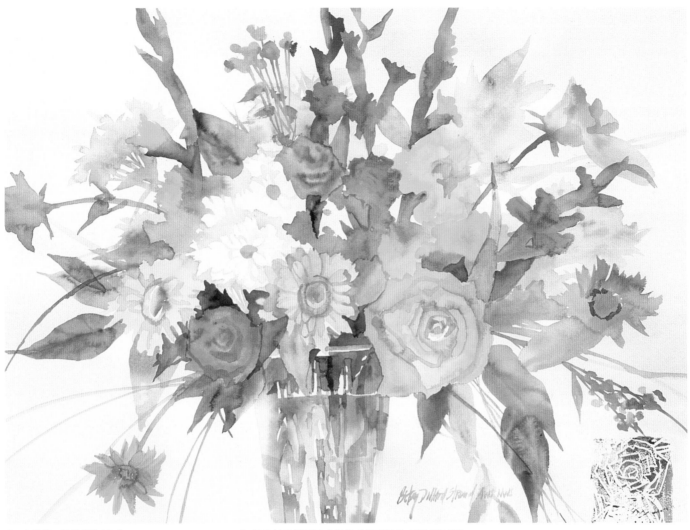

8: ADD DETAILS

Darken some of the rose shapes and add more detail with the same pigments used to create the flowers. Add some shapes to the vase and paint some darker green areas (adding mixtures of Indigo and Dragon's Blood to Sap Green) around the bottom rose to make it more prominent. Use your no. 6 rigger to add some "bear grass" by mixing up a puddle of paint and drawing several stalks with one fell swoop, beginning at the vase and extending beyond the picture plane. Notice how the soft spot of ambiguous shapes and light color on the top right balances the more vibrant colors elsewhere. As a final touch, carve a rose into your soft linoleum block. Paint your rose stamp with a mixture of red, green and yellow, and imprint it in the bottom right-hand corner.

A BOUQUET FOR LITTLE TUCKER

Betsy Dillard Stroud ÷ 22" × 30" (56cm × 76cm) ÷ Watercolor on 140-lb. (300gsm) cold-pressed paper ÷ Collection of the artist

DEMONSTRATION
organic shapes and geometric contrasts

In this exercise you'll combine organic curvilinear forms with geometric shapes, changing the color and the value every time you come up to a geometric shape. You'll use a limited palette to explore the coloristic possibilities that can arise from using only a few tubes of paint.

By adding an unusual element (geometric shapes) into an ordinary subject, you'll create a contemporary spatial statement and an intriguing composition at the same time.

materials list

SURFACE
140-lb. (300gsm) cold-pressed paper

PAINT
Watercolor ✦ Verzino Violet ✦ Blue Green ✦ Golden Lake

BRUSH
no. 14 round

OTHER
2B pencil

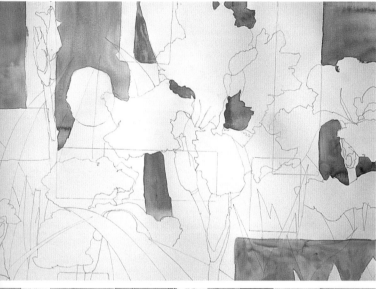

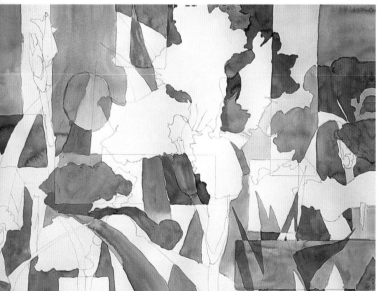

1: PAINT AROUND THE COMPOSITION

Do a contour drawing of a group of flowers using a 2B pencil. Don't put in details, and don't smudge your drawing. Make sure your shapes are interesting and that they touch the edges of the sides of the composition.

Over the contour drawing, draw from five to seven geometric shapes using squares, rectangles and circles. It's an arbitrary decision where to put them, but make sure to vary the size of each shape when you use it more than once.

Paint the spaces around the composition with a gray mixed from your three pigments. Mix this gray right on the paper by painting first one color and then dropping in the other two. Mixing on the paper allows pigments to separate in their natural way, creating unusual diffusions and sedimentation. Let each shape dry before you tackle the one next to it.

2: PAINT AROUND THE CENTER OF INTEREST

The biggest iris is the center of interest, so start by painting the shapes around it. Paint a dark Blue Green behind the iris. On the right side of the composition, paint the iris with a mixture of Golden Lake and Verzino Violet. Let that shape dry before painting the shape next to it. After it dries, paint the iris shape continuing into the next space with a neutral color; that way, you get contrast.

Alternate warm and cool, light and dark, color and neutrals throughout the composition. On the lower left, start painting the iris with the mixture of violet and gold. After it dries, contrast that color with violet for part of the back blossom.

Paint the leaf with a mixture of Blue Green and Golden Lake, dropping in Golden Lake along the rim after you paint the leaf. Try to think of each shape as a tiny cosmos of interesting color.

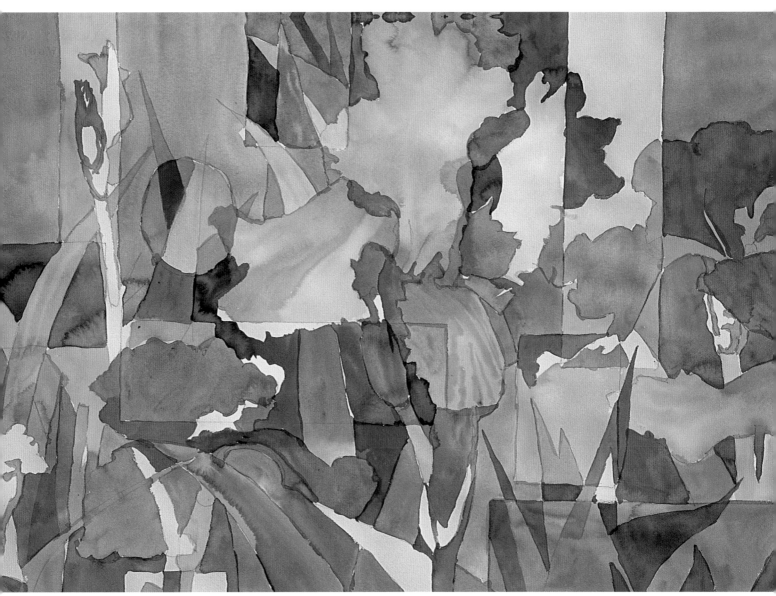

3: CREATE KALEIDOSCOPIC COLOR

Continue to paint the shapes, alternating warm and cool, light and dark,
color and neutral grays. Change the color and/or value with each brush-
stroke. For example, drop some Golden Lake into the top iris leaf while it
is still wet with the Blue Green-Golden Lake mixture. Notice the texture
on the far right iris. By painting pure water into the flowers, you can create
"blooms" that simulate the soft, feminine texture in the blossom. For
contrast against the blue background, mix up a light Verzino Violet wash
for the main iris. Paint that in, and drop some Golden Lake in places on the
petals while the violet is still wet. Draw with Verzino Violet into the bottom
petal to suggest the fine lines in the iris. Notice how kaleidoscopic the
painting is beginning to look!

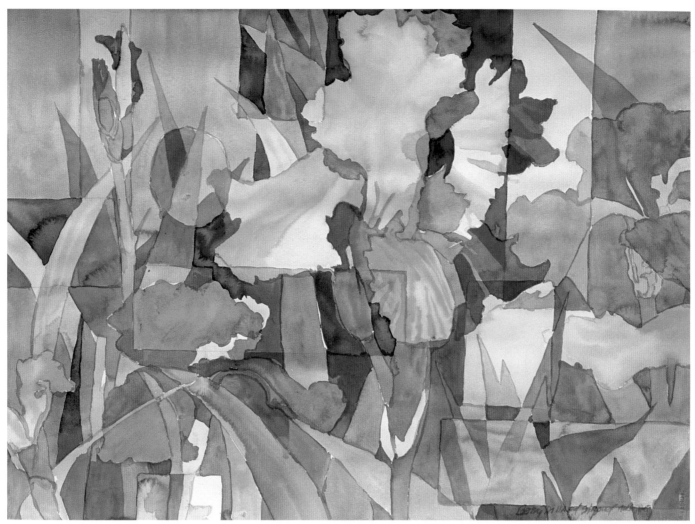

4: ACCENTUATE THE CONTRAST

Finish painting in all the shapes, again alternating contrasts—warm and cool, light and dark. Glaze over some of the geometric shapes with violet to darken them further, as in the glaze in the middle geometric box cutting into the iris. You may glaze over a whole shape or part of a shape. Darken the area behind the center of interest with another glaze of Verzino Violet. Now we have an exciting painting. What a challenge!

SHEPHERD'S IRISES

Betsy Dillard Stroud ❖ 22" x 30" (56cm x 76cm) ❖ Watercolor on 140-lb. (300gsm) cold-pressed paper ❖ Collection of the artist

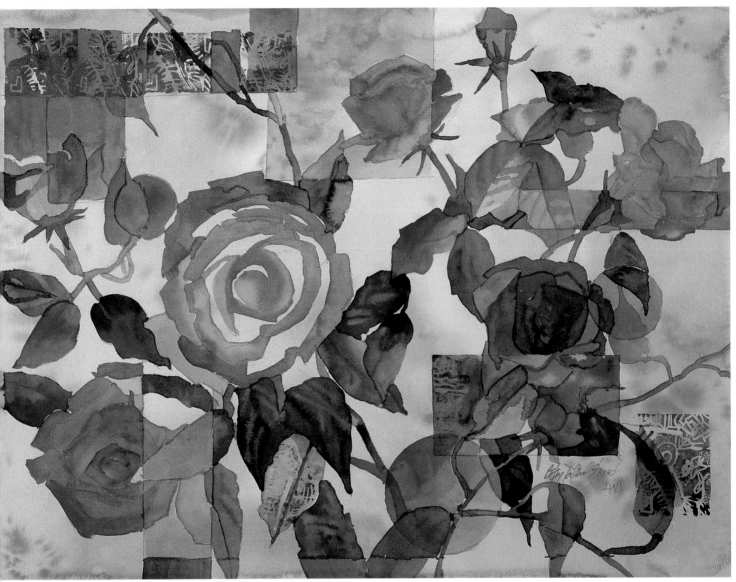

Organic Shape Painting

After doing a contour drawing of the roses, I added geometric shapes over the design. With a limited palette of Permanent Rose, Phthalo Blue and Golden Lake I began painting using thin washes of color. When I came to a geometric shape I changed the color or the value of the pigments and built up the darks gradually. As a final expression, I stamped into the composition using combinations of the three pigments mentioned above mixed with Pearlescent White watercolor.

ROSES FOR BIG MAMA
Betsy Dillard Stroud ÷ 22" × 30" (56cm × 76cm) ÷ Watercolor on 140-lb. (300gsm) cold-pressed paper ÷ Collection of the artist

Painting flowers wet-into-wet

There are many ways to paint wet-into-wet. You can saturate your paper on both sides and start painting; you can saturate your paper only on one side and start painting; or, technically, if you drop color into color that is already wet, you are painting wet-into-wet. For this exercise, you will saturate both sides of the paper. Do not staple the paper for this exercise. The paper, when saturated, will lie flat by itself. If you have buckling after your painting dries, coat the backside of the paper with gesso, gel or matte medium, and it will straighten out completely.

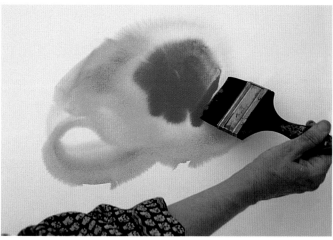

Saturate Your Paper
In wet-into-wet painting, it is important to wet the paper thoroughly and evenly, as you want the paint to spread and you do not want hard edges. Use a 2-inch (51mm) or 3-inch (76mm) brush to wet your paper in a methodical way, overlapping each stroke so that the entire paper is evenly saturated. While still wet, paint in thick pigment, so it doesn't wash out. Start out loosely to cover more space. Details can come later.

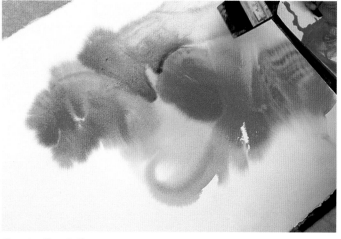

Create Gradations
You can create gradation in the paint by stroking a damp, clean brush across the thick pigment.

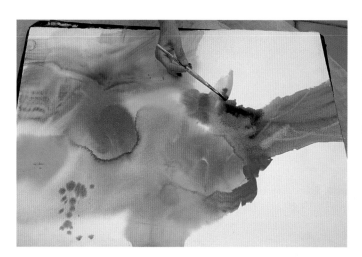

Use a Round Brush to Paint Specifics
Using a round brush will give you more control when working wet-into-wet. Use it for details and to make less-ambiguous shapes. Use it to drop in other pigments to create diffusions.

On the right I drew through the blue paint with plain water in a round brush. Water spattered into wet paint or drawn through wet paint makes entertaining texture.

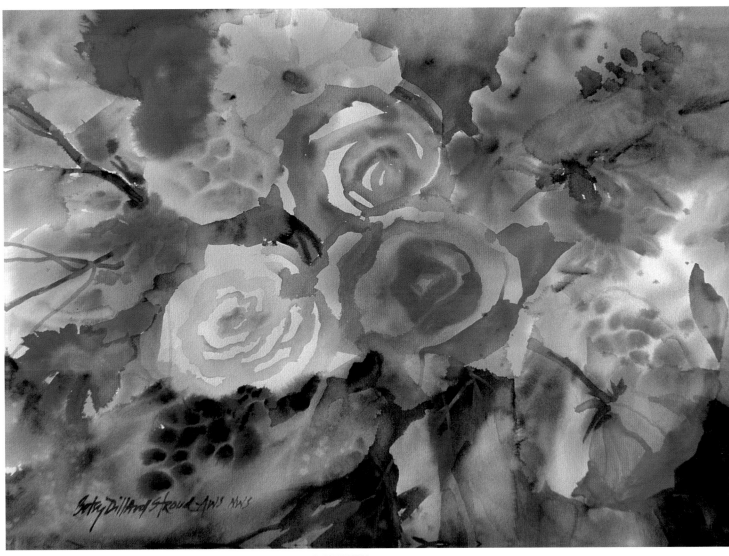

Capture Essences With Wet-Into-Wet Painting

This finished painting bears little resemblance to my wet-into-wet beginnings because I manipulated the paint many, many times before I finished.

By dropping in pure color and painting spontaneously, you can capture the essence of flowers—their grace, movement and color—without being too specific. Some artists believe that painting wet-into-wet is the purest form of watercolor painting. Try it, and I'm sure you'll agree it's a magical experience.

BONNIE'S BOUNTY
Betsy Dillard Stroud ✣ 22" × 30" (56cm × 76cm) ✣ Watercolor on 140-lb. (300gsm) cold-pressed paper ✣ Collection of the artist

Dark subject, light background

Artists from the Renaissance to the present day have sought to capture elusive light. Although we may not be able to capture the real light, we can symbolize that light in our paintings by creating contrasts—dark against light and light against dark.

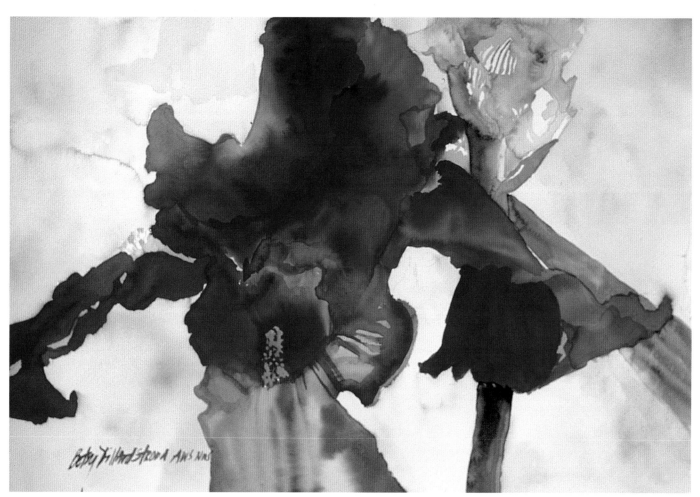

The Illusion of Shimmering Light

Placing a luminous dark iris against a patchwork of high-key pigments gives the dappled look of a sunny day. To express the beauty of light we must exaggerate the contrast between light and dark.

Paint your background first, diluting your pigments and changing the color with each brushstroke. As you paint, drop in water to create "blooms," which will also help suggest the effect of shimmering sunlight. The rich purple iris against the foil of the multi-colored background gives the illusion that we have, indeed, captured light.

PURPLE PASSION
Betsy Dillard Stroud ÷ 15" × 22" (38cm × 56cm) ÷ Watercolor on 140-lb. (300gsm) cold-pressed paper ÷ Collection of the artist

Light subject, dark background

A light subject against a dark background makes a more theatrical statement about light than a dark subject against a light background. In the latter, we find a "shimmering" kinetic quality of light. With a light subject against a dark background the effect is more of brilliant sunlight.

Portraying this kind of subject gives the artist an opportunity to explore the rich and luminous grays found in the cast and formed shadows of an exquisite white flower. Exploiting the dramatic contrast between light and dark is the key to capturing the illusion of bright, beautiful sunlight.

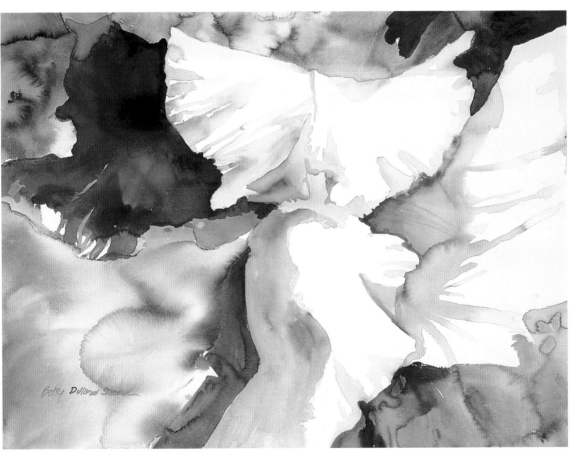

The Illusion of Brilliant Sunlight

In *The Winged Victory* I illustrated a light subject used against a dark background to suggest the illusion of light. I deliberately painted the back petals of the iris very dark to add more drama. Actually, the background is more of a midtone, but because the iris is so much lighter (and has the deep blue-purple petals), the background appears to be darker than it really is. In reality, the rich dark of the purple petals serves as a perfect foil to enhance the brilliance of the white iris. Notice the luminosity in the shadows of the iris. For the grays I dropped in red, yellow and blue simultaneously and let watercolor have its way. Luminous grays accentuate the brightness of the whites and provide a nice respite from the rich darks in this painting.

THE WINGED VICTORY
Betsy Dillard Stroud ÷ 22" × 30" (56cm × 76cm) ÷ Watercolor on 140-lb. (300gsm) cold-pressed paper ÷ Collection of the artist

DEMONSTRATION
painting expressive flowers

As an artist I am interested in capturing essences, trying not to rival nature but to express it with my own symbolism and style. Painting expressively captures the spirit of a flower more so than slavishly trying to copy the flower. By combining a realistic image with abstract trappings, you can play with both transparent and opaque passages in the same painting. You can create an ambiguity or a mysterious environment around your flower, which lends to an intriguing visual statement. You can paint both spontaneously and improvisationally, yet have some literal interpretation as well.

materials list

SURFACE
140-lb. (300gsm) hot-pressed paper

PAINT
Tube Acrylic ✦ Quinacridone Orange ✦ Violet ✦ Cerulean Blue ✦ Quinacridone Gold ✦ Luster Green ✦ Cool Gray ✦ Titanium White

BRUSHES
3-inch (76mm) synthetic brush (like Cheap Joe's Golden Fleece) ✦ no. 10 or no. 12 synthetic round

OTHER
Linoleum stamp ✦ Drafting or artist's tape

1: CREATE A LIGHT ABSTRACT UNDERPAINTING
Draw your flower composition. I drew an iris. Wet your paper thoroughly with the 3-inch (76mm) brush and flow on washes of Violet, Quinacridone Orange, Cerulean Blue and Quinacridone Gold. Paint fast so you don't get hard edges. Keep your values light, as this abstract underpainting will be your lightest light. Spatter a bit with the four pigments into the wet wash, and then let it all dry.

2: MAKE A BORDER
Take drafting or artist's tape and apply it around the top and sides of your painting. You will be creating a colorful border, making extra shapes to play with as you paint.

Paint your carved linoleum stamp with mixtures of Luster Green and the pigments from step 1, and stamp around the main floral image. After you stamp a few times, bring out the flower by darkening some areas around it with a transparent wash of Violet and Violet mixed with Cerulean Blue.

Darken the lower right corner with Quinacridone Orange and a little Violet to keep the eye from being drawn out of the painting.

Notice that the edges of the flower on the right come across the border of tape. Leaving this space open gives variety to your composition and keeps it from becoming too static.

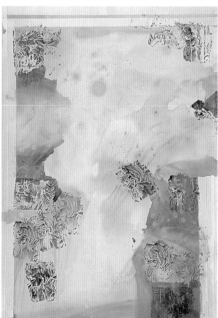

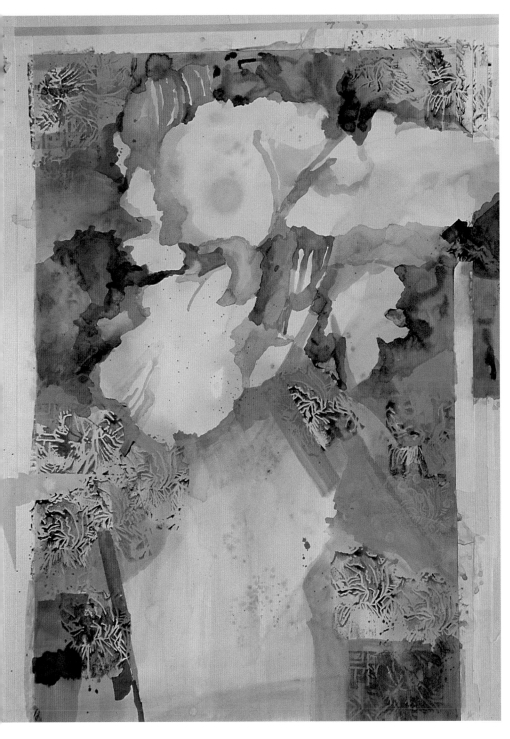

3: ADD OPAQUES FOR CONTRAST

Use your round brush to develop the main flower's back petal with calligraphic lines in Quinacridone Gold mixed with Quinacridone Orange. Drop a little Cerulean Blue in it while it's wet, and leave it be. Do the same to the bud on the right.

Darken the corner on the left with Quinacridone Orange, and drop in a little Cerulean Blue to keep the eye from being drawn out of that corner.

On the left suggest the shape of a petal by painting around the area with some Quinacri-done Orange. Mix a little Cool Gray into some Cerulean Blue, and brush it into the areas on the top of the painting. Shape a stalk on the left using Cool Gray mixed with a bit of Violet. Brush that mixture around the bottom petal on the left to give it more oomph. Brush on a thin wash of Violet to shape the front petals of the iris, but do it sparingly and keep the wash light. Because the flowers are delicate, a heavy hand is a no-no.

4: REMOVE THE BORDER TAPE AND ADD MORE OPAQUES

Once step 3 has dried, remove the artist's tape to expose the underpainted border. As you continue adding opaques to your painting you can paint abstract shapes into this border area to expand the subject and add interest.

The blossom on the right is competing with the main flower, so paint over it with a thin wash of Violet. Break through the top border using an opaque green mixed from Titanium White, Quinacridone Gold and Cerulean Blue.

Shape the petals bursting through the border on the right and left with negative painting (painting around the suggestive shape). Add opaques at the bottom of the petals to suggest the stalks, and paint around the other stalk shape at the bottom right with Cerulean Blue and Violet.

Separate the iris from the bud with a mixture of Cerulean Blue and Cool Gray. Break through the border on the top left with some cool gray to mimic the shape of a petal. Add a thin wash of Violet over the Quinacridone Orange that surrounds the iris to tone down the background.

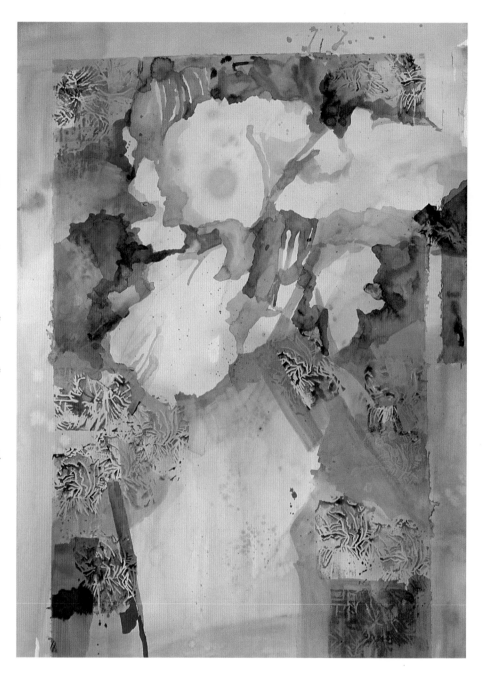

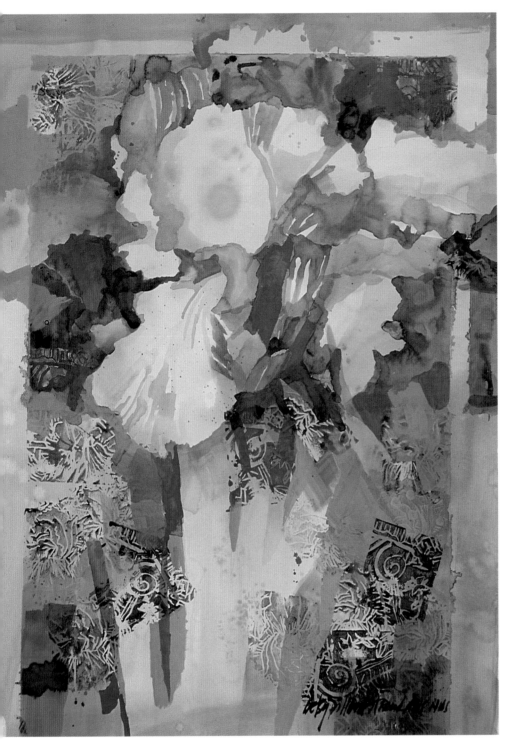

5: ADD FINAL TOUCHES

Bring the main flower out even more with opaques. Mix a cool yellow with Titanium White and Quinacridone Gold. Paint it on the top petal of the iris to the bottom left and a bit in the middle, breaking through the orange shape to suggest the back of the iris.

Tone down the bottom left rectangle (that stuck out like a sore thumb) with Violet.

Mix up a gray-green from Cool Gray, Cerulean Blue, and a little Quinacridone Gold. Brush it into the main stalk, fading it out toward the bottom and giving the stalk on the right a bit more definition. This painting satisfies me greatly. It has mood, harmonious color and lots of ambiguity. It says flower subtly and with grace—therefore, its name!

GRACE
Betsy Dillard Stroud ✢ 30" × 22" (76cm × 56cm) ✢ Acrylic on 140-lb. (300gsm) hot-pressed paper ✢ Collection of the artist

DEMONSTRATION
using a muted palette

The longer you paint, the more aware you become about the importance of grays. Color can't sing without a little gray chord to balance it. Learn about color harmonies by playing with different mixtures of pigments, dropping one into the other wet-into-wet, and alternating the order in which you add the pigments.

As I played with these ideas, I decided to experiment with grays to paint flowers. Gray, of course, sings a different chorus than most of our colorful bright flowers. A symphony of grays and muted pigments gives us an alternative way to suggest the quiet beauty and fragility of flowers.

materials list

SURFACE
140-lb. (300gsm) cold-pressed paper

PAINT
Watercolor ✦ Raw Sienna ✦ Indigo ✦
Neutral Tint ✦ Cobalt Blue Deep ✦ Dragon's
Blood ✦ Quinacridone Gold

Interference ✦ Interference Silver ✦
Interference Copper

BRUSH
no. 14 round sable

OTHER
2B pencil

1: SIMPLIFY AND PAINT FAST

Use a 2B pencil to do a contour drawing of your flowers, trying not to smudge the lines as you draw. Start on the right-hand side and use your round brush to float the following pigments together without stopping: Neutral Tint, Dragon's Blood and Raw Sienna. Do not dawdle. Keep the paint flowing and let watercolor do its thing. Paint the blossom and the stem, and let the pigments fuse.

2: MAKE LUMINOUS GRAYS

Make a separate puddle each of Quinacridone Gold, Dragon's Blood and Indigo. Begin defining the shadow pattern of the top flower by separately dropping in all three colors (watered down). Paint the petal of the bottom iris with a wash of Interference Copper. (You can see only a faint glow of the copper here, but it will have a profound yet subtle effect on your painting.) Brush in some Interference Silver into the top flower's bottom petal and carry it through to the stalk, alternating with passages of Dragon's Blood.

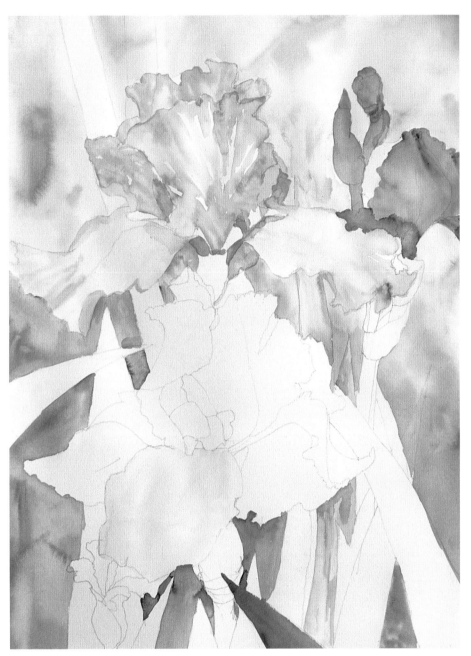

3: PAINT THE BACKGROUND

Mix up a thin, transparent wash of Raw Sienna, and start painting behind the flowers at the left top corner. As you move the wash through the top of the painting, vary the color a bit by dropping in watered-down Indigo, Interference Silver and Dragon's Blood. You'll paint the background on the bottom a little darker for contrast, so stop after you've painted around the top flowers.

Paint the bottom blossom of the big iris with a wash of Interference Copper and let all this dry.

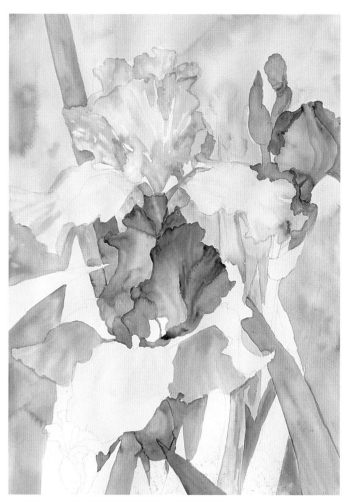

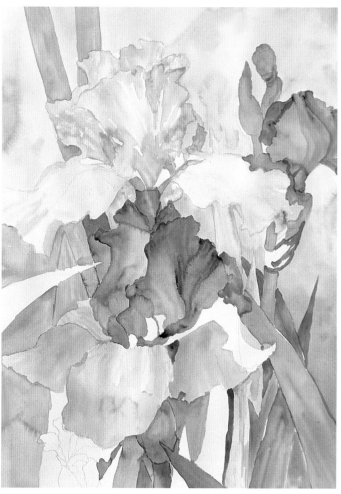

4: ADD INTERESTING DARKS

Begin describing the focal point by painting the
bottom flower with Neutral Tint, Dragon's Blood,
Indigo and Quinacridone Gold, changing the
color as you move across the iris. Paint the top
stalk with a midtone gray made of Neutral Tint
and Interference Silver. Paint the stalk at the
bottom with a mixture of Neutral Tint and
Indigo. Indicate the back petal of the top iris by
painting it with mixtures of Cobalt Blue Deep
and Interference Silver dropped into the wet
paint.

 Paint the background around the bottom
stalks with a little darker mixture of Neutral
Tint, Dragon's Blood and Quinacridone Gold.
As you paint, drop in some copper and silver.

5: ADD CALLIGRAPHY

Bring some more stalks into focus by painting
them with mixtures of Raw Sienna. Before the
sienna dries, draw in fine lines with Indigo to
suggest striations. Let each stalk dry before you
go on to the next, unless you want to merge
two shapes. Add a light gray wash over the
bottom petals of the iris with Raw Sienna and
Neutral Tint. Keep it light.

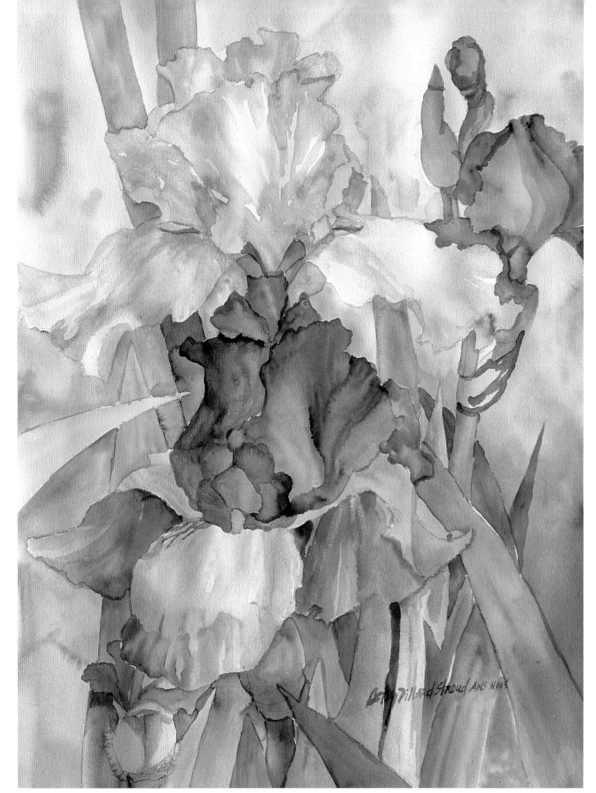

6: ADD IMPACT

Apply darker washes for more impact. As a last step, darken the bottom iris's petals where they are in shadow. Another alternative to experiment with would be to make the background very dark, so the dark of the irises would be a midtone, and the lights would become more dramatic.

SILENT DANCERS

Betsy Dillard Stroud ÷ 30" × 22" (76cm × 56cm) ÷ Watercolor on 140-lb. (300gsm) cold-pressed paper ÷ Collection of the artist

DEMONSTRATION
working with interference paint

The entry of iridescent and interference watercolor and acrylic into the already burgeoning list of available supplies opened incredible avenues of exploration for artists. Try them all. Thus far, Daniel Smith remains the only manufacturer of art supplies that makes interference watercolor. In this demo we'll use several of these exciting colors. I prefer to use all these materials sparingly, as too much can make your painting gaudy and unpleasant to look at. I find that interference watercolor can:

♦ Make beautiful grays when used with other pigments, especially the Pearlescent White and the Interference Silver.

♦ Add more weight to your watercolor when you apply it to linoleum stamps. Stamping is easier with acrylic, so that makes the interference and iridescent watercolor essential for stamping if you want to use only watercolor.

♦ Give a subtle reflective surface to your painting if used properly.

materials list

SURFACE
140-lb. (300gsm) cold-pressed paper

PAINT
Watercolor ✦ Orange Lake ✦ Blue Violet ✦ Indigo ✦ Dragon's Blood ✦ Sap Green ✦ Ultramarine Blue ✦ Cobalt Blue Deep ✦ Indian Yellow ✦ Permanent Green Light ✦ Permanent Red Deep ✦ Cupric Green

Interference ✦ Interference Silver ✦ Interference Copper ✦ Interference Hibiscus ✦ Interference Green

Iridescent ✦ Iridescent Garnet ✦ Duochrome Hibiscus

Gouache ✦ Pearl Gold

BRUSHES
no. 14 round sable

OTHER
Linoleum stamp carved with abstract images ✦ 2B pencil ✦ Kleenex tissue

1: DESIGN YOUR COMPOSITION AND START PAINTING

Use a 2B pencil to do a contour drawing of a vase of flowers, making sure your composition is well balanced. Make sure all the corners of your paper have different shapes and dimensions. Place your vase slightly off center.

When your drawing is complete, wet your vase with clear water. When the wetness dries to a sheen, float in a light Cobalt Blue Deep wash. Quickly drop in some Ultramarine Blue in areas that you want darker. Let it dry.

Paint a few leaves with a light wash of Cupric Green and drop in a little Cobalt Blue Deep.

2: ADD INTERFERENCE STAMPING

Paint your stamp with Interference Copper. Begin stamping in the top and continue stamping all over the background, changing the color of your stamp using all the luster and interference pigments listed in the materials list. Save the Pearl Gold for later, as it is gouache and will pull up if you paint over it.

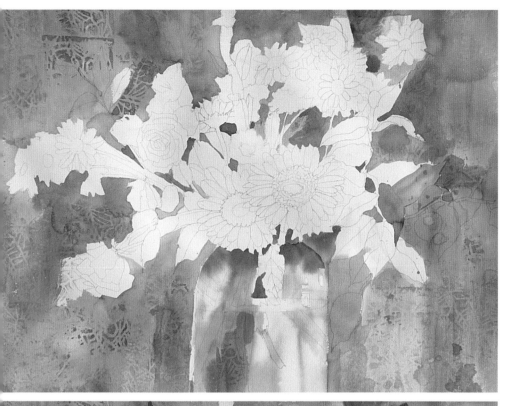

3: CREATE A MOOD WITH THE BACKGROUND

Make sure you have fresh pigments on your palette—no little piles, either! A good hefty squeeze is at least a fourth of a tube. Once your stampings and your first layers are dry, paint over the stamping with Ultramarine Blue, Cobalt Blue Deep, Sap Green and Cupric Green. After you finish, your vase should look incorporated in the background. That's what you want. It's most important to integrate your objects into the background so they don't look cut out. You can do this by softening edges and also by bringing the background color into the subject. For example, on some edges of the vase, make sure the color values are similar. Let this layer dry.

The cool colors and color harmony give this painting a subtle, quiet mood. One reason to paint the background first is for comparison. With the background painted, you can key in the color and intensity of flowers you want for the maximum contrast.

4: START THE FLOWERS

Using all the hot colors on your palette—the Orange Lake, the reds and the purples—start painting your flowers, beginning with the gerbera daisies in the center. Don't mix your pigments on the palette for this step. You'll get far better and brighter color by dropping one pigment into the next. Let each flower dry before you paint the one next to it. The center of interest will have the most interest and contrast, because that's where you want the most intensity, the brightest color and the most detail.

Drop Sap Green and Indian Yellow onto the leaves on the right. Try to vary the approach on each leaf. It's not necessary to let each leaf dry before painting the next one. Allow the color to flow so it unites the individual leaves into one shape. You can differentiate later.

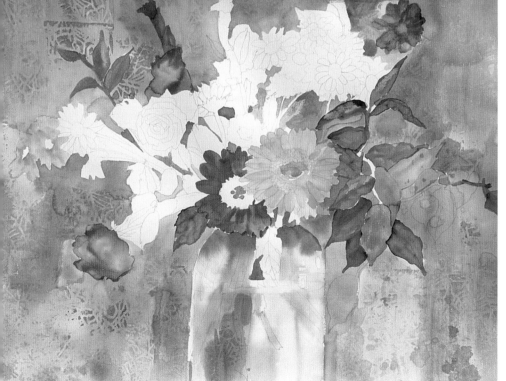

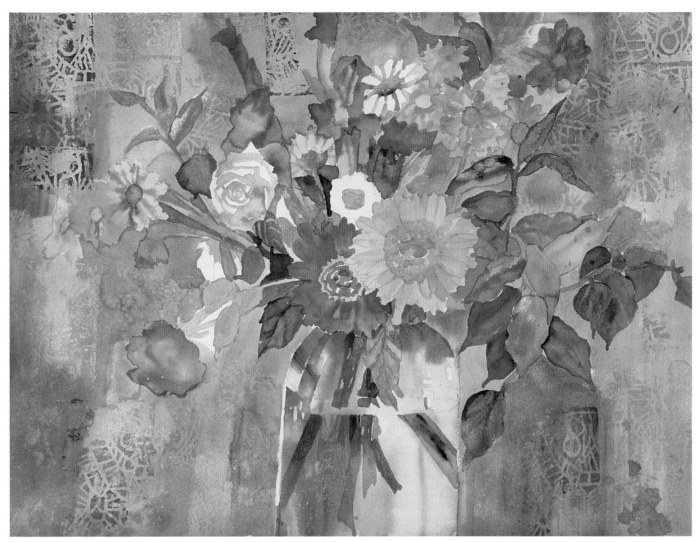

5: ADD CONTRAST AND DEFINITION

Paint some darker stalk shapes into the vase, using the greens, blues and Blue Violet on your palette. Near the top, wet a small area and drop in a little more Ultramarine Blue.

Glass is transparent, so you will create the illusion of looking through the vase. To suggest transparency there are a few tricks to make the viewer believe she is looking at glass: Use dramatic value differences and pick a few places to leave highlights by painting around them with a wash of Ultramarine Blue. Later you can lift some highlights out with water and a scrub brush.

Continue painting the flowers and leaves, as suggested in the previous step. In the white rose on the left, drop in some Duochrome Hibiscus and a little green. Use Interference Silver to draw ribbing in some of the leaves before they dry.

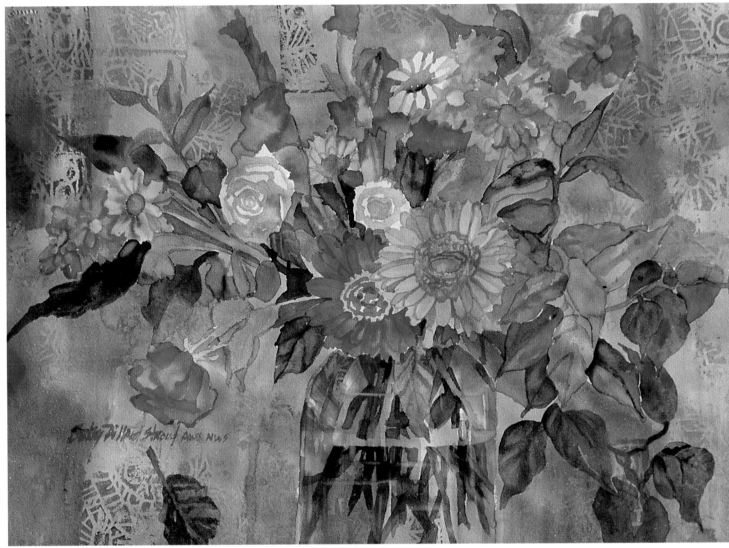

6: ADD FINAL DETAILS

Deepen the background by adding a transparent wash of Ultramarine Blue. Let it dry. Stamp a bit more over the background in the upper left and right corners to give a little more interest using the Interference Green and Interference Silver mixed with Indigo. I added a falling leaf to the composition on the left to suggest the passing of time. Tint some of the leaves and use calligraphy to describe their veins. Stamp into the vase in two places to suggest the background behind it, and further define the flowers by adding additional coats of paint and a little detail.

The composition still looks a bit unbalanced to me, so add another cluster of leaves on the right-hand side near the bottom. Define the middle flowers even more by adding some judicious darks around the petals and giving more form to the centers. Do the same to the outer flowers but to a lesser degree.

Lift out a few lights from the vase by brushing on water and blotting with a Kleenex tissue.

The cools of the background and the vase are a perfect foil for the bright and beautiful May flowers, while the variegated stamping provides a little mystique.

MAY FLOWERS FOR CELESTIA AND CABELL

Betsy Dillard Stroud ÷ 22" × 30" (56cm × 76cm) ÷ Watercolor, acrylic and gouache on 140-lb. (300gsm) cold-pressed paper ÷ Collection of the artist

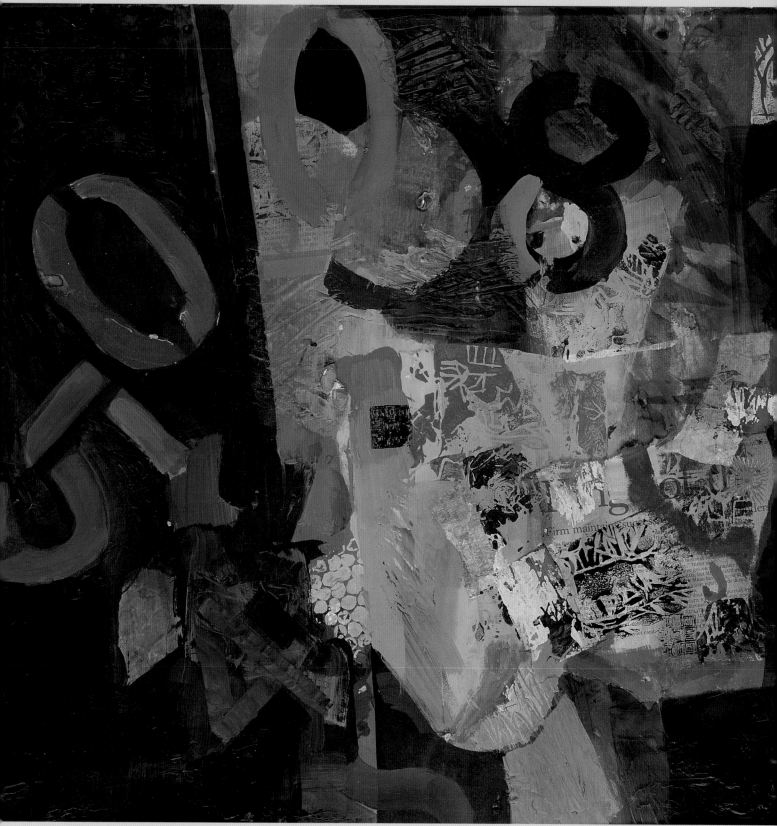

SORRY WRONG NUMBER
Betsy Dillard Stroud ✛ 22" × 30" (56cm × 76cm) ✛ Acrylic, newspaper collage, found objects, gel medium, Volume modeling paste, black gesso on 300-lb. (640gsm) hot-pressed paper ✛ Collection of the artist

"When you're in the studio painting, there are a lot of people in there with you—your teachers, friends, painters from history, critics—and one by one, if you're really painting, they walk out. And if you're really painting, you walk out."

—Audrey Flack from *Art and Soul: Notes on Creating*, E.P. Dutton, New York, 1986

the kitchen sink

Pull out all the stops. Do not restrain yourself. This is the time to put everything in your painting but the kitchen sink. (A slight modification: Use archival materials just in case you paint a masterpiece!)

Haven't you ever wanted to take a piece of paper outside, throw dirt on it, maybe even spit on it, jump up and down on it? Sure you have. Great art is never made by being timid. "Be Bold," says writer Brenda Ueland. "Be a pirate!" Fling caution to the winds as you fling paint!

To be on the safe side, you may have to do part of these exercises outside. Just wear some sunscreen.

A Little Bit of Everything

This painting has everything in it but cat soup (see page 122). I started with a layer of black gesso. After that dried I let it all hang out.

I discovered this method of painting when I combined the techniques of two well-known painters: Polly Hammett and Burton Silverman. Hammett is well known for her stunning paintings on 5-ply bristol board using thick watercolor straight from the tube. After she paints the thick layer of watercolor, she glazes with Manganese Blue. Then, she is able to lift out wonderful light passages using this method. Silverman's watermedia paintings are combinations of watercolor and gouache, with his painting begun on top of a gouache-painted surface.

I thought, "What if I use Hammett's technique of thick paint and glazing combined with Silverman's gouache-painted surface?"

This method gives you an opportunity to play with lifting, pattern and design. You'll have a lot of fun trying it.

materials list

SURFACE
140-lb. (300gsm) hot-pressed paper

PAINT
Gouache ◆ Permanent White or Titanium White

Watercolor ◆ Red Violet ◆ Lavender ◆ Naples Yellow Reddish ◆ Sap Green ◆ Turquoise Green ◆ Indian Yellow ◆ Light Red ◆ Dioxazine Purple ◆ Quinacridone Rose ◆ Verzino Violet ◆ Cobalt Blue

BRUSHES
no. 12 or no.10 round ◆ 1-inch (25mm) square brush ◆ no. 6 rigger

OTHER
Kleenex tissue ◆ 2B pencil ◆ Linoleum stamps

1: PREPARE YOUR SURFACE/DRAW YOUR SUBJECT/PAINT THE BACKGROUND

Use your 1-inch (25mm) square brush to coat your paper with Permanent White or Titanium White gouache. This layer of gouache will enable you to lift back to the original white of the paper. The gouache should be thick but thin enough to brush on the paper. Use as little water as possible, but do not lay down big clumps of gouache. It should thoroughly coat the paper. Let this step dry completely.

When dry, do a contour drawing of your subject onto the paper with a 2B pencil, drawing from a subject with a good pattern of light and dark. Do not draw details. Make it loose with just enough line to place your subject.

Use thick watercolor paint with just enough water to get the paint onto the paper with a round brush. Mix a warm gray with Turquoise Green and Light Red and begin painting the background around the floral bouquet. Notice how the brushstrokes show up on hot-pressed paper. Use the pigment almost straight from the tube.

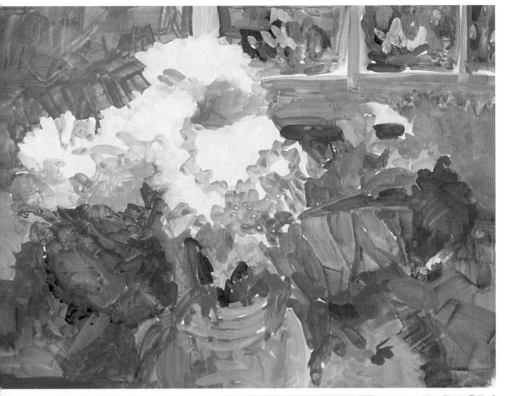

2: PILE ON THE PAINT

The paint must be thick enough to cover the gouache. Even if you have a white subject (such as the white flowers in this painting), cover every area with paint. Pigments that work well for white are those high-key pigments and opaque watercolors like Holbein's Shell Pink, Lavender, Lilac or Jaune Brilliant no. 1 or no. 2. Naples Yellow Reddish by Maimeri, or any Naples Yellow, would work in place of white.

Use staining pigments for the dark peonies (like quinacridones and phthalos). I used Red Violet, Dioxazine Purple and Verzino Violet. The staining pigment will smear a bit, but it only adds to the allure. Mix up a little Quinacridone Rose with Naples Yellow Reddish to get the lighter pink peonies. Add a mixture of abstract brushstrokes in different pigments in the windowpane area to lift out later. Paint the shadow area of the white flowers with mixtures of blue, red and Sap Green. Paint the jar using the white flower mix and Verzino Violet. Let dry.

3: CREATE A MOOD

Paint the leaves and stems with Sap Green, Indian Yellow and Cobalt Blue. Once that dries, mix up a big, thin puddle of Turquoise Green, and glaze it over the whole painting. Now it looks misty. Some of the gouache comes up, but don't worry—that's part of this technique. Glazing will bring all the disparate colors to a harmonious whole. Sometimes you can glaze more than once and with more than one color. Glazing will help create a mood. Let the glaze dry.

4: START TO ADD TEXTURE

Wet one of your linoleum stamps, and place it in
the background on the upper left of the painting.
Quickly pull it up and whisk a dry Kleenex tissue
over the area, lifting the paint. This won't work
with a damp tissue because you will muddy your
surface. Change your tissue every time you lift.
Wet some petal shapes and quickly blot to lift
lights out.

Lift out stems using your no. 6 rigger. Wet the
brush and run it along the shape you wish to
make, then blot.

5: LIFT OUT LIGHTS

If you need to change something in your paint-
ing, now is the time to do it. The longer you
wait to change something, chances are, the more
things you'll have to change. The space at the
upper left was too light and drew the eye up to
the corner. Before lifting anymore, use Dioxazine
Purple and Red Violet to add a dark flower shape
to the upper left where we stamped previously.
Mix up a little Dioxazine Purple with a little rose
to paint the silhouette of a peony shape over the
stamping. Make sure the paper is dry before you
do it.

Lift out the petals of the peonies and the
highlights in the jar one at a time, making
sure you use dry Kleenex tissue for each lift.
Remember, if you lift too much you can always
paint it again to darken it.

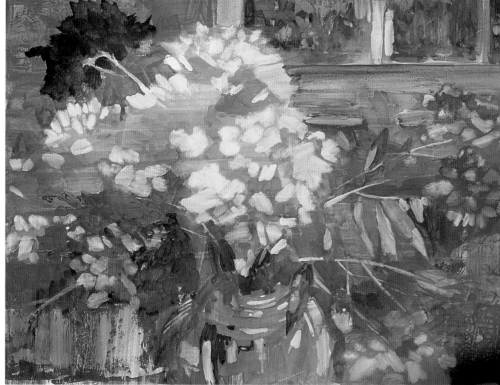

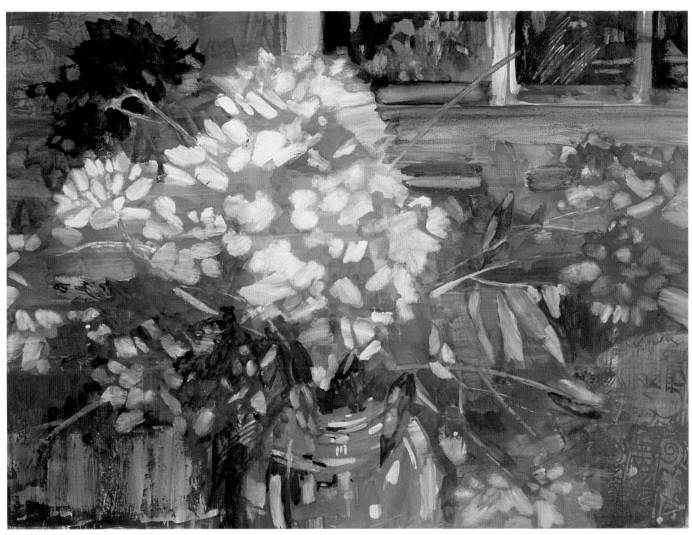

6: ADD SMALL DETAILS

After the dark silhouette of the purple peony in the upper corner dries, lift out some light places. Don't lift out too many, as you don't want the back flower to compete with the front ones. Use variety when you paint each flower. Some flowers need to be ambiguous and some need to be more defined—another example of contrast at work. For texture, take your brush handle, wet it and draw through the paint in the windowpane. Then, lift out some lights in the same area by blotting it with a Kleenex tissue.

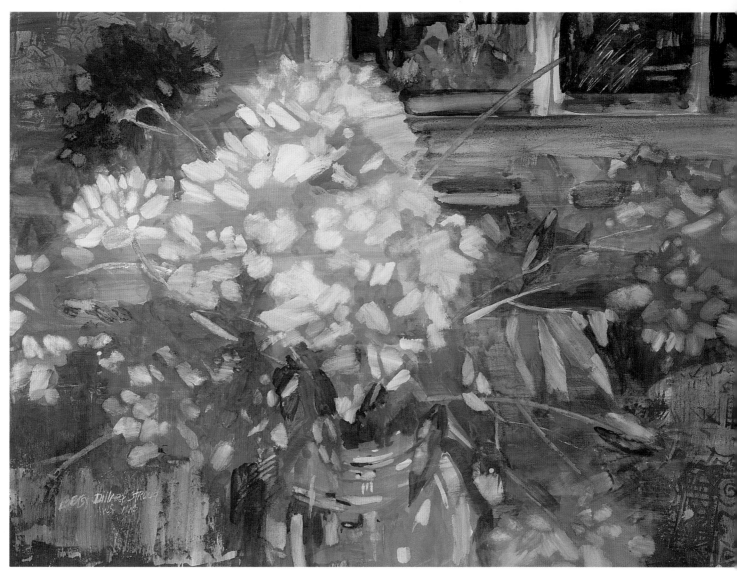

8: ADD FINAL TOUCHES

The last details you paint are likely to be the first things people see when viewing your painting. If the corners of your painting are too light, glaze over them with an additional coat of thin Turquoise Green. Make sure you keep a light touch with your brush so you do not pull up any more paint.

GEORGIE'S ESCAPADE
Betsy Dillard Stroud ÷ 22" × 30" (56cm × 76cm) ÷ Watercolor and gouache on 140-lb. (300gsm) hot-pressed paper ÷ Collection the artist

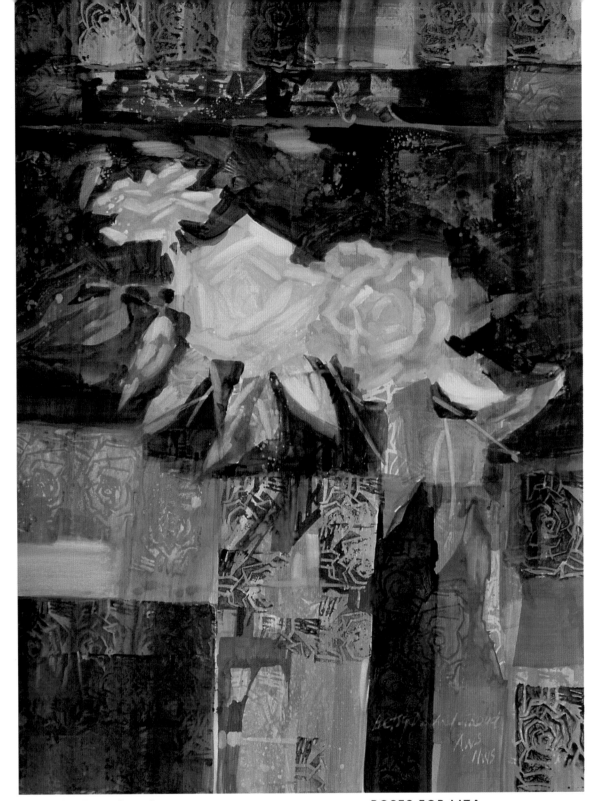

Lifting Out From Gouache

I started this painting by drawing the rose shapes in the middle part of the paper. Then I painted abstractly around those, deliberately trying for a dark neutral. I next stamped the painting with my rose stamp. After I completely covered the surface of the painting, I let it all dry. Then, I began glazing and stamping alternately. I sprayed water into the dark area behind the roses and lifted with a Kleenex tissue. I painted the roses with thick paint, left them to dry, and then lifted. Try something a bit abstract with this technique. Go back and forth between lifting, stamping and glazing, always allowing the drying time in between.

ROSES FOR LIZA
Betsy Dillard Stroud ✣ 29" × 21" (74cm × 53cm) ✣
Watercolor and gouache on 140-lb. (300gsm)
hot-pressed paper ✣ Collection of the artist

DEMONSTRATION
ink and tempera resist with watercolor

Watercolor and ink are natural partners. You can combine the two mediums in many ways too, and this technique is one of the more improvisational methods. There are four basic stages to this exercise. First you do the underpainting and the drawing. Second you do a coating of tempera where you want the underpainting to show. Third you coat the whole surface with black waterproof India ink. In the fourth stage you shoot the surface with a hose after it has dried overnight. Pretty wild, huh? It is fun, so try it!

materials list

SURFACE
140-lb. (300gsm) cold-pressed paper

PAINTS
Watercolor ◆ Verzino Violet ◆ Ivory Black ◆ Orange Lake ◆ Permanent Red Deep ◆ Indian Yellow

BRUSH
2-inch (51mm) or 3-inch (76mm) flat

OTHER
Black waterproof India ink ◆ White liquid tempera paint ◆ Sponge applicator for applying ink ◆ Frozen dinner container ◆ Drafting or artist's tape

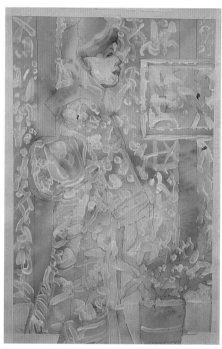

1: CREATE THE STRUCTURE FOR THE TEMPERA

Do an underpainting using intense mixtures of Verzino Violet, Orange Lake, Permanent Red Deep and Indian Yellow, and let dry. You want the paint to be intense but still transparent so that it won't wash completely off in the final stage of this technique. Keep your edges soft by wetting the paper first and then floating in the colors. Spatter here and there for a little added interest. Let this dry, and then draw your figure on the paper. Establish a mat by taping over the painted underpainting around the sides and the top, leaving an opening at the bottom. I like to leave an opening as a visual tool so that the eye can go in and out of the painting.

2: BLOCK OUT THE LIGHTS

As the underpainting in your painting will be created from lights, you have to think backward. Paint out these lights with white liquid tempera. Make sure the tempera is thick enough to cover, although using a more watery tempera in places can give you an interesting texture. As with all these stages, each stage should be completely dry before continuing. It is best to let the ink stage dry overnight.

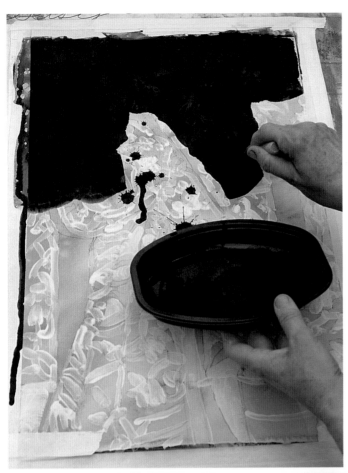

3: BLOCK OUT WITH INDIA INK

Make sure the tempera layer is completely dry before starting this step. Into a frozen dinner container, pour out enough India ink to coat your surface. If you have a small bottle of ink, you will probably need the whole thing. Use a sponge applicator to cover the entire surface with ink, painting right over the tempera. Let this dry overnight.

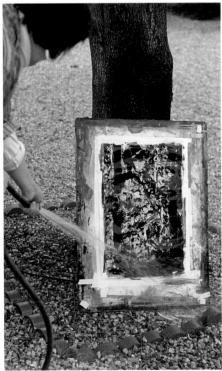

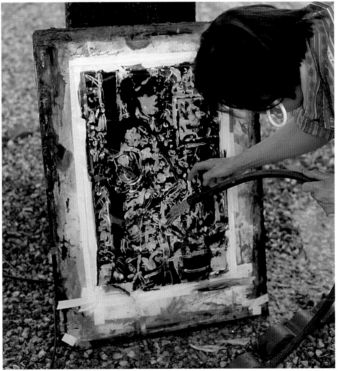

4: HOSE IT DOWN

Once the ink has dried, get out your hose and spray your painting. You really have to blast the ink to get it all off, so go for it!

5: SCRAPE IT OFF

You might have to use your fingernail to scrape a bit as you wash the surface with a hose; sometimes the tempera is thick and hard to come off. However, leaving a little tempera can be beautiful.

5: ADD FINAL TOUCHES

Glaze down the area next to the figure with a wash of Ivory Black, and do the same to the rectangle running down the right side of the painting. Some of the tempera stuck, so I left it on. If I wanted to tint more of the finished painting, I could, but I elected to leave it as is. This finished process looks much like a woodcut, don't you think?

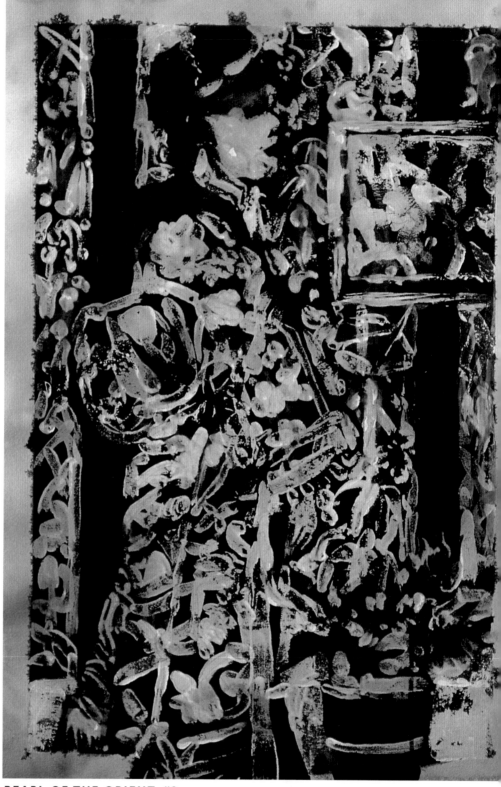

PEARL OF THE ORIENT, #2
Betsy Dillard Stroud ÷ 22" × 15" (56cm × 38cm) ÷ Ink, tempera and watercolor on 140-lb. (300gsm) cold-pressed paper ÷ Collection of the artist

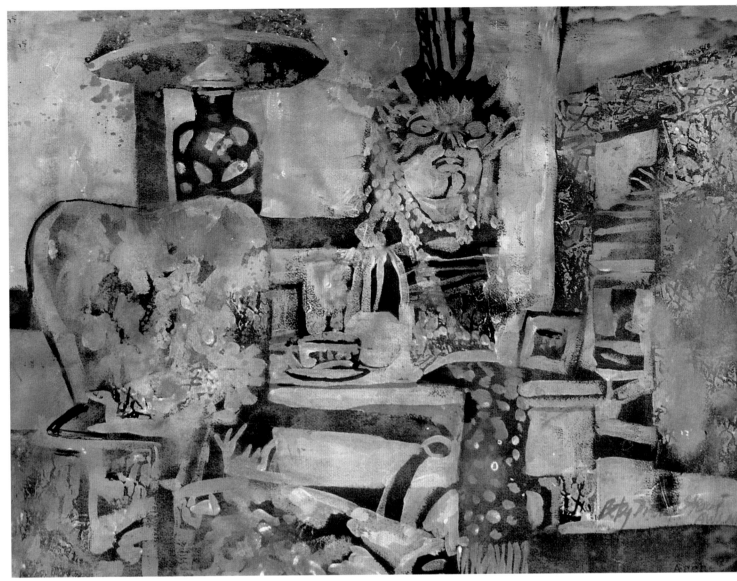

Adding Excitement to a Common Scene

Interiors is a more complicated subject than the demo painting—a section of my living room. I used almost a half bottle of tempera with this painting. Some of the original underpainting washed off, so I intensified the color after I washed off the tempera.

INTERIORS
Betsy Dillard Stroud ÷ 22" × 30" (56cm × 76cm) ÷ Ink, tempera and watercolor on 140-lb. (300gsm) cold-pressed paper ÷ Collection of the artist

DEMONSTRATION
matte medium lift-out over a watercolor underpainting

For a wild aesthetic ride, try this method of lifting. Do a light midtone underpainting of watercolor. Coat the underpainting with a mixture of ⅓ matte medium to ½ water. After it dries, you can lift out back to the original underpainting. The matte medium gives you a surface that makes the watercolor do unexpected things. It is hard to control and has an unusual texture that makes an excellent experimental surface.

materials list

SURFACE
140-lb. (300gsm) cold-pressed paper

PAINT
Watercolor ✦ Cobalt Blue Deep ✦ Permanent Red Deep ✦ Indian Yellow ✦ Cadmium Red Light ✦ Raw Sienna ✦ Sap Green ✦ Blue Violet ✦ Verzino Violet ✦ Cupric Green ✦ Shell Pink ✦ Lavender ✦ Naples Yellow Reddish ✦ Golden Lake ✦ Dragon's Blood ✦ Indigo

BRUSH
2-inch (51mm) or 3-inch (76mm) flat or sponge applicator ✦ no. 8, no. 14 round

OTHER
Fluid matte medium ✦ Drafting or artist's tape ✦ Kleenex tissue

1: CREATE THE UNDERPAINTING AND SEAL THE SURFACE

Using light values of paint and your 2-inch (51mm) flat brush, create an Indian Yellow, Permanent Red Deep and Cobalt Blue Deep underpainting and let it dry. You are laying down what will ultimately be your lightest light.

Once the underpainting is dry, do a contour drawing of a girl sitting at a table. Then use a big brush to paint a mixed layer of ⅓ matte medium to ½ water over the surface and let it dry. Make sure you cover the entire surface.

If you're unsure of your drawing, you may want to wait to complete your drawing until after you've coated the surface with matte medium and allowed it to dry. The matte medium seals the surface and won't allow you to erase.

2: START PAINTING THE SUBJECT

Mix up a flesh color. Flesh can be all colors. For Caucasian skin, a mixture of Raw Sienna and Cadmium Red Light is perfect. You can paint the shadows with the same mixture and a bit of Cobalt Deep Blue or Cupric Green dropped in. Paint your flesh color over the appropriate areas and let it dry.

3: ADD DARKS

Establish a basic midtone color for the hair with a mixture of Raw Sienna and Dragon's Blood. It's important to paint the darkest value as you will lift your lights out. Paint the dress with washes of Blue Violet and green, dropping in a little Verzino Violet as you paint.

4: COVER THE COMPOSITION

It's important to paint most of the surface, although you can leave some of the original underpainting showing as I did under the flowers. You can always cover this later. For now, leave some light to remind you what the lightest light can be.

Use mixtures of Shell Pink, Naples Yellow Reddish, Blue Violet, Verzino Violet, Sap Green and Golden Lake to paint the flowers and the background on the left. Paint the vase a flat color of Cobalt Blue Deep and the drapery a mixture of Indigo, violets and greens, like the dress. Add reds and violets to the drapery on the right. Mix up Dragon's Blood and Verzino Violet and paint the pillow and the seat of the chair. Paint the flowers below as you did the flowers in the upper left. You will lift out the container for the bottom flowers. Paint the chair with Shell Pink and Naples Yellow Reddish. Remember, even if the subject you are painting is light, you still want to paint it. If it is a light object, use opaque pigments like Naples Yellow Reddish, Shell Pink and Lavender. They are great for lifting.

5: LET THERE BE LIGHT

Use a wet no. 8 or no. 14 round brush to begin to model the figure by brushing the areas where you want to lift out a light. Blot immediately with a clean, dry tissue. Make sure you change your tissue every time you blot. Lift out some lights in the vase in the same way.

Lift out a design in the seat of the chair by drawing with a thin line of water and then blotting. Tape a wallpaper pattern behind the figure and the flowers, placing the strips of tape about a tape's-width apart. Let this all dry.

6: FINISH WITH MORE DARKS AND LIGHTS

Darken the top of the dress with Verzino Violet and Blue Violet. After this dries, lift out a light pattern to suggest folds. Lift out a pattern in the bottom skirt by drawing shapes with water and blotting.

Lighten the face and the parts of the hand and the arm to give them more form.

Create more pattern in the chair and in the pillow by stamping and blotting. Lift out the chair's filigree design, then glaze it back with blue if it's too light.

Lift out more strands of her hair.

Add a little pattern in the far drapery.

Lift out the pot holding the bottom flowers.

Paint the area around the tape with water, and then blot to lift out the wallpaper pattern.

Define the flowers without much detail by lifting out a few lights to suggest light and shadow. Lift a few more lights in the vase.

After studying the painting for a few days, I realized the right arm was a little too long. Although I followed a photograph, the dichotomy between the arm and the dark pillow was too much of an eyesore. I scrubbed out the bottom of the pillow, made that shape ambiguous and solved the problem.

LADY OF LEISURE
Betsy Dillard Stroud ÷ 30" × 22" (76cm × 56cm) ÷ Watercolor and matte medium on 140-lb. (300gsm) cold-pressed paper ÷ Collection of the artist

DEMONSTRATION
the kitchen sink

Are you ready? This is where we let it all hang out and then throw it all in the painting. When you paint in an intuitive, spontaneous way, get ready to make split-second decisions. It's design as you paint, so how do we start this crazy demo? First of all, during the process of painting, listen to that inner voice—not the second voice that calls you a dingbat, but the first voice that says, "Put a little chartreuse over in that corner!" That voice is the creative voice—the one you can trust. The wilder the beginning, the more sensational the ending. So, let's get started.

materials list

SURFACE
140-lb. (300gsm) cold-pressed paper

PAINT
Tube Acrylic ✦ Luster Red ✦ Cool Gray ✦ Medium Magenta ✦ Carbon Black ✦ Cadmium Red Light ✦ Titanium White ✦ Napthol Crimson ✦ Cadmium Orange ✦ Cadmium Red Orange ✦ Quinacridone Magenta

BRUSHES
3-inch (76mm) flat ✦ no. 10 or no. 12 synthetic round

OTHER
Gel medium ✦ India ink ✦ Plexiglas (small piece) ✦ Several pieces of newspaper ✦ Linoleum stamp carved with an abstract design ✦ Sandwich paper ✦ Stencils of letters ✦ Spray bottle filled with watered-down liquid gesso (about ¼ gesso to ¾ water) ✦ Drafting or artist's tape ✦ Putty knife or spatula

1: SPLISH-SPLASH

Tear off some different sizes of artist's tape, and apply them at various places around the upper middle of your surface. Wet the paper in a small section in the upper middle, then take a stopper filled with India ink and drop it onto the wet paper. You can also use an old, small round brush (do not use your good brushes with ink), and spatter in some more ink. Let this dry.

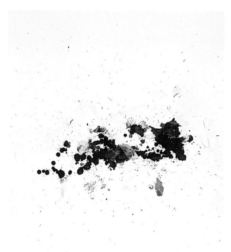

2: MAKE A MONOPRINT

A monoprint is a painting done on a surface such as Plexiglas that is then transferred to your paper. You can do this process in a variety of ways by using a printing press, a giant rolling pin or by simply applying the paper to the glass and rubbing your hand or a barren over it. We'll do the latter.

Squeeze out dabs of Cadmium Orange, Cadmium Red Orange, and Medium Magenta on the Plexiglas in an abstract pattern.

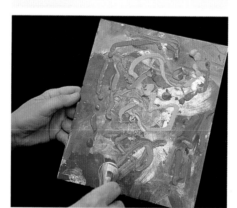

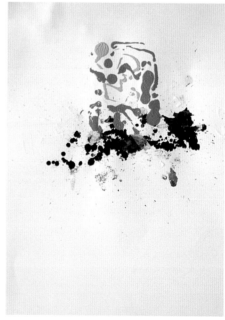

3: IMPRINT THE IMAGE
Quickly press the paint side of the Plexiglas to your paper, and just as quickly pull it off.

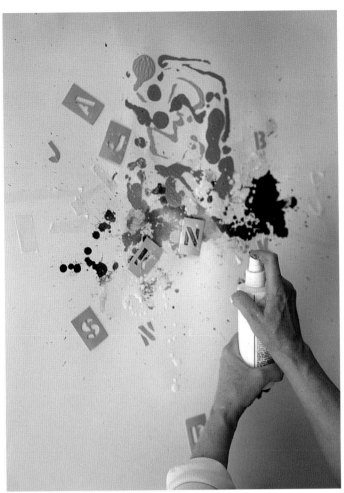

4: SPRAY WITH GESSO

Place some alphabet stencils at random around your paper. Notice that some stencils are popped out of their square container, and some are not. Dare I say the word again? Variety! Practice spraying your gesso/water mix before you spray it on your paper. Some of it will probably drip down, but that will add to the texture and the allure.

5: MODEL WITH GEL MEDIUM

With a putty knife or a spatula, apply some soft gel medium to your paper where you want texture—perhaps at the top and in the middle sections. Vary your strokes and flatly move the knife at angles to get an interesting texture. Play! Allow the medium to dry completely.

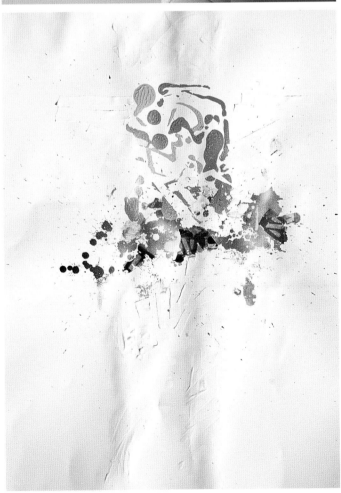

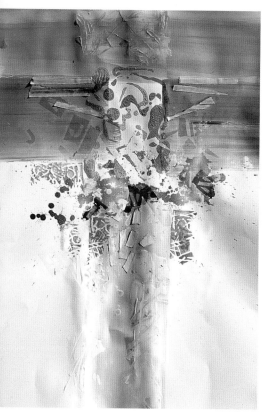
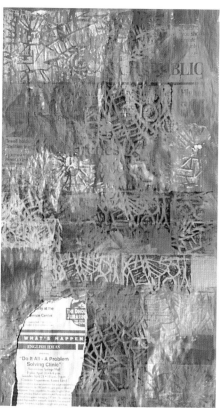
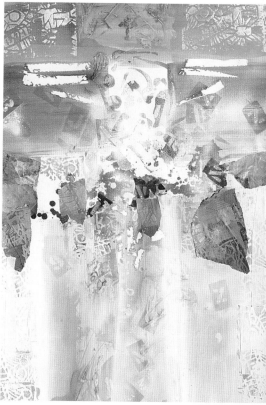

6: WATCH TEXTURE EMERGE

Tear some more pieces of tape and apply at random on your paper. With a wash of Napthol Crimson, paint in a wide band of color over your top texture. Then, mixing it with a transparent Carbon Black wash, extend that wash painting around your monoprint image. We are developing a center of interest here, and although this painting will be totally abstract, it is still good to have a focal point. Mix up some Luster Red with a little Carbon Black, and paint it down the middle. Lastly, paint your stamp with a mixture of red and Luster Red, and begin to stamp into the composition. Do not worry about the warping of the paper. We can straighten it out by painting gesso, matte medium or gel medium on the back of the paper. Notice the texture emerging as you paint over the surface. It is exciting—like watching a photograph develop.

7: CREATE COLLAGE PAPER

Don't toss out that old newspaper. It makes excellent collage material, and furthermore, once you coat it with acrylic, it becomes archival. I have a still life I painted on newsprint in 1956, and it is in perfect condition. Using the same pigments as in your monoprint, paint a page of newspaper. After it dries, stamp onto it with your carved linoleum using a little Luster Red mixed in with Carbon Black, some Cool Gray, and some Titanium White. I tore out a piece of the newspaper to show you that I folded it double before I painted it to give it more body. Let it dry.

8: ADD COLLAGE AND MORE TEXTURE

Tear some pieces out of your painted newspaper collage. With gel medium, adhere the torn pieces to the surface of your paper. Do some stamping on the sides of the composition with Luster Red, and take off the tape on the top. Stamp with some Titanium White on the top band. Adhere some painted sandwich-paper collage on the sides of your composition. With a thin veil of gesso—one part gesso to four parts water (it should be translucent)—paint over parts of the design, such as the monoprint to push it back a bit. Mix up thin washes of Carbon Black and red, and glaze some of the letters around the composition.

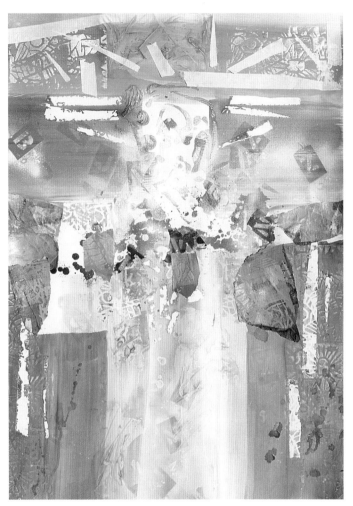

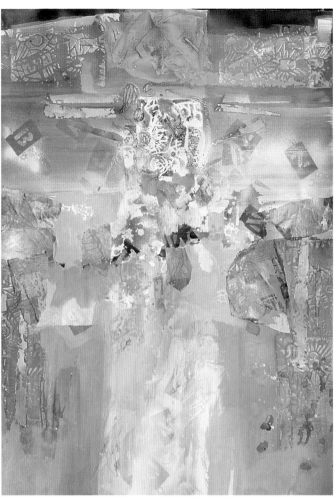

9: CREATE MULTIPLE LAYERS

Put down some more tape in places, as we will glaze the surface repeatedly. Every time you glaze, remember to leave just a bit of the previous surface showing. This creates mystery, as if we are looking through layers of meaning in your painting. It is a bit like revealing parts of yourself. Mixing up a thin wash of Carbon Black glaze, paint over the two sides of the composition. Leave a light in the middle.

10: ADD OPAQUE GRAYS FOR CONTRAST

Opaque gray painted around the composition will enhance the beauty of the other colors. Using Cool Gray, paint the left middle and the bottom right. Mix it with a little red for variation, and paint that concoction near the Cool Gray on the left and on the right. Take off the tape, and tint some of your tape shapes, making sure to vary the color a bit in hue or value. Paint a dark Carbon Black design around the top of your painting and let it dry.

11: ADD FINAL TOUCHES

Paint a glaze of Quinacridone Magenta over the top red. Add more Cool Gray over the vibrant red. Paint your stamp with a mixture of Luster Red, orange and a little Carbon Black, and stamp it over the muted section where the monoprint is.

Cat Soup seemed an appropriate title for this piece, as it is the name of a sludge that my sister Caroline and my cousin Bill and I used to make as children. To make cat soup we'd get a huge pot into which we'd throw everything in the kitchen that was already open (except the sink)—baking soda, ketchup, flour, worcestershire sauce, etc. Then, we'd cook it, letting it boil over. It was revolting, and with great glee, we called it cat soup. Unlike my original concoction of cat soup, I want this painting to be beautiful, well designed and exciting.

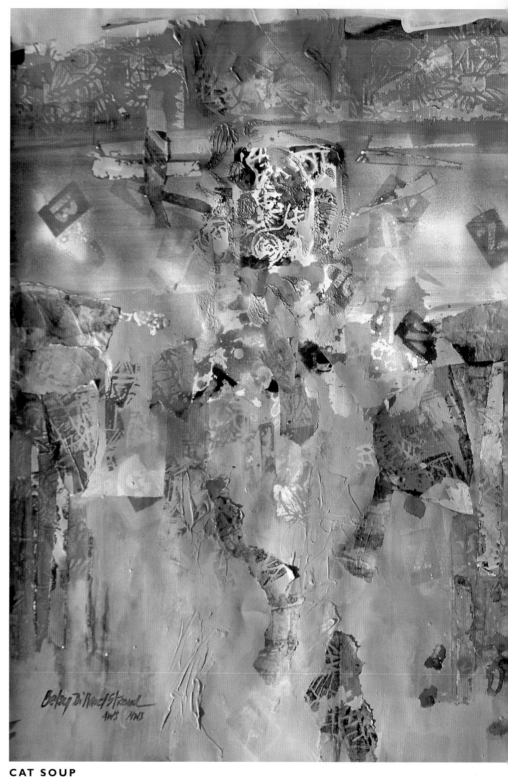

CAT SOUP
Betsy Dillard Stroud ÷ 30" × 22" (76cm × 56cm) ÷ Acrylic on 140-lb. (300gsm) cold-pressed paper ÷ Collection of the artist

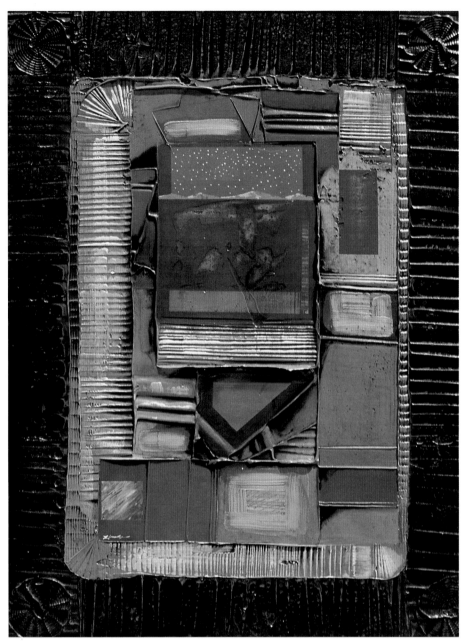

A Wild Mix of Materials

Wild man Matt W. Lisenby's paintings are not only technical masterpieces, he literally sets them on fire after he paints them—just for the effect!

Using a mixture of plumber's putty and caulk, Lisenby slathers the thick mixture onto a primed canvas with a trowel and manipulates it on the surface till he has the texture and abstract pattern he desires. He must complete this layer within fifteen minutes or the putty-caulk mixture dries and becomes hard as a rock. After this layer dries, Lisenby paints the canvas.

In this particular painting, he wanted to exorcise blue from his palette, so he made it a "blue" painting, using all the blues in his paint box. After the acrylic dried, Lisenby poured denatured alcohol over select portions of the painting and struck a match. Boom! Great texture resulted, resembling tiny craters made by meteorites.

BLUE
Matt W. Lisenby ⸭ 50" × 36" (127cm × 91cm) ⸭ Acrylic on canvas ⸭ Collection of Dr. Prue Gerry

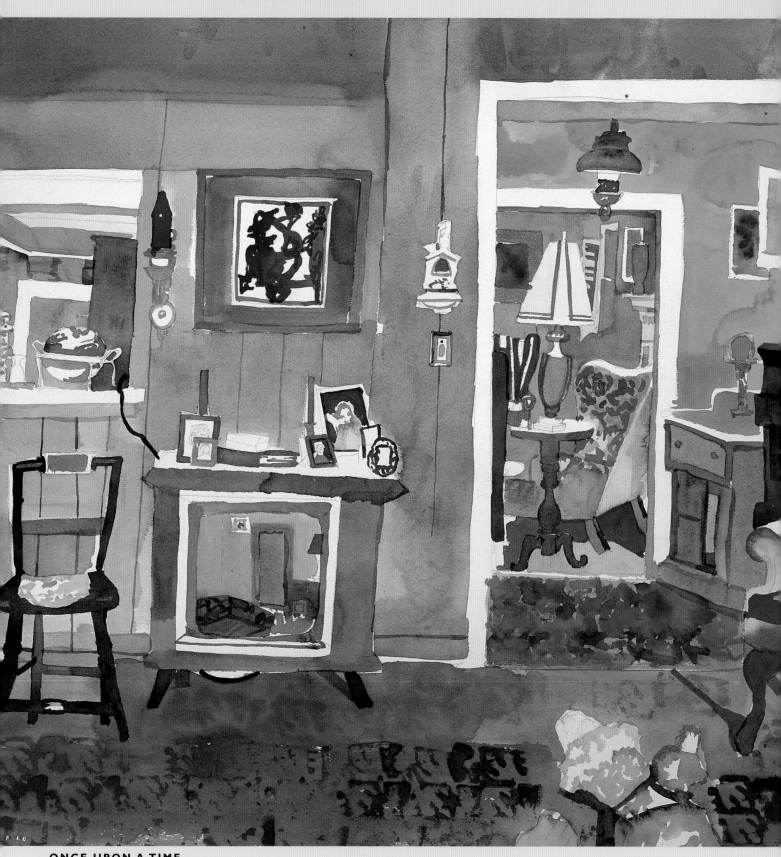

ONCE UPON A TIME
Betsy Dillard Stroud ÷ 22" × 30" (56cm × 76cm) ÷ Watercolor on 140-lb. (300gsm) cold-pressed paper ÷ Collection of the artist

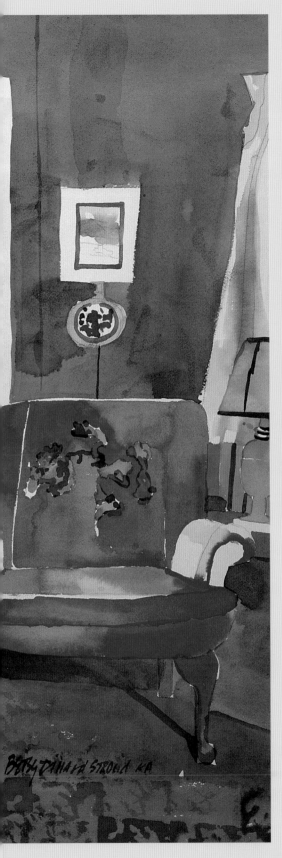

"A room full of pictures is a room full of thoughts."

—Sir Joshua Reynolds
(1723–1792)

creative content

If style is the way you talk with paint, what is it you have to say? Most artists realize that creating good art requires more than technical ability. Good art transcends good technique. Good art has content. If technical ability provides you with the tools to make your painting, content gives you the foundation from which you start.

How do you get content in your work? The answer is amazingly simple: Paint what you love, what you know and what you feel. When you learn to do this in your own expressive way, you will have content in your work.

"Oh well," you might say. "I just want to paint landscapes." Really? What do you want to paint about landscapes? Is it to record light? Is it to preserve a historical spot for posterity? Is it to express some ecological concern?

Even if you are a fledgling, it is important to think about why you want to paint. The most profound and provocative insights we bring to our work come from within. They come from our deepest desires, obsessions and beliefs translated and transformed into a creative statement, from our own personal response to our inner and outer worlds. In this chapter, we will explore ten different ways to help you find content in your art. Take the challenge. Try one, more or all of these ways, and enjoy the journey.

Try a New Approach

Instead of thinking in terms of perspective and three-dimensionality, I approached this subject using flat patterned two-dimensionality (see page 128). I did this painting sitting in my mother's den, looking through the various doors that went through her kitchen and into her living room. I depicted the scene whimsically, suggesting mood and ambience with interpretive color and flat design. Even my dog, Scalawag, is in the painting, seen as a flat pattern against the rug.

Paint a creative self-portrait

Each of us has a wealth of information inside us, just waiting to be expressed in our own individual way. At sixteen, I was sent to boarding school. We girls were geniuses at making up games to keep away our terrible homesickness. One of the games we played generated ideas I now use in my workshops.

Stop reading now, and get your sketchbook and pen. I'm going to ask you a question, and it is very important that you write down the first three answers that occur to you. This will help you ferret out some of your individual expression. Are you ready?

Who are you?

Don't dally. Answer it fast and with the first three things that come to mind. At sixteen, I answered, "An artist, a girl and a child of God."

After you have written your three answers, you are ready for the second part of the game, which is to come up with three symbols that stand for each of our responses. (For example, if you're a teacher, you could use an apple to symbolize that fact.)

Now, the third part of the game: perhaps the most challenging aspect is to put these three symbols in a painting. Moreover, try thinking of a color scheme that might signify what you are trying to depict.

Gail's answer to this question was: Wife, which is symbolized by her ring; Mother, symbolized by the faces in the background; and Artist, symbolized by the brush and board. In addition to her symbols, Gail used color symbolically—red, orange and purple for "Red Hot Mama."

MY LIFE (STUDENT WORK)
Gail Wilkinson ÷ 30" × 22" (76cm × 56cm) ÷ Watercolor and collage on 140-lb. (300gsm) cold-pressed paper ÷ Collection of the artist

Paint from memory

We are walking encyclopedias of memories, for everything we see, hear, taste and feel stays in the subconscious. Everything. When you allow yourself to paint from memory, a world of sight, sense and feeling comes forth.

Sometimes when we paint on location or paint from the figure or still life, it is daunting to try to record everything we see. As Hans Hoffmann said, "The ability to simplify means to eliminate the unnecessary so the necessary can speak." Painting from memory frees you to explore the expressive uses of color, design and feeling that come from within.

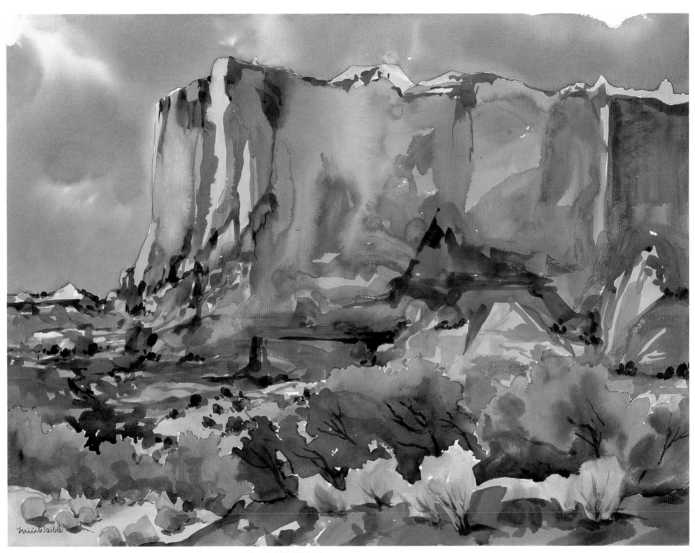

In this charming landscape of a giant canyon seen from the Tumurru Ranch in Utah, Weible's depiction shows how emotional, passionate and expressive a memory can be. Notice the simplistic presentation. When you paint from memory, details are forgotten and you get at essences.

EL CAPITAN
Miri Weible ÷ 22" × 30" (56cm × 76cm) ÷ Watercolor on 140-lb. (300gsm) cold-pressed paper ÷ Private collection

Try a new approach

With this exercise, select a subject and paint it using a different perspective, a different medium, a different technique or a different format. In other words, approach your subject in a way you've never tried before. When you try a new approach, the emphasis is on changing your way of looking at and rendering your subject. Many a time when I've been stuck in a rut, some wise artist-friend has said, "Switch mediums! That'll get you going!" Or, "Think about putting your subject in some environment you'd never expect to see it in," an exercise that artist Virginia Cobb used to have her students do in workshops.

Ender uses a geometric format and a patterned design to portray her love of flowers. Her innovative approach gives us an unusual and exciting spatial solution to an everyday ordinary subject, and it makes us see flowers in a new way.

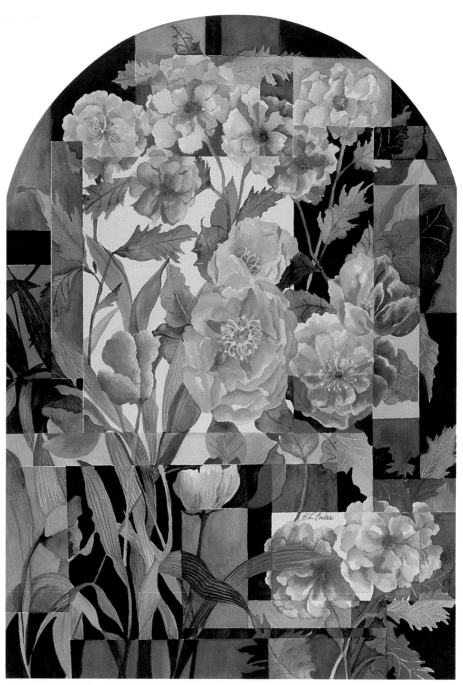

WINDOW TO MY GARDEN (STUDENT WORK)
Bonnie L. Ender ÷ 29" × 20" (74cm × 56cm) ÷ Watercolor on 300-lb. (640gsm) cold-pressed paper ÷
Collection of the artist

Work in a series

Exploring one idea sets in motion a great creative journey. Start with one of your favorite subjects, and see how many different ways you can depict it. Perhaps you'll explore it with different color expressions or perhaps different formats or perhaps different media. You may find yourself going off in a completely different track.

The late great Millard Sheets once told me to plan twenty paintings that would show "who I am." Then, as I progressed doing the paintings, not to be surprised if I changed course or if my idea changed as I went along. Most importantly, he told me to allow my ideas to change without fighting that change.

With the board flat, I poured on pigments in Indigo, Brown Madder, New Gamboge and Winsor Red. I separated, stirred and dissolved each pigment before the pour. The second of my signature postcard series, this painting won the High Winds Medal in the 1992 American Watercolor Society Exhibition in New York, and I consider it to be one of my most successful with respect to color, design and impact. After the pour, I developed the composition. Finishing touches of spatter gave an extra spatial dimension to this painting. Working in a series allows the artist to explore an idea to its limits. Often, each painting in a series will present a different problem, and that is the challenge.

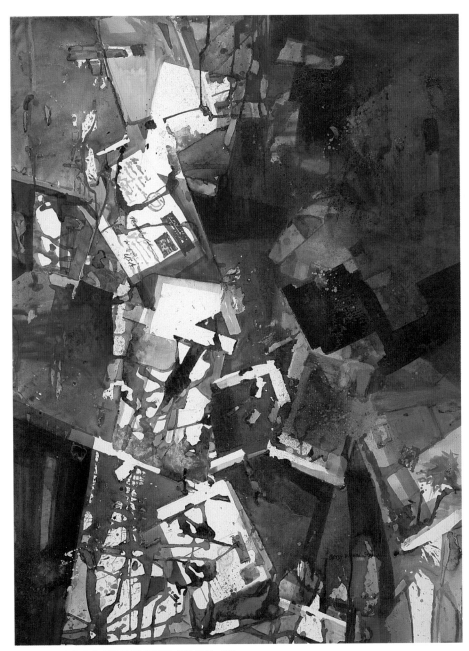

POSTCARDS FROM THE EDGE, #2
Betsy Dillard Stroud ÷ 40" × 30" (102cm × 76cm) ÷ Watercolor on cold-pressed watercolor board ÷
AWS High Winds Medal Winner 1992 ÷ Collection of the artist

Paint a personal shield

This exercise was suggested from an idea in *Personal Mythology* by David Feinstein (Jeremy P. Tarcher, Inc., Los Angeles, CA, 1988). Think back on times in your life when you were the happiest—perhaps a childhood memory. Invent a symbol for that memory. Next, think of a time when you were terrifically challenged—perhaps your first bitter experience. Make up a symbol for that. Next, think of a symbol that would heal that bad experience—perhaps combining it with the symbol of happiness you created. Then, think of your strengths and make up symbols for those. Lastly, what are your aspirations for the future? Perhaps there are artistic ones combined with personal ones. Make up symbols for those. On a big piece of watercolor paper, draw a big circle. Divide the circle into five segments to represent these questions. Draw in your symbols with paint, and decorate your medicine wheel.

Painting a personal shield can help you define areas of your life. In Schutzky's representation, in the center of the wheel, there is a flower blossom that is "a symbol of my entire life," she says. "It is a connecting line to the women in my family. The ritual of checking the garden as it broke ground, grew and blossomed, was shared with my grandmother, my mother and my daughter." Doing some of the creative exercises mentioned in this chapter helped Schutzky "embark on new discoveries in painting I never would have supposed."

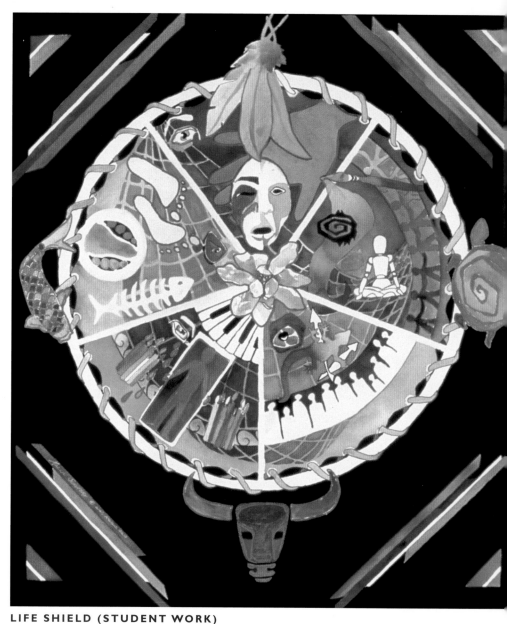

LIFE SHIELD (STUDENT WORK)
Marilyn Schutzky ✦ 32" × 30" (81cm × 76cm) ✦ Watercolor, acrylic and gouache on 300-lb. (640gsm) paper ✦ Collection of the artist

Paint from dreams

Combine images you remember from your dreams in symbolic color expressions and explore those memories. Think of the great surrealist Salvador Dali, whose haunting images conjure up mysterious marriages of dissimilar objects in obscure and ambiguous surroundings. Many artists rely on and have relied on the power of the subconscious to influence their paintings.

This painting derives from a dream I mentioned in chapter three about an icon that appeared to me (see page 32). As it spoke in "dream talk," it hung about in the air in front of my face, and on its bottom a long sable brush was attached in a leather sling. Although I couldn't understand what it was saying, its image haunted me. It took me a couple of years to come up with the idea of carving that image. From that dream my series *Pieces of a Dream* was born. The carvings in the painting represent the secret language of dreams. I have done at least fifty of these, and it is an ongoing series. Carved dream images stamped into color fields and a multitude of layers symbolize the mystery, language and ambiguity of the dream world.

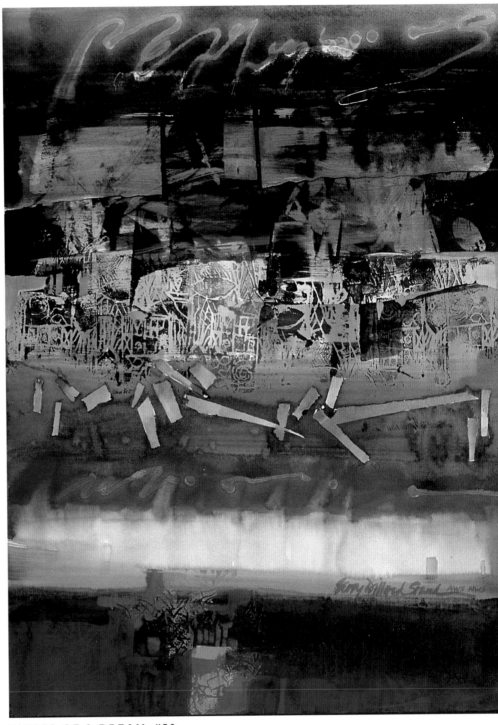

PIECES OF A DREAM, #59
Betsy Dillard Stroud ⚬ 30" × 22" (76cm × 56cm) ⚬ Acrylic on Strathmore Aquarius II ⚬
Collection of the artist

Invent personal symbols

As artists we are all symbol makers, substituting our interpretive images for the real thing. We can't put an actual tree in our painting, for example, but we can make up a symbol for that tree.

All the symbols in this painting refer to things about Hughes's life. The feather refers to a faux finish tool that she uses for faux marbling in her work. The Egyptian prescription symbol Eye of Horus is in the top left-hand corner, and the feathers and fern leaves point to the medicine wheel of well-being in the upper right-hand corner.

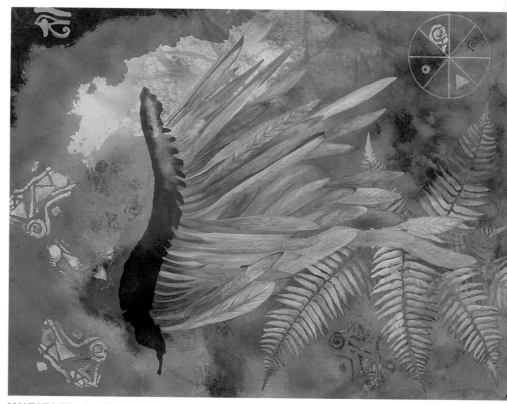

UNTITLED (STUDENT WORK)
Margaret Hughes ÷ 22" × 30" (56cm × 76cm) ÷ Acrylic on 140-lb. (300gsm) cold-pressed paper ÷ Collection of the artist

YOUR PERSONAL TASTES

Reflecting your personal tastes and inventing your personal symbols to use in your painting will empower you both as an individual and as an artist. Soon, you will have a unique vocabulary of symbols. Expressing your individual mythology will help you create an artistic language all your own. Once you have found your voice, all you have to do is sing with it!

Use ideas from books

Any book that inspires you can become a subject for a painting. You might want to depict a character from a book or a vividly described scene. Think of John Singer Sargent's magnificent portrait of Lady Macbeth in the National Portrait Gallery in Washington, DC. With my postcard series, I took the title from Carrie Fisher's book *Postcards From the Edge*. Pouring and creating spontaneously from my deepest feelings and using postcards and other cards expressing my ideas and thoughts definitely evoked aspects of Fisher's title.

For my workshops I like to use the book *Signs of Life: The Five Universal Shapes and How to Use Them* by Angeles Arrien (Arcus Press, 1994). Arrien talks of the five universal shapes—the square, the equidistant cross, the spiral, the triangle and the circle—and how they appear in every culture and art in the world. Moreover, she explains that phenomenally, they seem to mean the same for all cultures. For example, the circle is a universal symbol for wholeness and unity, and the spiral is a symbol for growth and change. According to Arrien, when you list your preferences for these shapes numerically—from one to five, with one being your favorite—you are really showing where you are in your life.

My students do this exercise by selecting their preferences, carving a soft linoleum block with their shapes designed in it and creating a painting using these shapes and stamps. For all, it appears to be a cathartic, inspiring and exhilarating exercise.

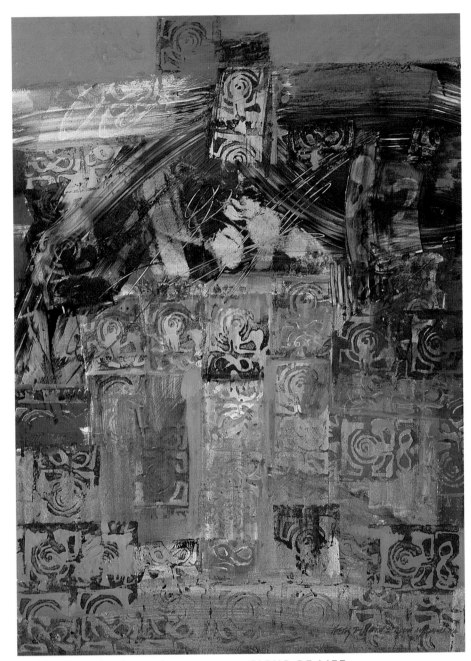

Doing the personal preference shape test outlined in the book, *Signs of Life: The Five Universal Shapes and How to Use Them*, I carved a linoleum stamp based on this exercise. I applied layers of acrylic paint transparently, which made a delightful contrast with the stamped layers. I began alternating stamping and painting opaquely in a playful way until the composition began to talk to me. I combined other acrylic techniques such as lifting out and dragging combs through the wet paint.

SIGNS OF LIFE
Betsy Dillard Stroud ✢ 40" × 30" (102cm × 76cm) ✢ Acrylic on 140-lb. (300gsm) hot-pressed paper ✢ Collection of the artist

Paint from your writing

When you paint from your own writing, you have enough aesthetic fodder to last a lifetime. Pick a subject. It could be flowers or politics, anger or laughter, pain or joy. Set a timer and write for ten minutes about this subject. You might start with this: "When I think about _____, I _____." Let your ideas flow freely. Don't limit yourself. Write anything and everything that comes into your mind. Rely on your sensory information and memories of the subject you address to lead you along.

At the end of ten minutes, stop and read what you have written. Look at your terminology. What nouns did you use? What textures? What colors did you conjure? What sensory explanations are in your text? Use a highlighter or magic marker, and lighten all the interesting phrases in your writing. Do a painting based on this exercise.

The writing assignment for Hazel Stone was to write about her name. After the exercise, Stone decided to do a painting about her name. First she drew her name in block letters, folded the sheet together and cut around the shapes. When she opened the cut paper, she had an abstract design based on her name. She transferred the design to her watercolor paper. Using colors that suggest the word "Hazel," she began to paint. The rocklike structure created by cutting the shapes out abstractly symbolized her last name, which connotes stability, durability, reliability and immortality. An ancillary meaning for "Stone" is a *marker for a sacred space*. All these meanings find expression in this exciting painting.

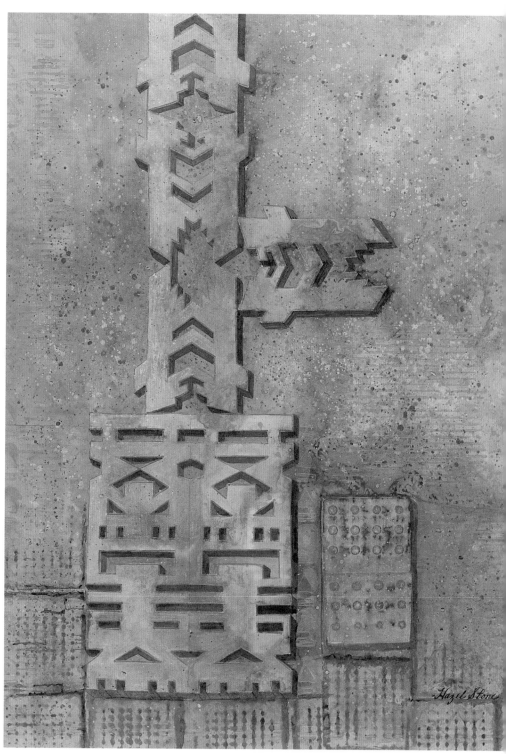

NOMENCLATURE (STUDENT WORK)
(from her sculptural series) ✧ Hazel Stone ✧ 30" × 22" (76cm × 56cm) ✧ Watercolor, acrylic and ink on Strathmore Aquarius II ✧ Collection the artist

Paint from a "what-if" list

Many of my paintings originated from the question, "What if?" For example, what if you painted something you never painted before with your left hand? This actually happened to me once when I injured my right hand, had to teach a workshop, and decided to paint with my left. I did an intriguing abstraction that looked Japanese. When it was finished I called it *Geisha Girl.*

What if you painted inharmonious colors and then glazed them with a "mother color" to pull them all together? What if you painted something you always wanted to paint but were afraid to try? That's just an example of a what-if list. Make your own. There's an unlimited supply of aesthetic raw material here.

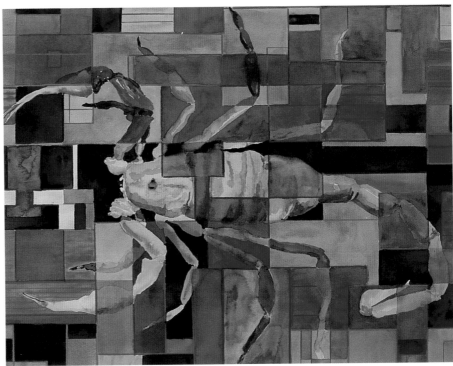

Baird drew a grid pattern and treated his scorpion design geometrically as a picture puzzle by thinking "What if I presented this subject in a geometric way?" He painted each square or rectangle a bit differently than the next (for contrast) and portrayed the scorpion in brighter and warmer pigments than the background for emphasis in this delightful and whimsical depiction.

SCORPION (STUDENT WORK)
Norbert Baird ÷ 22" × 30" (56cm × 76cm) ÷ Watercolor on 140-lb. (300gsm) cold-pressed paper ÷ Collection of the artist

A few words about abstract art

What do you think of when you hear the term "abstract art"? Perhaps you've walked into a museum and on the wall is a construction of masking tape spattered with paint. You walk closer to look at the title, hoping for a hint as to its meaning. The title reads "The Mystical Rondo of a Midlife American." It's enough to send you out screaming into the street, isn't it? One of the most important parts of being an artist is to educate yourself so that you yourself can decide what is and what isn't good art. This is especially true of abstract art. On page 139 you'll find a list of books that will explain abstract art in much greater depth than I can here. The more you delve into areas you don't understand, the richer your art will become.

Types of abstraction found in this book

Basically, the paintings in this book represent two types of abstraction: Nonobjective or subjective art and stylized abstraction (my term). Nonobjective or subjective art has no recognizable subject matter (although it may have some reference to reality). Stylized abstraction is art that is fractured, attenuated or purposely distorted in some way for emotional, intellectual, spiritual or aesthetic reasons. *Cosmic Cowgirl* (page 9), with its distinct reference to visual reality, is stylized abstraction. On the other hand, subjective art originates from intrinsic, intangible ideas that sometimes cannot be articulated through recognizable symbols. My series *Imago Ignota* (see page 17) is an example of that type of abstraction. In a sense, all art derives from some sort of abstraction. But how did the abstract art we know today develop? Why? To understand those questions, let's take a brief look at the yesterday.

A brief history

After the invention of photography in the nineteenth century, painters, freed from traditional moorings, turned to new sources for their subject matter. The dogmatic demands of the Church were an ancient echo in a faraway wind, and the propagandistic art of the eighteenth century was all but forgotten. Artists embraced a new, composite world, essentially a world of feeling. In

Experimentation and Process

Phillips's abstractions grow out of experimentation and process. His canvases combine texture and mood with an energetic dialogue between transparent and opaque passages. For texture Phillips often coats his canvas with both coarse and extra-coarse pumice gel to which he adds soft gel. Using a trowel or a variety of palette knives, Phillips applies the pumice in abstract patterns of various thickness onto the canvas. His earliest washes of fluid acrylics are improvisational rides of flowing color and are totally transparent. As he layers, he gradually switches from fluid acrylics to heavy-body acrylics, from transparents to opaques. He applies color accents with heavy gel added to pigment for a thickened matte look. Once he is pleased with his color patterns, he begins the reduction process, a salient characteristic of his work where, like a sculptor, he cuts away unwanted colors and shapes with gesso. Phillips's paintings are masterful examples of lost and found edges combining with ambiguous shapes, that inhabit an ethereal space of color and intrigue.

"When I paint it's an editing process in which I work back and forth between color and gesso, until the image I desire emerges."

—Dick Phillips

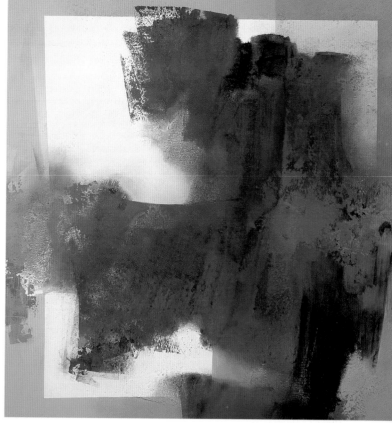

NAVAJO
Dick Phillips ✛ 54" × 50" (137cm × 127cm) ✛ Acrylic and pumice gel on canvas ✛ Private collection

Thoughts Revealed

Here Sampson exemplifies the use of process to reveal her innate thoughts and feelings about the landscape. She started with an old watercolor painting and began building form, layering with oil pastels on top of the watercolor. Soon, images emerged that reminded her of the forest. She employed "sgraffito" (scraping through the paint back to the original surface or through several layers). Her surface became a tactile landscape of multileveled forms, contrasting the impasto of the pastel with the transparent pieces of the original watercolor weaving throughout her composition.

this world they explored everything from impressions, music and sounds to dreams and psychoses. Out of these explorations, a new subject matter evolved, a subject matter with its own unique vocabulary and visual icons—a subject matter whose symbols bore little reference to the world of fact.

The Impressionists taught us to look at light and color in a new way, and Cézanne and Picasso gave us a new concept of space. In the twentieth century, a group of New York painters exploited the importance of the individual gesture in painting. Their aesthetic approach, labeled Abstract Expressionism, changed the course of modern painting forever.

Capturing essence

To the abstract painter, capturing the essence of something is very much akin to the idea of poetry. Jean R. Sampson, poet and painter, advises us that because abstract art is a lot like poetry, you should not necessarily try to get any meaning out of it. "Do not turn that part of your brain on," she says. "Listen to the painting as if you were listening to music. Let the rhythms carry you wherever they will."

Sampson adds, "Abstract art is a hatching place, a place where dissimilar things mate." How then does the bewildered viewer enter this hatching place? I have three suggestions.

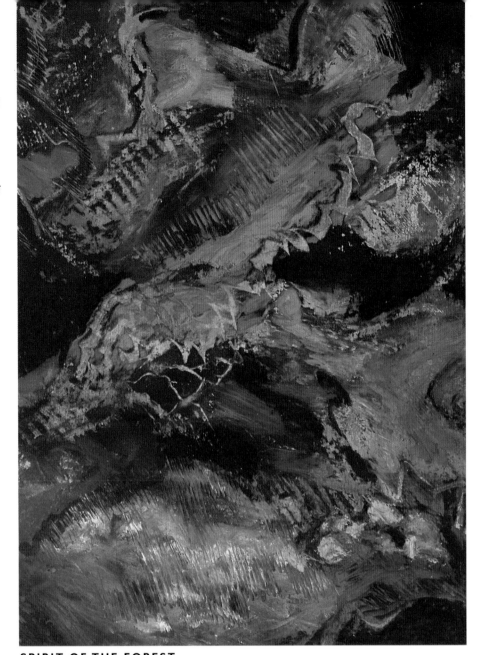

SPIRIT OF THE FOREST
Jean R. Sampson ✦ 7" × 5" (25cm × 13cm) ✦ Watercolor and oil pastel on 300-lb. (640gsm) watercolor paper ✦ Collection of the artist

First, we must listen with our eyes and our heart. Second, we must learn a new visual vocabulary. Third, we must change our frame of reference. In order to change our frame of reference, we must leave the comfort zone of the familiar to reside in the ambiguous, beguiling terrain of the subconscious, a landscape perceived through the intuition and the subjective mind.

My insightful uncle/stepfather prompted my own artistic journey. Herbert Nash Dillard was a well known

"The dance between the existing object and what it calls forth from my imagination results in a visual expression of the struggle of new life forms, which emerge writhing into a new recreated world."

—Jean R. Sampson

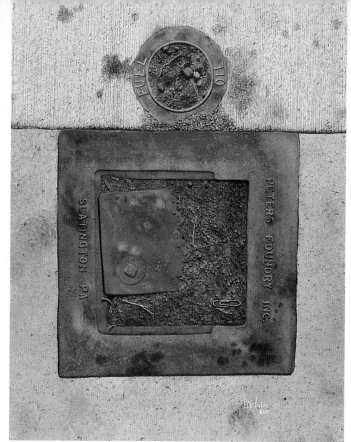

Photo-Realism Can Look Abstract

Lynn McLain's painting looks abstract, but it is a photo-realistic painting of a manhole cover. McLain started abstractly with thin, transparent washes comprising the underpainting. Step by step he brought his subject to a very realistic finish, so real that it looks as if you can feel the rust on the manhole cover. Yet, his depiction of that cover is so different from the way we usually view manhole covers that his realism takes on an abstract quality.

ROAD CHATTER, #16
Lynn McLain ÷ 39" × 31" (99cm × 69cm) ÷ Watercolor on 300-lb. (640gsm) cold-pressed paper ÷ The Mario Cooper and Dale Meyers Award from the American Watercolor Society for 2000 ÷ Private collection

Unusual Subjects Can Look Abstract

At first glance, *Requiem for an Old Warrior* looks totally nonobjective—an abstract painting. The subject, however, is the battleship Arizona lying in its shallow ocean grave in Pearl Harbor. It's paradoxical, isn't it? Something very realistic—I did it from photographs I made on the spot—can look abstract. I did this painting on a black gesso underpainting, and very carefully, I used layers of paint to bring it to life. Finally, I added opaques and some metallics at the very end to suggest texture and light.

REQUIEM FOR AN OLD WARRIOR
Betsy Dillard Stroud ÷ 30" × 20" (76cm × 51cm) ÷ Acrylic on illustration board ÷ Collection of the artist

and beloved professor of English at the Virginia Military Institute. For thirty years he took cadets to Europe for their "Walkabout," opening their eyes to art and their ears to Shakespeare. On one of these exotic tours, he and his beloved cadets were at a famous museum. They stood looking at a rather abstracted landscape painting when an over-dressed, somewhat haughty woman approached them. "Ha!" she said conde-scendingly. "I've never seen a landscape that looked like that before." Where-upon Herbert turned to look at her as

he said, "And, don't you wish, Madam, you could?"

Art as a reflection of society

Art is the ultimate zeitgeist, and as its most reliable historian, reflects all the facets and vagaries of society: its thoughts, ideologies, confusions and insanities. It is reasonable to assume, therefore, that in such a complicated world, art itself becomes more enigmatic and obfus-cated. Usually it is only in retrospect that its pronouncements, observations and introspections clarify things for us.

Art and ideas about art are in a constant flux. As artists and witnesses to emerging artistic phenomena, we must attempt to understand patterns and themes that may baffle us. Artists are visionaries, and it is our creative task to interpret and explain this com-plex world and sometimes to challenge it. Part of that creative task is to open ourselves to thoughts and ideas that initially may frighten us or cause us dis-comfort. And, as artists, the other part of that task is to look for landscapes we have never seen before.

FEMMES FATALES
Betsy Dillard Stroud ✧ 30" × 40" (76cm × 102cm) ✧ Watercolor on watercolor board ✧ Collection of the artist

bibliography

Betts, Edward. *Master Class in Watermedia*. Watson-Guptill Publications, New York, 1994.

Brooks, Leonard. *Painting and Understanding Abstract Art*. Van Nostrand Reinhold Co., New York. 1964.

Field, Joanna. *On Not Being Able to Paint*. Jeremy P. Tarcher/Perigree, New York, 1984.

Jenkins, Paul. *Anatomy of a Cloud*. Harry N. Abrams, New York, 1983.

Masterfield, Maxine. *Painting the Spirit of Nature*. Watson-Guptill Publications, New York, 1984.

Shahn, Ben. *The Shape of Content*. Harvard University Press, Cambridge, MA. 1957.

conclusion

Our journey together is not ended. To paraphrase T.S. Eliot in *The Four Quartets*: The beginning is often the end, the end—the beginning. We begin at the end.

As we express ourselves through the technical abilities we have mastered, let us not forget that true content always comes from deep within. Giving visual life to our feelings, thoughts and ideas about the world, both inner and outer, is the task before us. It means listening to our heart with an attentive ear, and it means being bold enough to express all the things we care most about. It means "Painting From the Inside Out."

Painting as Healing

As a tribute to my fiancé who was killed by a drunk driver, I carved Hopi symbols that relate to death and the afterlife and intertwined his initials among these symbols. An owl mask, given to me by a friend, served as a focal point. The reference is to a book entitled *When the Owl Calls Your Name*. I did the painting using my pouring technique, and as I poured and moved around the painting, I said good-bye to him. Later, I stamped into the composition with my carved symbolic block. Doing a series of paintings in Gene's memory helped me heal from this tragedy, a consummate example of "Painting From the Inside Out."

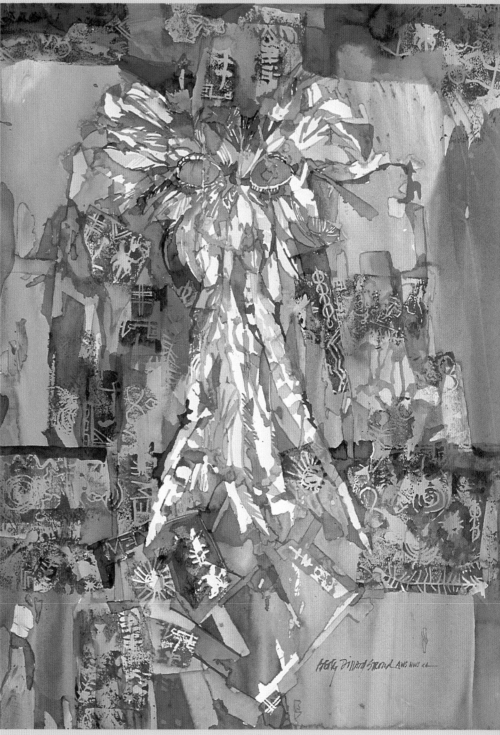

OWL DANCE: A GOOD-BYE
In Memory of Charles Eugene Worth (November 12, 1947–January 21, 1997) ✛ Betsy Dillard Stroud ✛ 30" × 22" (76cm × 56cm) ✛ Watercolor on 140-lb. (300gsm) cold-pressed paper ✛ Collection of the artist

"Art is not cozy and it is not mocked. Art tells the only truth that ultimately matters. It is the light by which human things can be mended. And after art, there is, let me assure you all, nothing."

—Iris Murdoch from *The Black Prince*, Penguin Books, New York, 1973.

contributors

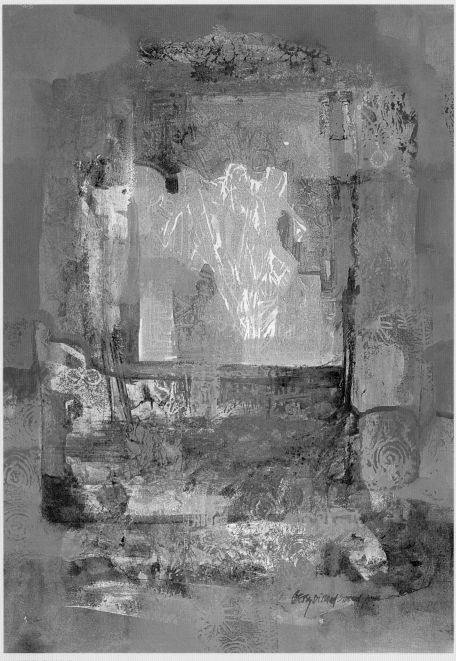

EMERGING
Betsy Dillard Stroud ✦ 30" × 22" (76cm × 56cm) ✦ Acrylic on Strathmore Aquarius II ✦
Collection of the artist

index

Explore your art with North Light Books!

Beautifully illustrated and superbly written, this wonderful guide is perfect for watercolorists of all skill levels! Gordon MacKenzie distills over thirty years of teaching experience into dozens of painting tricks and techniques that cover everything from key concepts, such as composition, color and value, to fine details, including washes, masking and more.

ISBN 0-89134-946-4, hardcover, 144 pages, #31443-K

Traditional Chinese watercolors capture the essence of natural objects with a profound, unmatched beauty. Renowned artist Lian Quan Zhen shows you how to paint in this loose, liberating style through a series of exciting, easy-to-follow demonstrations. You'll learn how to work with rice paper and bamboo brushes, then master basic Chinese brushstrokes and compositions principles.

ISBN 1-58180-000-2, hardcover, 144 pages, #31658-K

Infuse your watercolor florals with drama and intimacy! These five step-by-step demonstrations and easy-to-follow instructions show you how to capture nature's beauty up close. You'll learn how to mingle colors, manipulate light and design dynamic compositions. It's all the information you need to portray stunning, close-focus flowers with confidence and style.

ISBN 0-89134-947-2, hardcover, 128 pages, #31604-K

Claudia Nice introduces you to the joys of keeping a sketchbook journal, along with advice and encouragement for keeping your own. Exactly what goes in your journal is up to you. Sketch quickly or paint with care. Write about what you see. The choice is yours—and the memories you'll preserve will last a lifetime.

1-58180-044-4, hardcover, 128 pages, #31912-K

You have thousands of artistic ideas and images just waiting to be pulled up into the light. *Celebrate Your Creative Self* helps you develop the tools and techniques you need to express them! Mary Todd Beam provides dozens of hands-on demonstrations and projects that expand the boundaries of your imagination by experimenting with light, color, texture and design. You'll start creating fresh, moving works of art that capture the energy, personality and uniqueness of the artist within you.

ISBN 1-58180-102-5, hardcover, 144 pages, #31790-K

These books and other fine North Light titles are available from your local art & craft retailer, bookstore, online supplier or by calling 1-800-221-5831.